DAVID BUSCH'S QUICK SNAP GUIDE TO LIGHTING

David D. Busch

Course Technology PTR
A part of Cengage Learning

COURSE TECHNOLOGY
CENGAGE Learning™

Australia, Brazil, Japan, Korea, Mexico, Singapore, Spain, United Kingdom, United States

COURSE TECHNOLOGY
CENGAGE Learning™

David Busch's Quick Snap Guide to Lighting
David D. Busch

Publisher and General Manager, Course Technology PTR:
Stacy L. Hiquet

Associate Director of Marketing:
Sarah Panella

Manager of Editorial Services:
Heather Talbot

Marketing Manager:
Jordan Casey

Executive Editor:
Kevin Harreld

Project Editor:
Jenny Davidson

Technical Reviewer:
Michael D. Sullivan

PTR Editorial Services Coordinator:
Jen Blaney

Interior Layout Tech:
Bill Hartman

Cover Designer:
Mike Tanamachi

Indexer:
Larry Sweazy

Proofreader:
Sandi Wilson

For product information and technology assistance, contact us at
Cengage Learning Customer & Sales Support, 1-800-354-9706

For permission to use material from this text or product,
submit all requests online at **cengage.com/permissions**
Further permissions questions can be emailed to
permissionrequest@cengage.com

All trademarks are the property of their respective owners.

Library of Congress Control Number: 2008902402

ISBN-13: 978-1-59863-548-5

ISBN-10: 1-59863-548-4

Course Technology
25 Thomson Place
Boston, MA 02210
USA

Cengage Learning is a leading provider of customized learning solutions with office locations around the globe, including Singapore, the United Kingdom, Australia, Mexico, Brazil, and Japan. Locate your local office at: **international.cengage.com/region**

Cengage Learning products are represented in Canada by Nelson Education, Ltd.

For your lifelong learning solutions, visit **courseptr.com**

Visit our corporate website at **cengage.com**

Printed in China
3 4 5 6 7 15 14 13 12

For Cathy,
who continues to be
the light of my life.

Acknowledgments

Once again thanks to the folks at Course Technology, who have pioneered publishing digital imaging books in full color at a price anyone can afford. Special thanks to executive editor Kevin Harreld, who always gives me the freedom to let my imagination run free with a topic, as well as my veteran production team including project editor Jenny Davidson, and technical editor Mike Sullivan. Also thanks to Mike Tanamachi, cover designer; Bill Hartman, layout; and my agent, Carole McClendon, who has the amazing ability to keep both publishers and authors happy.

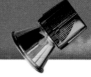

About the Author

With more than a million books in print, **David D. Busch** is one of the best-selling authors of books on digital photography and imaging technology, and the originator of popular series like *David Busch's Pro Secrets* and *David Busch's Quick Snap Guides*. He has written seven hugely successful guidebooks for Nikon digital SLR models, and six additional user guides for other camera models, as well as many popular books devoted to dSLRs, including *Mastering Digital SLR Photography, Second Edition* and *Digital SLR Pro Secrets*. As a roving photojournalist for more than 20 years, he illustrated his books, magazine articles, and newspaper reports with award-winning images. He's operated his own commercial studio, suffocated in formal dress while shooting weddings-for-hire, and shot sports for a daily newspaper and upstate New York college. His photos have been published in magazines as diverse as *Scientific American* and *Petersen's PhotoGraphic*, and his articles have appeared in *Popular Photography & Imaging*, *The Rangefinder*, *The Professional Photographer*, and hundreds of other publications. He's also reviewed dozens of digital cameras for CNet and *Computer Shopper*.

When About.com named its top five books on Beginning Digital Photography, debuting at the #1 and #2 slots were Busch's *Digital Photography All-In-One Desk Reference for Dummies* and *Mastering Digital Photography*. During the past year, he's had as many as five of his books listed in the Top 20 of Amazon.com's Digital Photography Bestseller list—simultaneously! Busch's 100-plus other books published since 1983 include bestsellers like *David Busch's Quick Snap Guide to Using Digital SLR Lenses*. He is a member of the Cleveland Photographic Society, which has been in continuous operation since 1887, and can be located at www.clevelandphoto.org.

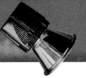

Contents

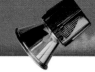

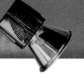

Preface

You've mastered your digital SLR (mostly), used it to create a few thousand photographic master-pieces, and now you are looking to add some skills in the use of light in all its wondrous varieties. But, you have some questions. How do I create and work with diffuse light? How can I tame daylight so that my pictures don't look harsh and overexposed? What is the secret to working with multiple light sources? What accessories and equipment will help me use light most creatively? What is color temperature? You don't want to spend hours or days studying a comprehensive book on digital SLR photography. All you want at this moment is a quick guide that explains the purpose and function of each type of lighting, how to use it to create great-looking pictures, and how to improve the lighting you find in a scene. Why isn't there a book that summarizes whole collections of these concepts in a page or two with lots of illustrations showing what your results will look like when you use this type of lighting, or that?

Now there is such a book. If you want a quick introduction to working with light and exposure, improving your photos with filters and reflectors, or transforming good lighting into great lighting, this book is for you. Once you realize that light is the tool you use to paint your photographs, you need this *Quick Snap Guide*.

I'm not going to tell you everything there is to know about using your digital SLR camera; I'm going to tell you just what you need to get started using light effectively to take compelling photos that will amaze your friends, family, colleagues—and yourself.

Introduction

This is the fourth book in my *Quick Snap* guide-book series, each of which takes a single puzzling area of digital photography and condenses each concept into a few pages that explain everything you need to know in easy-to-absorb bullet points, some essential text that summarizes just what you absolutely need to know, and is clearly illustrated with a few compelling photographs. Previous books in this series have dealt with point-and-shoot and digital SLR cameras, and the selection and use of interchangeable lenses. This one is devoted entirely to the mysteries of light.

Like all my *Quick Snap* guides, this book is aimed at photographers who may be new to SLRs or new to digital SLRs, and are overwhelmed by their options while underwhelmed by the explanations they receive in most of the photography books available.

The most comprehensive guidebooks try to cover too much material. You're lost in page after page of background and descriptions, most of which you're not really interested in. Books of this type are great if you already know what you don't know, and you can find an answer somewhere using voluminous tables of contents or lengthy indexes.

The book is designed for those who'd rather browse their way through a catalog of ideas and techniques, arranged in a browseable layout. You can thumb through and find the exact information you need quickly. All the basics of light and lighting techniques are presented within two-page and four-page spreads, so all the explanations and the illustrations that illuminate them are there for easy access. This book should solve many of your problems with a minimum amount of fuss and frustration.

Then, when you're ready to learn more, I hope you pick up one of my other in-depth guides to digital SLR photography. They are offered by Course Technology, each approaching the topic from a different perspective. They include:

Quick Snap Guide to Digital SLR Photography
If you're new to digital SLRs, this book belongs in your camera bag as a reference, so you can always have the basic knowledge you need with you, even if it doesn't yet reside in your head. It serves as a refresher that summarizes the basic features of digital SLR cameras, and what settings to use and when, such as continuous autofocus/single autofocus, aperture/shutter priority, EV settings, and so forth. The guide also includes recipes for shooting the most common kinds of pictures, with step-by-step instructions for capturing effective sports photos, portraits, landscapes, and other types of images.

Daivd Busch's Quick Snap Guide to Using Digital SLR Lenses
Like this book, my lens guide concentrates on a single set of topics—choosing and using lenses. If you're ready to go beyond the basics but are unsure which interchangeable lens or two to buy, and, more importantly, how and when to use them, this book offers focused, concise information and techniques. It includes overviews of how lenses work, and which types are available, discussions of all lens controls and features, including image stabilization/vibration reduction, and how to select the best lens and settings for particular types of photos.

Mastering Digital SLR Photography, Second Edition
This book is an introduction to digital SLR photography, with nuts-and-bolts explanations of the technology, more in-depth coverage of settings, and whole chapters on the most common types of photography. Use this book to learn how to operate your dSLR and get the most from its capabilities.

Digital SLR Pro Secrets
This is my more advanced guide to dSLR photography with greater depth and detail about the topics you're most interested in. If you've already mastered the basics in *Mastering Digital SLR Photography*, this book will take you to the next level.

Should you need instruction on how to get the most from specific camera models, look for my Course Technology books for the most recent cameras introduced by Nikon, Canon, Pentax, Sony, and other vendors under the *David Busch's Guides to Digital SLR Photography* banner. You can find more information about those books at www.nikonguides.com and www.dslrguides.com.

Who Am I?

After spending many years as the world's most successful unknown author, I've become slightly less obscure in the past few years, thanks to a horde of camera guidebooks and other photographically-oriented tomes. You may have seen my photography articles in *Popular Photography & Imaging* magazine. I've also written about 2,000 articles for magazines like *Petersen's Photo-Graphic* (which is now defunct through no fault of my own), plus *The Rangefinder*, *Professional Photographer*, and dozens of other photographic publications. But, first, and foremost, I'm a photojournalist and made my living in the field until I began devoting most of my time to writing books. Although I love writing, I'm happiest when I'm out taking pictures, which is why I took 14 days late last year for a solo visit to Spain—not as a tourist, because I've been to Spain no less than a dozen times in the past—but solely to take photographs of the people, landscapes, and monuments that I've grown to love.

Over the years, I've worked as a sports photographer for an Ohio newspaper and for an upstate New York college. I've operated my own commercial studio and photo lab, cranking out product shots on demand and then printing a few hundred glossy 8 × 10s on a tight deadline for a press kit. I've served as a photo-posing instructor for a modeling agency. People have actually paid me to shoot their weddings and immortalize them with portraits. I even prepared press kits and articles on photography as a PR consultant for a large Rochester, N.Y., company, which shall remain nameless. My trials and travails with imaging and computer technology have made their way into print in book form an alarming number of times, including a few dozen on scanners and photography.

Like you, I love photography for its own merits, and I view technology as just another tool to help me get the images I see in my mind's eye. But, also like you, I had to master this technology before I could apply it to my work. This book is the result of what I've learned, and I hope it will help you master your Nikon D60 digital SLR, too.

As I write this, I'm currently in the throes of upgrading my main website, which you can find at www.dbusch.com, adding tutorials and information about my other books. There's a lot of information about several different camera models right now, but I'll be adding tips and recommendations about newer models and a list of equipment and accessories that I can't live without in the next few months. I hope you'll stop by for a visit.

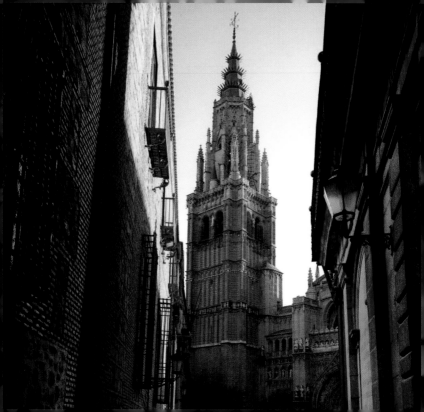

1 Basics of Good Lighting and Exposure

nless you're extraordinarily lucky, or supremely observant, great lighting, like most things of artistic value, doesn't happen by accident. It's entirely possible that you'll randomly encounter a scene or subject that's bathed in marvelous lighting, illumination that perfectly sculpts an image in highlights and shadows. But how often can you count on such luck? Ansel Adams is often quoted as saying (although he probably didn't) that "The harder I work, the luckier I get."

The great photographer was known for his patience in seeking out the best lighting for a composition, and he *did* actually say, "A good photograph is knowing where to stand." My own take on excellence in illumination is that you have to possess the ability to *recognize* effective lighting when it is already present, and have the skill to manipulate the light when it is not.

This chapter will launch you down the road to being able to use the light that is present, manipulate it when necessary to achieve the effects you want, and to create good lighting from scratch using the tools available. I'm going to present some basic lighting concepts that you can use right now and apply with the more advanced information presented in later chapters.

High-Contrast Lighting

To be able to use good lighting yourself, you have to be able to recognize it when you see it. There is a great story about photographer George Krause spending the early part of his career shooting photographs *only* on overcast days, under diffuse, low-contrast illumination (illustrated in the next section). That kind of lighting can be exceptionally challenging, because there is no interplay of highlights and shadows to add depth to a composition. Only when Krause was convinced that he understood soft lighting did he move on to work with more dramatic applications of light. No example of my own in this book could illustrate the idea of *good lighting* more vividly than Krause's *Shadow*, taken in Seville, Spain more than 40 years ago. I urge you to check it out at **www.georgekrause.com/ shadow.htm**. Does the photo show an old woman—or an old woman followed by a dark secret?

High-contrast lighting is illumination that provides images that offer stark, brightly lit highlights and dark, inky shadows, with relatively few tones in the middle. Such images are seen as especially dramatic, because they capture the eye, drawing attention to the bold and strong shapes within the frame. High-contrast photos are often seen as dynamic, in the sense that something is going on in the picture, when compared to images that have less contrast and are seen as flat and static.

Today, high-contrast photos are sometimes considered bad form, because digital photographers must constantly battle to overcome sensors that can't always record the full range of tones in a scene and, instead, produce images with an excessive amount of contrast. In truth, it's only *unwanted* contrast that's bad. Indeed, back at the beginning of my career in the days of film and darkrooms, one of the most popular tools was high contrast lith ("lithographic") film, which could produce nothing *but* black-and-clear images. Another favorite was extra contrasty photographic paper, like the legendary Agfa

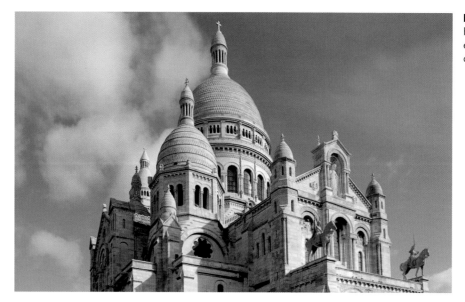

Figure 1.1
High-contrast lighting emphasizes texture and detail.

Brovira #6, which was, in those pre-Spinal Tap days, the equivalent of being able to turn your amp up to 11.

High-contrast lighting does a number of things for you.

◆ It can brighten up low-contrast subjects and make them more vibrant and interesting.

◆ It can take images of normal contrast and give them a bold look.

◆ It can salvage images that are already excessively high in contrast.

◆ It emphasizes texture and detail.

◆ It can be used to provide a unified look among several images that differ in contrast, by pegging them all to the high contrast end.

◆ In portraiture, higher contrast lighting can give male faces a rugged, masculine look, and, if used in moderation, accentuate character lines in older people.

High-contrast lighting emphasizes texture, as you can see in Figure 1.1. Because of the shadows cast by the sunlight, each detail of the cathedral stands out in vivid relief. This type of lighting is highly directional. It illuminates the subject from a well-defined source that is relatively narrow, and the beam of light doesn't spread much, which is the source of the deep, sharp-edged shadows. The built-in flash unit on your camera often produces illumination of this sort. High-contrast lighting is generally direct, and at some distance from the subject; indeed, the farther you move a light source from a subject, the more harsh and sharp it becomes. Later in this book, I'll show you how to create high-contrast lighting when you need it, and how to correct for it when you don't. Figure 1.2 shows the results of a typical high contrast lighting setup.

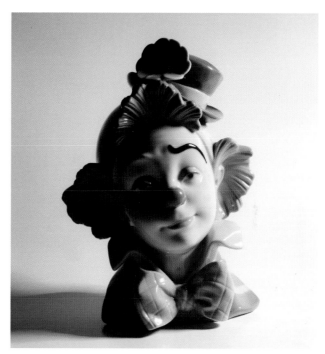

Figure 1.2 High-contrast illumination produces deep, sharp-edged shadows.

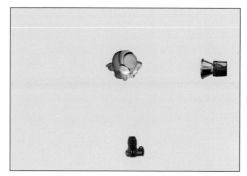

Figure 1.3

HOW IT'S LIT

The clown figurine shown in Figure 1.2 was lit with a single direct light from the right side, as pictured in Figure 1.3. No fill-in light was used to illuminate the shadows, other than light that might have bounced back from the surrounding areas.

3

Low-Contrast Lighting

Like high-contrast lighting, the low-contrast variety isn't inherently bad; it's inherently *different*. This kind of lighting is also called *soft* or *diffuse* illumination, because it provides a gentle, subtle, sometimes moody look to the subject matter.

With low-contrast lighting, there are few or no shadows, and those that exist have soft edges. The entire subject is washed with a non-directional light that seems to come from every angle. Diffuse lighting almost always is produced by the use of reflectors to soften and spread the illumination before it is bounced toward your subject; or by passing the light *through* some sort of translucent material, such as the fabric of a white umbrella, or the diffusion screen of a soft box. As you move a light source closer to a subject, its illumination tends to "wrap around" the subject and provide more even lighting. Move the source farther from the subject, and it becomes more directional and gains contrast.

There are several things low-contrast lighting can do for you.

- ◆ It can soften high-contrast subjects and make them more subdued.
- ◆ It can take images of normal contrast and give them a moody look.

- ◆ It can partially recover images of subjects that are excessively high in contrast.
- ◆ Like high-contrast imaging, it can be used to provide a unified look among groups of pictures that differ in contrast by giving them all a softer look.

- ◆ It masks details, which can be useful in portraiture, where soft lighting hides skin flaws, provides a more glamorous or romantic look to photos of female subjects, and offers a gentler rendition of older people who would prefer to downplay the ravages of time.

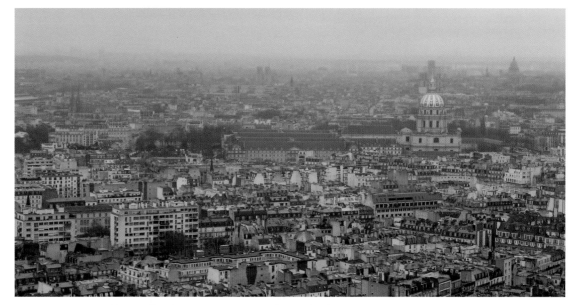

Figure 1.4 Overcast days produce low-contrast images with muted colors.

One thing to keep in mind is that it is possible to *combine* low-contrast lighting in the same photograph, to good effect. For example, you can shoot a human subject outdoors in the soft, diffuse lighting in the shade of a tree, with the background illuminated by harsh direct sunlight. The contrast between the two can help separate your main subject from the background and provide an interesting look.

You'll often encounter low-contrast lighting outdoors on cloudy and overcast days, or those plagued by haze or fog, as shown in Figure 1.4. Notice that in this view of Paris, colors are muted, too; low-contrast lighting tends to produce desaturated hues. Back in the pre-digital days, photographers would use

films noted for their vivid colors, such as Kodak Ektachrome or Fujifilm Velvia; today, you can simply boost the saturation setting of your digital camera.

Figure 1.5 shows a typical low-contrast lighting arrangement. The shadows are minimal, which reduces the three-dimensional look of the porcelain figurine compared to the high-contrast image in the previous section. Note that the shadow areas are subdued, but not eliminated entirely. Low-contrast lighting can be used to soften subjects, but shouldn't be carried to extremes. Without any shadows at all, the figurine would look flat and two-dimensional. I'll show you an example of a shadowless image in the next section.

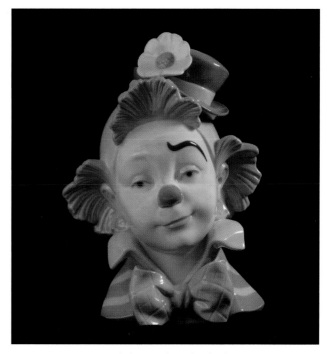

Figure 1.5 Low-contrast lighting softens the shadows.

Figure 1.6

HOW IT'S LIT

In this case, the clown was lit with a pair of umbrellas located in front of the figurine and at about a 45-degree angle from the lens axis, as shown in Figure 1.6. The left umbrella was moved slightly farther back, and set to 3/4 intensity so the shadows cast by the other umbrella weren't completely filled in. If your light source can't be varied in intensity, just move it back a bit more to reproduce this effect. Note that the light bulbs shown are modeling lights that preview the lighting effect of the flash.

High-Key Lighting

Another illumination concept you need to understand is the difference between *high-key* and *low-key* lighting. It's easy to get these styles of lighting confused with high-contrast and low-contrast types, and adding to the confusion is the reality that high-key images are relatively low in contrast, while low-key images can be high in contrast. What's going on here? I'll explain each type in this section and the one that follows.

High-key lighting is bright. When an image is photographed in a high-key style, it is typically *very* bright, with lots of white tones. The darkest areas may actually fall in what is considered a middle tone area, and there are maybe no dark shadows at all, as you can see in Figure 1.7, which has almost no blacks. Because all the tones are relatively homogenous, high-key lighting can be considered relatively

low in contrast. But, as you've learned, not all low contrast images are bright; a photo can consist of predominantly middle tones or dark tones and still be considered low contrast. What distinguishes all kinds of low contrast images is the restricted tonal range. High-key photos are just one type of reduced contrast image.

High-key lighting became popular at the beginning of the film and television eras, because neither medium was able to capture scenes of high contrast. Originally, a rather clumsy "three-light" scheme was used, with a trio of fixtures illuminating each person in a scene (to the left, right, and middle). That produced a bright, uniform lighting pattern with no shadows. In addition to reducing the contrast of the shot so it was easier to photograph technically, high-key lighting was fast to set up, and allowed film

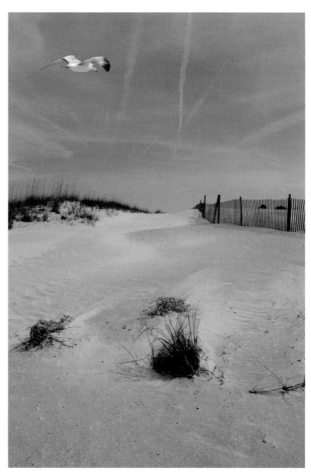

Figure 1.7 High-key images have a preponderance of light tones, with few true blacks.

LIGHTING RATIOS

A lighting ratio is a comparison between the level of illumination of the highlight areas of an image, and the amount of light falling into the shadows. For example, if an exposure of 1/500th second at f/11 is required to properly expose the highlights of an object, while the shadows would require an exposure of 1/500th second at f/5.6, then the lighting ratio would be 3:1. High-key images often have a ratio of 2:1 or even 1:1, while low-key images can produce ratios of 8:1 or higher. I'll explain lighting ratios in more detail in Chapter 5.

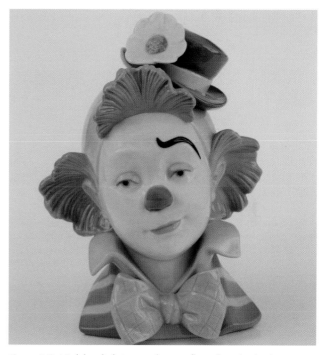

Figure 1.8 High-key lighting produces a flat, often shadowless image.

and television production to complete more scenes in less time. Still photographers generally use more sophisticated lighting arrangements to produce high-key effects (it's unlikely that you'll want to bathe each subject in your photo with their own triad of lights), but the same general bright, upbeat, virtually shadowless illumination scheme is used.

Figure 1.8 shows a high-key image. Compared to the low-contrast image in the previous section (Figure 1.5), this one has virtually no shadows; all the tones in the picture fall into the light to middle-tone range.

Figure 1.9

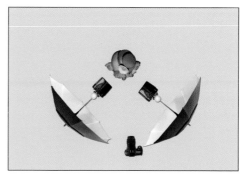

HOW IT'S LIT

The clown figurine shown in Figure 1.8 was lit with a pair of lights of equal intensity bounced into umbrellas set at roughly 45-degree angles from the lens axis, as shown in Figure 1.9. This produces a soft, even lighting with virtually no shadows, especially when combined with light bouncing back from the light-colored background.

Low-Key Lighting

Low-key images are typically very dark, and often are illuminated by a single light source that provides dramatic highlights, while allowing the rest of the image to fade to darkness. A low-key image is often high in contrast, but some can include shadow areas that are illuminated with a fill-in ("fill") light, so there is detail in the dark areas, creating an effect that artists call *chiaroscuro* (Italian for "light-dark"). If you remember that low-key photos are always dark (sometimes even murky), you can differentiate them from the broader category of high-contrast images.

The scene in Figure 1.10 shows a cathedral as seen from an alleyway opposite. The cathedral's tower is illuminated by flood lighting, while the alley has several street lamps to dimly light the narrow passage. This lighting creates a dramatic mood for the picture, which was taken at midnight on a crisp October day. You can see the same scene from roughly the same vantage point

at 6 a.m. the following day in Figure 1.11. The early morning light is still fairly high in contrast, but the foreboding low-key effect is gone.

Low-key lighting is another offshoot of the film and television area, and became popular rather early, despite the technical limitations imposed by high-contrast scenes, because more dramatic lighting was needed for serious drama, film noir, horror, and other heavier fare. Where high-key lighting illuminates the entire subject evenly, low-key lighting emphasizes the contours of a person or object by providing light only to the edges, while allowing other areas to fall into shadow, as you can see in Figure 1.12.

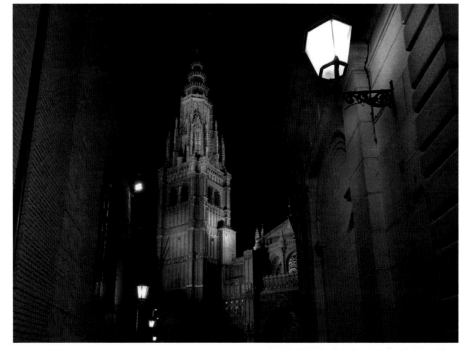

Figure 1.10
Low-key lighting creates a moody effect.

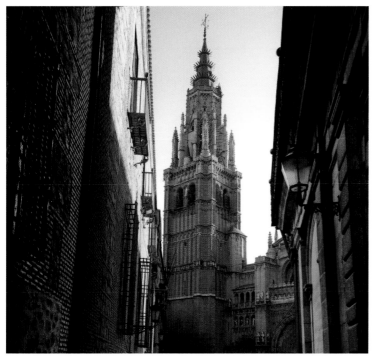

Figure 1.11 The same scene shot by early morning light has a brighter look.

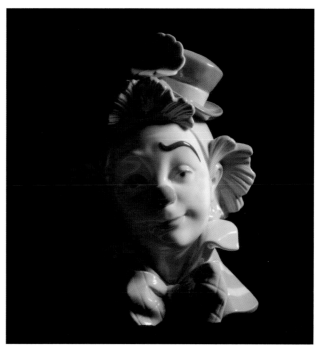

Figure 1.12 Low-key lighting often uses only a single light source, with the shadows filled in by reflected light.

Figure 1.13

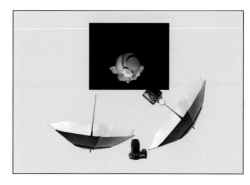

HOW IT'S LIT

The clown figurine shown in Figure 1.12 was lit with a single direct light from the right side, as pictured in Figure 1.13. No fill-in light was used to illuminate the shadows, other than light that might have bounced back from the surrounding areas and the umbrella used as a reflector.

Light and the Exposure Triangle

An integral part of using lighting correctly is achieving the correct exposure, so that the final image has the tonal values you want to accurately (or imaginatively) represent your subject. Three components of the camera, the shutter speed, lens opening (or aperture), and sensor sensitivity (measured in ISO values), determine the exposure for a given scene. These three aspects that involve your camera, its mechanics, and controls are known as the *exposure triangle*, shown in Figure 1.14.

◆ **Shutter speed.** This is the length of time that the sensor is effectively exposed to light. I say *effectively*, because, at briefer shutter speeds, the entire sensor may not be exposed all at one time; the camera may use a traveling "slit" to expose only a small section of the sensor at a time. In addition, electronic flash has a duration that's shorter than the amount of time the shutter is completely open, so that, even though your camera is set for 1/200th second, the sensor may be *effectively* exposed for only the 1/1,000th second duration of the flash.

◆ **Aperture.** The aperture represents the quantity of the light that is allowed to pass through the lens to the sensor, much like garden hoses of different diameters allow more or less water to flow during a given time period.

◆ **ISO.** This is the relative sensitivity of the sensor. Each camera has a *base sensitivity*, which is its lowest true ISO setting. It can then produce higher (or even lower) ISO sensitivities by amplifying (or deamplifying) the signal as photons are captured.

The three components of the exposure triangle work *proportionately* and *reciprocally* to produce an exposure. That is, if you double the amount of light that's available, increase the aperture by one stop, make the shutter speed twice as long, or boost the ISO setting 2X, you'll get twice as much exposure. Similarly, you can increase any of these factors while decreasing one of the others by a similar proportion to keep the same exposure.

There are six aspects that affect light as it travels from its source to your sensor. The six factors that influence the light we use to take photos are as follows:

◆ **Light source.** The most important attribute of light is its *intensity*. How bright is the light at its source? As light grows more intense, it allows using exposures that have faster shutter speeds, smaller apertures, reduced ISO settings, or some combination of the three. Lower light levels mandate slower shutter speeds, larger apertures, and higher ISO settings, all of which can have negative effects on our pictures, in the form of motion blur, reduced depth-of-field, and visible noise. In some cases, we may have some control over the intensity of illumination, as when shooting indoors with artificial light fixtures we can adjust or dim. Outdoors, it's beyond our abilities to adjust the brightness of the sun, but we can introduce translucent or opaque light-blockers to the path of the light to intercept some of it, or reflectors to re-direct the illumination.

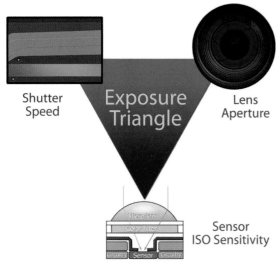

Figure 1.14
The three elements of this triangle determine the exposure of your image.

Shutter Speed

Exposure Triangle

Lens Aperture

Sensor ISO Sensitivity

◆ **Light duration.** Light sources aren't necessarily continuous. Electronic flash units, for example, expend all their light within a brief period, quickly enough to affect the overall exposure when flash is the main illumination of an image. Indeed, if flash is the primary light source, the effective "shutter speed" of the exposure is the duration of the flash's burst. Although the camera may have been set to 1/250th second, the action-stopping capabilities of the flash might be 1/1,000th second.

◆ **Light emission, reflection, or transmission.** Light reaches the lens directly (as when light from a candle is captured in an image); by reflection (bouncing off an object); or by transmission (after passing through a translucent object that's lit from behind). The amount of light that completes this journey without being absorbed, blocked, spread (diffused), or interrupted determines the exposure required.

◆ **Light passing through the lens.** Not all of the illumination that reaches the lens passes through to the sensor. If you have a filter mounted on your lens, it will remove or modify some of the light (see Figure 1.15). Inside the lens, a variable-sized roughly circular diaphragm, or *aperture*, dilates and contracts to control the amount of light that enters the lens. The

aperture is adjusted in size by your camera's autoexposure system, or by manual settings you make. As you'll learn in the next section, the relative size of the aperture is called the *f/stop*.

◆ **Light passing through the shutter.** Once light makes it all the way through the lens, the amount of time the sensor is exposed to that illumination is determined by the camera's shutter.

The shutter can remain open for as long as 30 seconds (or even longer if you use the Bulb setting) or as briefly as 1/8,000th second, depending on which digital camera you own. The "shutter" may be a physical device that opens and closes for a given period of time, or, in the case of the highest shutter speeds, an electronic mode that activates and deactivates the sensor for a brief period while the physical shutter is open.

◆ **Light captured by the sensor.** Finally, the illumination that a fraction of a second ago began its journey from your subject to the camera crosses the finish line and reaches the sensor. But not all the light passing through the shutter is captured by the individual pixels (or *photosites*) of the sensor. If the number of photons reaching a particular photosite doesn't pass a set threshold, no information is recorded. Similarly, if too much light illuminates a pixel in the sensor, then the excess isn't recorded or, worse, spills over to contaminate adjacent pixels. We can modify the minimum and maximum number of pixels that contribute to image detail by adjusting the ISO (or *sensitivity*) setting. At higher ISOs, the incoming light is amplified to boost the effective sensitivity of the sensor.

These aspects—the quantity of light produced by the light source, the amount reflected or transmitted towards the camera, the light passed by the lens, the amount of time the shutter is open, and the sensitivity of the sensor—all contribute to the actual exposure.

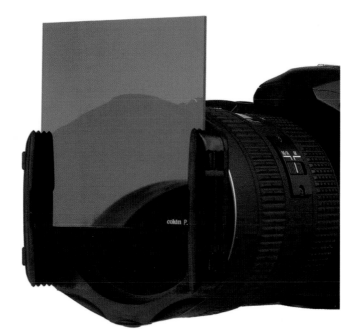

Figure 1.15 A filter placed in front of the lens removes some of the light before it reaches the sensor.

F/Stops

Many people rely most on only two legs of the exposure triangle: they set their ISO sensitivity to a value appropriate for the type of photos they are going to take (a low ISO outdoors in bright sunlight; a higher setting for sports, indoors, or in other reduced-light environments) and forget it. (They also may forget that many cameras have an *auto ISO* option that adjusts sensitivity for them, sometimes producing unintended results.)

Then, they (or their camera's exposure meter) adjust only the f/stop, shutter speed, or both, to arrive at an exposure. That's a common practice, and there's nothing wrong with it as long as you keep in mind that ISO sensitivity is an available and important option for adjusting exposure.

I like to use the term *f/stop* frequently when referring to the lens opening, in order to remind you that the expression represents a *fraction*, as I'll explain shortly.

However, an f/stop can also be properly referred to as an *aperture*, and the physical lens feature is often called the *iris diaphragm* or simply *diaphragm*. These are all terms that describe a variable-sized, roughly circular opening in the lens that dilates and shrinks to determine the amount of light that passes through the lens to the sensor.

This aperture is roughly comparable to the pupil of the human eye. When the light is bright and harsh, the pupils contract; under dimmer conditions, the pupils expand to admit more light. F/stops aren't absolute values: an aperture described as f/8 with one lens may actually be larger

or smaller than an f/8 setting with a different lens. That's because they represent the *relative* size of the actual physical lens opening compared to the focal length of the lens. For example, with a lens with a focal length of 50mm, an aperture that measured 12.5mm in diameter would produce a lens opening with the value f/4 (50 divided by 12.5). The same size opening in a lens with a 100mm focal length would produce a lens opening with the value f/8 (100 divided by 12.5).

Because of this relationship, you can visualize f/stops as the denominators of fractions. That's why "larger" f-numbers represent

F/STOPS VERSUS STOPS

In photography parlance, *f/stop* always means the aperture or lens opening. However, for lack of a current commonly used word for one exposure increment, the term *stop* is often used. (In the past, EV served this purpose, but Exposure Value and its abbreviation has been inextricably intertwined with its use in describing Exposure Compensation.) In this book, when I say "stop" by itself (no f/), I mean one whole unit of exposure, and am not necessarily referring to an actual f/stop or lens aperture. So, adjusting the exposure by "one stop" can mean both changing to the next shutter speed increment (say, from 1/125th second to 1/250th second) or the next aperture (such as f/4 to f/5.6). Similarly, 1/3 stop or 1/2 stop increments can mean either shutter speed or aperture changes, depending on the context. Be forewarned.

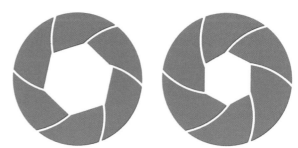

Figure 1.16
An aperture of f/5.6 (left) is larger than an aperture of f/8 (right).

smaller apertures, and "smaller" f-numbers represent *larger* apertures (see Figure 1.16). Once you become smarter than a fifth grader (long ago, or recently), you have no trouble with the concept that 1/2 is larger than 1/4 and 1/8, and that 1/16 is smaller than even an odd-ball fraction like 1/11. Similarly, f/2 is larger than f/4 and f/8, and f/16 is smaller than f/11.

Of course, it doesn't help demystify things to know that the relationship between f/stops involves the square root of two (1.4). So, f/2 isn't *twice* as large as f/4 in terms of area; it's four times as large, just as f/4 is actually four times as large as f/8. Intermediate numbers, based on that pesky square root of two, are needed to represent actual doubling and halving of aperture size. So, a lens might be marked:

f/2, f/2.8, f/4, f/5.6, f/8, f/11, f/16, f/22

with each larger number representing an aperture that admits half as much light as the one before. You need to understand that relationship to calculate

exposure, or to apply exposure settings selected by your camera's metering system.

While we're most concerned about lighting and exposure in this book, you should be aware that your choice of an f/stop has other effects on your image that can cascade down to your lighting and exposure decisions.

These include:

◆ **Overall sharpness.** The f/stop you select can have a dramatic effect on the sharpness of your image. Most lenses are not at their sharpest wide open using the largest f/stop. They will perform better at an opening that's one or two stops smaller (say, f/8 with a lens having a maximum aperture of f/4). Nor do most lenses produce their best results at the smallest lens openings, due to a phenomenon

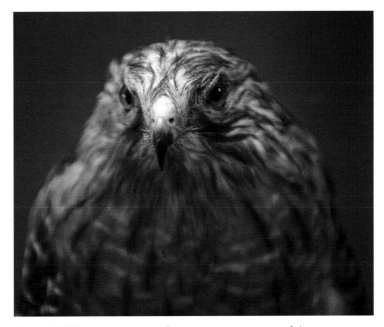

Figure 1.17 Larger apertures produce a very narrow range of sharpness, or depth-of-field.

called *diffraction*. Light striking the edges of the diaphragm at, say, f/22, scatter, reducing sharpness compared to a larger f/stop, such as f/8. If your lighting scheme is designed to enhance the texture and sharpness of your subject, you'll want to choose an f/stop that doesn't detract from that goal.

◆ **Depth-of-field.** The f/stop selected also determines the *range* of sharpness available, called *depth-of-field*. Larger apertures (smaller numbers) produce less DOF (see Figure 1.17), while smaller apertures (larger numbers) generate more DOF. You may plan your lighting for a portrait so that the background is de-emphasized. If so, you might want to use the available depth-of-field as an additional tool.

◆ **Background appearance.** The f/stop used can affect how the out-of-focus portions of your image appear, a process that's separate from depth-of-field considerations. This property is called *bokeh*, from a Japanese word meaning blur, and determines whether out-of-focus highlights in the image appear as visible discs, or as less obtrusive shapes that are less prominent. While bokeh is important from a pictorial standpoint, in terms of lighting it is significant chiefly in how the backgrounds complement or detract from your lighting arrangement.

Shutter Speeds

The second leg of the exposure triangle that most of us work with is the shutter speed, represented in fractions (of a second), such as 1/60th, 1/125th, 1/250th, 1/500th, and 1/1,000th second (at least, until the fraction reaches 1/1 and the measurements convert to whole seconds). In practice, the numerator is usually omitted, so that 60, 125, 250, 500, 1,000, and so forth are used instead. Most digital cameras represent exposures of longer than a second with numbers followed by a single or double quote mark, so 2", 2.5", and 4", and so forth represent 2.0, 2.5, and 4.0-second exposures, respectively.

As I noted earlier, exposure settings are most commonly made using the aperture and shutter speed, followed by adjusting the ISO sensitivity if it's not possible to get the preferred exposure (that is, the one that uses the "best" f/stop or shutter speed for the depth-of-field or action-stopping we want).

In modern cameras, the shutter resides just in front of the sensor, which lies in the *focal plane* where light focused by the lens converges. Such shutters are, appropriately, called *focal plane shutters*. The most common type of focal plane shutter consists of a pair of curtains that travel vertically. The gap between the curtains allows the sensor to be exposed to light. A shutter that is closed prior to exposure looks something like Figure 1.18. (The illustration is not a photograph of an actual focal plane shutter; it's just a concoction I put together to show you how all the elements of a shutter work together.)

Focal Planes and Shutter Speeds

When the shutter button is depressed all the way, the first curtain moves up, exposing the sensor, as you can see in Figure 1.19. After a period of time, the second curtain begins to travel upwards, too, trailing the first curtain and producing a moving "slit" as shown in Figure 1.20. The width of the slit determines the relative shutter speed. A narrow opening produces a fast shutter speed; a wider opening creates a slower shutter speed.

There are a couple limitations you should know about. Figures 1.19 and 1.20 show a slit width that, in this fictitious camera,

Figure 1.18 The focal plane shutter is completely closed.

produces a shutter speed of 1/500th second. A slit twice as wide would create a shutter speed of 1/250th second, and one twice as wide as *that* would result in a shutter speed of 1/125th second. Indeed, that 4X width exposes the whole sensor at once, and can't get any wider, so shutter speeds *longer* than 1/125th second are produced by introducing a delay before the second curtain starts to close. Exposing the sensor to light for

30 seconds before the second curtain begins its upward travel would give you a shutter speed of 30 seconds (natch).

Going in the other direction, there's a limitation on just how narrow the slit can be. With our fictitious example camera, the slit would need to be 1/2 as wide to create a 1/1,000th second shutter speed, 1/4 as wide for 1/2,000th second, and 1/8 as wide for 1/4,000th second.

Many digital cameras can't narrow the gap between the first and second curtains any more than that, so 1/4,000th second is the top shutter speed. A few can go to 1/8,000th second or faster. Some cameras generate faster shutter speeds electronically, by turning the sensor on or off very quickly while the two shutter curtains are wide open.

But wait, as they say, there's more! Electronic flash has a very

brief duration, much shorter than the shutter curtains' vertical travel at fast speeds. Camera designers work around this problem by allowing the flash to fire *only* during that period when the shutter is completely open. With our example camera, the shutter is fully open at 1/125th second; flash pictures can be taken at shutter speeds of 1/125th second or slower.

Figure 1.19 The first curtain has traveled 1/4 of the distance across the focal plane, exposing the sensor through the slit produced.

Figure 1.20 The first curtain continues to travel, and the second curtain begins to trail it, gradually exposing the sensor.

Because shutter speeds and f/stops are proportional, you can produce the exact same exposure using many different combinations of settings. Table 1.1 shows equivalent exposure settings using various shutter speeds and f/stops. I'll explain more about calculating the best exposure in the next chapter.

If your camera has chosen one of these exposure pairs, and you'd rather use a different combination, there will usually be a provision to change from one exposure pair to an equivalent

pair by spinning a dial or adjusting some other control. So, if your camera has chosen 1/500th second at f/4 and you'd prefer a little more depth-of-field, you can use the control to switch to 1/250th second at f/5.6 or 1/125th second at f/8 using the same ISO setting. Conversely, if you'd rather work with a wider f/stop to apply *less* depth-of-field for selective focus, you can switch to 1/1,000th second at f/2.8, or 1/2,000th second at f/2 (assuming your lens has either or both of those fairly large aperture options).

You can switch among equivalent exposures in Aperture Priority or Shutter Priority modes, too, but only by changing the "dominant" control in your selected mode. That is, to produce a faster or slower shutter speed in Aperture Priority mode while retaining the same exposure, you must adjust the aperture up or down. To use a larger or smaller aperture in Shutter Priority mode, switch to a faster or slower shutter speed.

As with f/stops, the shutter speed you select has effects on your image other than exposure:

◆ **Subject blur/sharpness.** Faster shutter speeds are required to "freeze" fast-moving objects, those in motion that are closer to the camera, and those that are moving across the frame. In each case, the motion is more apparent because of the speed, distance, or direction of the subject. Conversely, you'll find that slower shutter speeds will work well for objects that are stationary or not moving quickly, those that are more distant, or which are moving toward the camera, because the apparent motion

is less. Using motion-stopping capabilities, or allowing movement to blur is your choice, and part of your creative decision. Some types of pictures, just as motor racing, look best when there is at least some blur to indicate that the subject was moving.

◆ **Camera/lens movement/sharpness.** A second kind of motion blur, caused by movement of the camera or photographer, can also affect pictures. In some cases, it can be applied creatively, as when the camera is panned from side to side to capture a sharp image of an athlete while allowing the background to blur, as you can see in Figure 1.21. But, most of the time, camera shake just robs your pictures of sharpness. It can be produced during long exposures if the camera isn't mounted on a tripod or other support (or, even when properly mounted if the support is less than rock steady). Camera shake is increased by long lenses, which magnify the motion of the camera at the same time distant subjects are brought closer. If camera motion blur is objectionable, use a sturdy support; select a faster shutter speed; or use a camera or lens

Table 1.1 Equivalent Exposures

Shutter speed	f/stop	Shutter speed	f/stop
1/8th second	f/32	1/250th second	f/5.6
1/15th second	f/22	1/500th second	f/4
1/30th second	f/16	1/1,000th second	f/2.8
1/60th second	f/11	1/2,000th second	f/2
1/125th second	f/8	1/4,000th second	f/1.4

with built-in vibration reduction/image stabilization/anti-shake features. Nikon and Canon build this feature into many of their lenses; Sony, Olympus, Pentax, and others include it in the camera body so that *every* lens can be used with the stabilization feature.

◆ **Noise.** Longer shutter speeds (usually those of several seconds and longer) can introduce those random, multicolored speckles we call visual noise into your photographs. (Another, equally objectionable type of noise is produced at the highest ISO settings of a camera.)

While the built-in noise reduction features of digital cameras can mask this visual interference, they tend to rob your image of detail, too. So, you should consider the possibility of noise when selecting longer shutter speeds (and higher ISOs).

◆ **Use of flash.** As I noted earlier, the shutter speed you select can affect your use of electronic flash for a given photograph. Most digital cameras have a maximum shutter speed (usually between 1/160th and 1/500th second) at which flash can be used. (Some have a mode called "high speed sync" that allows flash at even faster speeds, but reduces the effective output of the flash.) When it comes to use of lighting, this maximum sync speed can cramp your style when you want to use flash as a fill-in under high light levels. If the overall exposure in daylight that you want to use is 1/1,000th second at f/8 (say, for reduced depth-of-field when using selective focus), your flash isn't going to do you much good to fill in the shadows if your camera allows a shutter speed no faster than 1/200th second. Shutter speed can also be a limitation at the low end, too; if you use flash with a low shutter speed (to prevent the surroundings from going pitch-black), you can end up with ghostly secondary images unless the camera is mounted on a tripod.

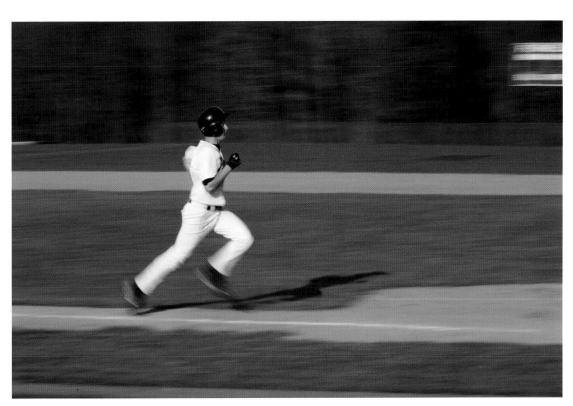

Figure 1.21 Camera motion can be used creatively to introduce blur to an action picture.

Adjusting Exposure with ISO Settings

The third way of adjusting exposure is by changing the ISO sensitivity setting. This option is often overlooked, or used as a "last resort." That's because higher ISO settings are seen as necessary evils. You're told you should use the lowest ISO setting possible for best quality, and increase the sensitivity only if a given ISO doesn't allow the "best" exposure. So, we tend to set the ISO once for a particular shooting session (say, at ISO 100 or 200 for bright sunlight outdoors, or ISO 800 when shooting indoors) and then forget about it. However, changing the ISO is a valid way of adjusting exposure settings, especially if you own a newer digital camera, as the latest batch tend to minimize visual noise at reasonable ISO settings, with many fully usable up to ISO 800 or ISO 1,600 (and beyond) with very little objectionable visual noise.

The typical digital camera has ISO options ranging from ISO 100 (although some go as low as ISO 50) up to around ISO 1,600 or ISO 3,200. A few newer cameras offer ISO settings of 6,400 (while still producing acceptable results), and one of my favorite models actually has High 1 and High 2 settings that are the equivalent of ISO 12,800 and ISO 25,600. At the latter setting, the pictures are usually too grainy to use, but I've actually gotten decent results. Figure 1.22 shows an informal snapshot grabbed at a camera club meeting where I was complaining that ISO 25,600 was overkill, and took this photo of the club president at 1/250th second at F/11 (indoors!) using that lofty ISO setting with a Nikon D3. I was unable to make my point, because the image, as you can see, doesn't look that bad, grain and noise-wise.

Although I steer away from ISO settings higher than 3,200 with most cameras, I do end up using ISO adjustments quite frequently when shooting in the studio. That's especially true in Manual mode, which is my only option when using studio flash (which are not compatible with my camera's TTL electronic flash exposure system). My studio flash units produce bursts that call for exposures at f/11 or f/16 at ISO 200. If I want a little more exposure, I can switch to ISO 400, or, for a little less, change to ISO 100, with no need to change the f/stop (which increases or decreases your depth-of-field). Or, I can change to a larger or smaller f/stop, and adjust the ISO to keep the same exposure.

Outside the studio and *sans* flash, perhaps, I am using Shutter Priority mode (discussed in the next chapter) and the metered exposure at ISO 200 is 1/500th second at f/11. If I decide on the spur of the moment I'd rather use 1/500th second at f/8, I can press a button to switch to ISO 100. It's a good idea to monitor your ISO changes, so you don't end up at ISO 1,600 accidentally. Many cameras can adjust the ISO automatically as appropriate for various lighting conditions.

If you must use a high ISO setting to adjust exposure, take advantage of your camera's noise reduction (NR) features. Some models have a single NR option, which can be turned on or disabled entirely if you want to avoid the loss of detail that aggressive noise reduction can produce. Others allow choosing a level of noise reduction, from low, medium, to high, plus off. Noise cancellation can be broken

down into two categories as well: High ISO Noise Reduction and Long Exposure Noise Reduction, because each type of situation produces a different type of noise. You can activate or deactivate the High ISO and Long Exposure noise reduction separately, as you might not need both.

The visual noise produced by your camera can also be minimized or eliminated using programs that run on your computer, after the shot has been taken and transferred to your hard disk. Adobe's Camera Raw plug-in for Photoshop and Photoshop Elements has built-in noise reduction that can be applied when the image is imported. Both image editors have their own noise cancellation filters, as well. Noise reduction is included with third-party applications like Noise Ninja and Bibble Pro. Once you've learned how to minimize the effects of noise at high ISO settings, you'll have the freedom to use sensitivity adjustments as an exposure tool more often.

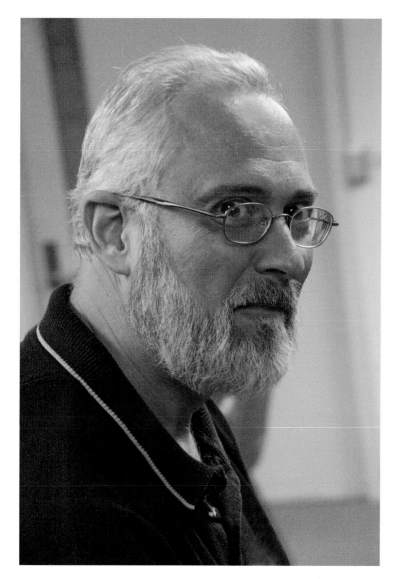

Figure 1.22
High ISO settings don't necessarily lead to disaster with newer digital SLRs, as this ISO 25,600 snapshot proves.

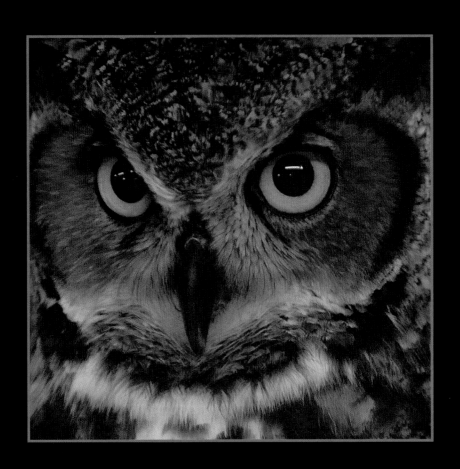

Optimizing Exposure

The light you work with comes in many forms. You may use the light that's available at a scene, supply your own illumination, or manipulate light to provide the exact look you want. But, no matter how carefully you shape your picture with light, if the exposure is wrong for that image, you may not get the effect you seek. A carefully crafted silhouette exposed improperly may be transformed into a murky portrait with a washed-out background. If the exposure is incorrect, your languid landscape might emphasize an uninteresting foreground at the expense of a gorgeous expanse of lush foliage in the middle part of an image, because our eyes are automatically attracted to the brightest parts of an image. Exposure, composition, and lighting must work hand-in-hand to produce the best photos.

Digital SLRs use light-sensitive electronics—the camera's built-in meter—to measure the light passing through the lens. Digital SLRs use much more refined methods of metering light, too, compared to the earliest through-the-lens film models that measured an amorphous blob of light averaged out over the entire frame, without much regard to where specific bits of illumination originated in the image.

There are three different aspects of calculating exposure that you need to take into account when working with a digital camera. How and where within a scene is the exposure measured? That's the camera's *metering mode*. Once the amount of illumination is measured, what controls, such as shutter speed, f/stop, and ISO sensitivity, are used to adjust the camera to arrive at the correct exposure? Those options are usually called the *exposure modes*. Finally, how can you adjust exposure to override or fine-tune the settings calculated by the camera's metering system? The tools you have to work with include *exposure value* (EV) *compensation*, and *bracketing*. This chapter explains all the elements that go into arriving at the right exposure for a particular image.

Metering Modes

This section introduces you to the three to five different metering modes found in advanced digital cameras, especially digital SLR models. Each of them divides the area seen in the viewfinder into exposure zones, and gives more or less emphasis to some of the zones, depending on the mode you've selected and the programming of the camera.

Evaluative/Matrix

The best choice for most situations is *Matrix metering*, also called *Evaluative metering*. Brightness patterns from a large number of metering zones in the frame (from 35 to more than 1,000) are collected, and then compared against a large database of sample pictures compiled by the camera manufacturer. Matrix metering enables the camera to make some educated guesses about the type of picture you are taking, and chooses an exposure appropriately. For example, if the camera detects that the upper half of the frame is brighter than the bottom half, it may make a reasonable assumption that the image is a landscape photo and calculate exposure accordingly. Your camera is not only capable of figuring out that you're shooting a landscape photo, it can probably identify portraits, moon shots, snow scenes, and dozens of other situations with a high degree of accuracy.

In addition to overall brightness of the scene, the system may make changes based on the focus distance (if focus is set on infinity, the image is more likely to be a landscape photo); focus or metering area (if you've chosen a particular part of the frame for focus or metering, that's probably the center of interest and should be given additional weight from an exposure standpoint); and the difference in light values throughout the frame (effectively, the contrast range of the image).

The camera may even be able to decide when it's best to provide *less* exposure than might be called for when using a "dumb" exposure system. It's often smart to build in some bias towards underexposure, because incorrectly exposed shadows are easier to retrieve later on (say, in your image editor) than overexposed (*blown* highlights).

Partial

When you want to emphasize a large central area of an image when calculating exposure, you might want to use the mode called *Partial*, which is a faux Spot mode offered by Canon in its digital SLRs. It uses roughly nine percent of the image area to calculate exposure, which is a rather large "spot." Introduced with early models of Canon's dSLR line, Partial metering has been mostly supplanted by true Spot metering and Center-Weighted metering. Use this mode if the background is much brighter or darker than a largish subject in the center of the frame.

Spot

If you want to ignore the brightness in most of an image and zero in on a specific subject, you can use Spot metering. This mode confines the reading to a limited area in the center of the viewfinder, which may make up just two to about four percent of the total image, depending on your camera. This mode is useful when you want to base exposure on a small area in the frame.

The calculations arrived at with Spot metering can vary depending on the size of the spot, what the camera elects to do with the spot of information, and how much flexibility the photographer is given over the process. With some cameras, you might be able to choose the size of the spot. Or, you may be allowed to move the spot around in the viewfinder using your camera's cursor controls (usually switching from one autofocus zone to another), so that you meter the subject area of your choice,

rather than a central area forced on you by the camera.

If your camera doesn't have the option of moving the metering spot, you can frame the image so the area you want to measure is in the center of the frame, and then lock exposure (usually by pressing the shutter release halfway, or by holding down a dedicated exposure lock—AE-L—button). You'll find this Spot metering especially useful for backlit subjects or macro photography.

Center-Weighted

A Center-Weighted metering mode allows emphasizing a subject in the middle of the frame while also taking into account the rest of the image. In this mode, the exposure meter emphasizes a zone in the center on the theory that, for most pictures, the main subject will be located in the center. Center-Weighting works best for portraits, architectural photos, and other pictures in which the most important subject is located in the middle of the frame. As the name suggests, the light reading is *weighted* towards the central portion, but information is also

used from the rest of the frame. If your main subject is surrounded by very bright or very dark areas, the exposure might not be exactly right. However, this scheme works well in many situations if you don't want to use one of the other modes.

One vendor's camera may calculate Center-Weighted exposure based on an average of all the light falling on a frame, but with extra weight given to the center (the size of which may be adjustable). Others may use a modified spot system with a really large, fuzzy spot, so that light at the periphery of the frame is virtually ignored, even though the system is *called* Center-Weighting.

Averaging

Very few cameras offer an Averaging mode, which gives equal weight to all portions of an image. Averaging is the least effective metering method in most circumstances, because it doesn't allow for differences in brightness between important and unimportant parts of your picture. If your camera offers an averaging option, it would be useful if you

happen to have a neutral gray card (described in more detail later in this chapter). If you fill up the frame as seen through the viewfinder with the gray card itself, an Averaging meter would suggest an accurate exposure *for that gray card*. You could then take a picture of a scene illuminated by the same kind of light and be confident that the middle tones of the scene, including the medium gray of the card itself, would be rendered properly. But, most of the time, you'll want to use one of the other metering options to calculate exposure.

Figure 2.1 shows the approximate coverage areas of four

metering modes offered with Canon digital SLRs, with the viewfinder/LCD icon used to indicate them shown in the upper-left corner of each representation. Nikon, Pentax, Sony, Olympus, and other vendors have a similar mix of metering modes, and use their own icons. At upper left you can see the 35 different exposure zones used for Evaluative (Matrix) metering; at upper right, the large circle that represents the faux Spot mode called Partial; at lower left, the area metered in Spot mode is indicated in blue; while at lower right you can see the middle zone of the frame that is emphasized in Center-Weighted mode.

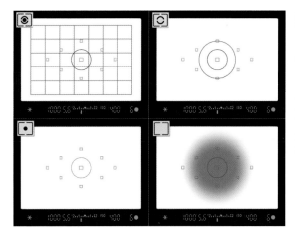

Figure 2.1
Typical Evaluative/Matrix (upper left); Partial (upper right); Spot (lower left), and Center-Weighted (lower right) metering mode coverage.

Aperture Priority

Once the amount of light has been measured and the correct exposure calculated, digital cameras need to apply that information by setting the shutter speed, aperture (lens opening), or ISO (sensitivity of the sensor). Most digital cameras have up to five different types of *exposure modes* that determine how the exposure settings are made. These include Aperture Priority, Shutter Priority, Program, Manual, and, with some cameras, a set of custom exposure modes usually called *Scene modes*.

In Aperture Priority mode, you select the f/stop you want to use, and the camera selects the appropriate shutter speed needed for the correct exposure. (Some cameras can be set to adjust the ISO if the selected aperture requires a shutter speed that is faster or slower than the ideal setting.)

Aperture Priority is also called Aperture Preferred, and is abbreviated either A or Av (for aperture value) on your camera controls.

Aperture Priority is an excellent choice when you want to use a particular lens opening to achieve a desired effect. Perhaps you'd like to use the smallest f/stop possible to maximize depth-of-field in a close-up picture. Or, you might want to use a large f/stop to throw everything except your main subject out of focus, as shown in Figure 2.2. Perhaps you'd just like to "lock in" a particular f/stop because it's the sharpest available aperture with that lens. Or, you might prefer to use, say, f/4 on a lens with a maximum aperture of f/2.8, because you want the best compromise between speed and sharpness, as in Figure 2.3

Figure 2.2
Aperture priority allows specifying a large aperture for selective focus that concentrates attention on the main subject.

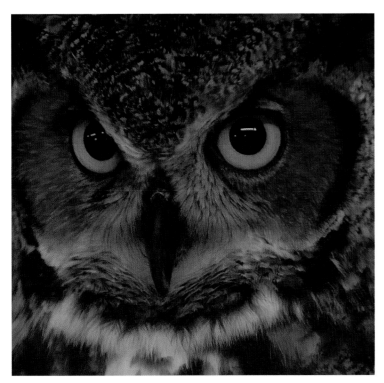

Figure 2.3 In this case, an aperture of f/4 was selected to provide the best compromise of speed, sharpness, and depth-of-field when capturing this wary owl.

Aperture Priority can even be used to specify a *range* of shutter speeds you want to use under varying lighting conditions, which seems almost contradictory. If you're shooting a soccer game outdoors with a telephoto lens and want a relatively high shutter speed, but you don't care if the shutter speed changes a little should the sun duck behind a cloud, set your camera to Aperture Priority, and adjust the aperture until a shutter speed of, say, 1/1,000th second is selected at your current ISO setting. (In bright sunlight at ISO 400, that aperture is likely to be around f/11.) Then, go ahead and shoot, knowing that your camera will maintain that f/11 aperture (for sufficient DOF as the soccer players move about the field), but will drop down to 1/750th or 1/500th second if necessary should the lighting change a little.

Keep in mind that the camera may be unable to select an appropriate shutter speed at the preferred aperture and that over- and underexposure will occur at the current ISO setting. That's the major pitfall of using Aperture Priority: you might select an f/stop that is too small or too large to allow an optimal exposure with the available shutter speeds. For example, if you choose f/2.8 as your aperture and the illumination is quite bright (say, at the beach or in snow), even your camera's fastest shutter speed might not be able to cut down the amount of light reaching the sensor to provide the right exposure. Or, if you select f/8 in a dimly lit room, you might find yourself shooting with a very slow shutter speed that can cause blurring from subject movement or camera shake. Aperture Priority is best used by those with a bit of experience in choosing settings. Many seasoned photographers leave their cameras set on Aperture Priority all the time.

Shutter Priority

Shutter Priority is the opposite of Aperture Priority. In this mode, you select the shutter speed you'd like to work with, and the camera's metering system selects the appropriate f/stop. Perhaps you're shooting action photos and you want to use the absolute fastest shutter speed available with your camera; in other cases, you might want to use a slow shutter speed to add some blur to a sports photo that would be mundane if the action were completely frozen. Shutter Priority mode gives you some control over how much action-freezing capability your digital camera brings to bear in a particular situation. Shutter Priority is also called Shutter Preferred, and may be abbreviated on your camera's controls as S or Tv (for time value).

Of course, Shutter Priority presents the same problem you might encounter with Aperture Priority. It's possible to select a shutter speed that's too long or too short for an ideal exposure under some conditions. I've shot outdoor soccer games on sunny Fall evenings and used Shutter Priority mode to lock in a 1/1,000th second shutter speed, only to find my camera refused to shoot when the sun dipped behind some trees and there was no longer enough light to shoot at that speed, even with the lens wide open. Your camera will tip you off with a blinking Hi or Lo or other message in the viewfinder, so you can select a different shutter speed and try again.

As with Aperture Priority, you can use Shutter Priority to lock in a specific *range* of apertures that will be used. To use our soccer

game example again, perhaps you want to make sure you use a relatively small f/stop, such as f/11, but you don't care if the aperture changes a little. A high shutter speed is your main priority. Go ahead and set your camera to Shutter Priority, and adjust the shutter speed until an aperture of f/11 is selected at your current ISO setting. (In bright sunlight at ISO 400, that shutter speed will be around 1/500th second.) Shoot away. If lighting conditions remain the same, your camera will maintain that f/11 aperture, but will drop down to f/8 or an intermediate f/stop if necessary should the lighting change a little during the game.

The shutter speed you select for a given photo affects two key parts of your image: the overall exposure (when mated with the ISO and f/stop parameters) and the

AUTO ISO

With both Shutter Priority and Aperture Priority, you may have the option of directing your camera to increase or decrease the ISO sensitivity to keep those shutter speeds and apertures within the "ideal" range. Cameras that implement this feature may let you specify a minimum shutter speed and maximum ISO setting to use in this ISO Auto mode. For example, in Aperture Priority mode, if you want to avoid using shutter speeds lower than 1/30th second, you can tell the camera to raise the ISO whenever a shutter speed slower than that is specified by the exposure system. In either Aperture or Shutter Priority modes, you can specify that ISO will be increased, say, to no more than ISO 1000 automatically, avoiding higher sensitivity settings that can increase grain.

relative sharpness of your image in terms of how well subject or camera motion is stopped. A high shutter speed will freeze fast-moving action in front of your camera, and potentially negate any shakiness caused by camera movement. If a shutter speed is not high enough to stop this movement, elements in your image will be stretched and blurred. Creatively, you might actually *want* this blur in order to add a feeling of motion to your images. So, it's important to choose the right shutter speed to stop action when you want to freeze a moment in time, or to allow your subject to "flow" when that's what you're looking for.

To maintain the most control over the amount/lack of blur in your photographs, you need to understand that components in your image are subject to this blurring to varying degrees. Indeed, it's possible to have one image with several subjects, each with a different amount of blur. Here are some things to keep in mind when selecting a shutter speed:

◆ **High shutter speeds counter camera shake.** If your camera shakes during an exposure, all of the image will be blurry to a degree. Anti-shake measures built into the camera or image stabilization/vibration reduction included in a lens can counter some camera shake, but are not cure-alls. Higher shutter speeds (1/500th to 1/1,000th second or shorter) can help eliminate camera shake.

◆ **Motion across the frame requires higher shutter speeds.** Motion across the frame (left to right or right to left) appears to move more quickly than motion that's headed toward or away from the camera. In Figure 2.4, the baseball is traveling across the frame, and so appears slightly blurred even at a shutter speed of 1/500th second. A speed of 1/2,000th second would freeze the ball in mid-flight, but the blur shown here is actually more effective because of the feeling of motion it adds to the image.

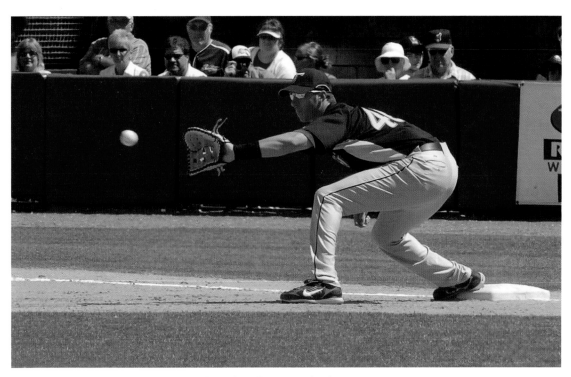

Figure 2.4 Action across a frame requires the highest shutter speed to freeze action.

◆ **Motion towards the camera seems slowest.** Motion coming toward the camera appears to move much more slowly. An athlete barreling over high hurdles (as in Figure 2.5) can be frozen at a relatively slow shutter speed—1/250th second may be sufficient—because the apparent motion isn't as fast.

◆ **"Slanted" movement is in between.** If a subject starts out on one side of your frame, and approaches you while headed to the other side, it will display blur somewhere between the two extremes.

◆ **Distance reduces apparent speed.** Subjects that are closer to the camera blur more easily than subjects that are farther away, even though they're moving at the same absolute speed, because their motion across the camera frame is more rapid. A vehicle in the foreground might pass in front of the camera in a split-second, while one hundreds of feet away may require three or four seconds to cross the frame.

◆ **A moving camera emphasizes or compensates for subject motion.** If you happen to be moving the camera in the same direction as a subject's motion (this is called *panning*), the relative speed of the subject will be less, and so will the blur. Should you move the camera in the other direction, the subject's motion on the frame will be relatively greater.

The correct shutter speed will vary based on these factors, combined with the actual velocity of your subject. (That is, a tight end racing for a touchdown in an NFL game is very likely moving faster [and would require a faster shutter speed] than, say, a 45-year-old ex-jock with the same goal in a flag football game.) The actual speed you choose also varies with the amount of intentional blur you want to impart to your image, as in Figure 2.6.

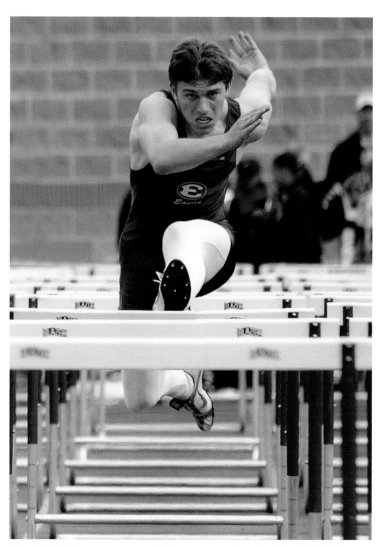

Figure 2.5 Action moving toward the camera, such as this shot of a hurdler at 1/250th second, can be captured at a slightly slower shutter speed.

For example, if you want to absolutely stop your subject in its tracks, you might need 1/1,000th to 1/2,000th second (or faster) for the speediest humans or speeding automobiles. You might apply 1/500th second to a galloping horse to allow a little blur in the steed's feet or mane. Shutter speeds as slow as 1/125th second can stop some kinds of action, particularly if you catch the movement at its peak, say, when a leaping basketball player reaches the top of his or her jump and unleashes the ball.

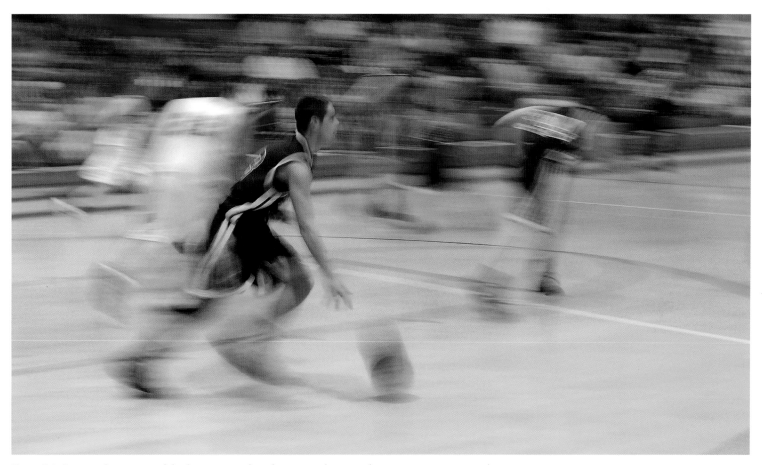

Figure 2.6 Panning the camera while shooting at a slow shutter speed can produce an interesting sports photo.

Programmed Exposure Modes

Virtually all digital cameras have a user-adjustable fully automatic exposure mode called Program, Programmed Exposure, or Programmed Auto, usually marked with a P on the camera controls. Entry-level and some intermediate models may have additional programmed exposure modes, including Auto or Full Auto, and a series of settings called Scene modes suitable for specific types of situations (and with names to match), such as Portrait, Landscape, Sports, Night, or Close-Up. Scene modes may be categorized by different names by various manufacturers. (Canon calls them Basic Zone modes, while Nikon prefers the term Digi-Vari Program.) The concept is the same: with any programmed mode, the camera makes most (or all) of the decisions for you, and may or may

not permit overriding those settings. Fortunately, these automatic modes usually work with your camera's Matrix metering method (described earlier in this chapter), so they can intelligently analyze your image and arrive at a fairly accurate exposure on their own.

Don't confuse P mode (discussed next) with Auto or Full Auto, which is usually marked on the camera with a green camera icon, the words AUTO, or a green rectangle (because A or Av usually means Aperture Priority). Fully automatic exposure modes make *all* settings and may prevent any sort of adjustment by the user. That might be useful when you hand your camera over to a non-photographer to ask him to take your picture standing in front of the Grand Canyon, but Auto won't be the preferred exposure mode for more experienced photographers.

With most cameras, P mode also sets the shutter speed and aperture for you, and may adjust ISO sensitivity as well, but allows you to *override* the settings it chooses to customize the actual exposure to best suit the image you want to create. In truth, P probably won't be your favorite mode, either. But, because you can countermand the camera's selection of settings, Program exposure is entirely acceptable when you want to reduce the number of decisions you make in a given situation.

Perhaps you see a fleeting grab shot opportunity and there is no time to figure out which exposure mode to use. Set the camera to P and fire away. Review the shot on your LCD, and if a little more or less exposure is needed, dial that in (see EV Compensation later in this chapter) and take

another picture. If the exposure is fine, but you'd rather use a different equivalent exposure, say, a larger f/stop and shorter shutter speed to stop action or provide less depth-of-field for selective focus (or a smaller f/stop and longer shutter speed to increase depth-of-field or add blur) you can do that.

Scene modes are a little less restrictive than Auto/Full Auto, and may do a better job of dealing with the type of situations they were designed for. Scene modes may make some settings for you, and may limit the other settings you can make by blocking out overrides for focus method, exposure, brightness, contrast, white balance, or saturation. Figure 2.7 shows the mode dial of several different popular digital SLR cameras that feature Scene modes.

Here are some of the common Scene modes found in digital SLRs:

◆ **Portrait.** Uses a large f/stop to throw the background out of focus and activates red-eye reduction in the flash.

◆ **Night.** Reduces the shutter speed for exposures in low light levels, to allow longer exposures without flash, and to allow ambient light to fill in the background when flash is used. You'd probably have to use a tripod with this Scene mode.

◆ **Night Portrait.** Uses a long tripod-assisted exposure, often with red-eye flash, so the backgrounds don't sink into inky blackness. Figure 2.8 shows a typical image taken using Night Portrait mode.

◆ **Beach/Snow.** Adds some exposure to counter the tendency of automatic metering systems to *underexpose* when faced with very bright settings.

◆ **Sports.** Uses the highest shutter speed available to freeze action, and may choose Spot metering to expose for fast-moving subjects in the center of the frame.

◆ **Landscape.** This mode chooses a small f/stop to increase depth-of-field, improving your chances of having both foreground and distant objects in sharp focus. With some cameras, this mode also increases the saturation setting to make the landscape more vivid.

◆ **Macro.** Some cameras have a close-up Scene mode that shifts over to Macro focus mode and tells the camera to focus on the object in the center of the frame.

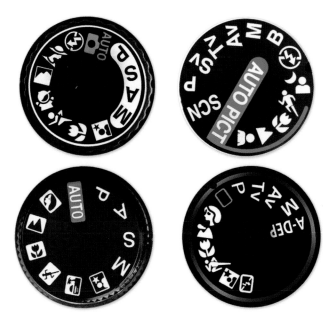

Figure 2.7 Scene modes (indicated by the icons on the mode dials) are available in entry-level cameras from many different vendors, including Nikon (upper left), Pentax (upper right), Sony (lower left), and Canon (lower right).

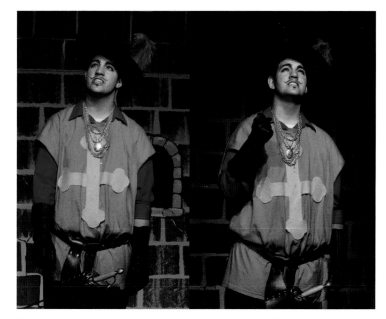

Figure 2.8 The Night Portrait scene mode (illustrated at left) uses slower shutter speeds with flash to prevent the background from fading into darkness, as shown at right.

Manual Exposure

Manual exposure is a useful option that many photographers discover after they've become familiar with their camera's sophisticated exposure system. As I've emphasized in this chapter, there are many situations in which automated exposure modes, including P and Scene mode settings are entirely appropriate. The semi-automated Aperture and Shutter Priority modes are useful when you want to use a specific f/stop or shutter speed. And, manual exposure can be especially effective in situations like those I list here, where you are faced with specific exposure or equipment challenges that are best resolved with manual settings. Some advanced photographers actually prefer to set their exposure manually most of the time, because most cameras provide an indication in the viewfinder or status LCD to confirm that your manual settings agree with the exposure the camera itself has calculated.

Perhaps you're shooting a silhouette with an underexposed foreground subject, and using the exposure compensation controls proves to be a clumsy and inconvenient way of countermanding the camera's settings. You might be working in a studio environment using multiple flash units. The additional flash are triggered by slave devices (gadgets that set off the flash when they sense the light from another flash, or, perhaps from a radio or infrared remote control). Your camera's exposure meter works fine with a built-in flash or dedicated unit, but doesn't compensate for the extra non-dedicated flash units, or can't interpret the flash exposure at all. You need to set the aperture manually.

The biggest pitfall facing those who want to set exposure manually is lack of familiarity. Those of us who generally use one of the automated or semi-automated modes tend to be a little rusty

when it comes to manual exposure. It's a good idea to investigate how manual exposures are achieved with your camera. Fortunately, most cameras make manual operation very easy. Just choose M mode, and turn the command dial or other control to set the shutter speed, and use either a secondary dial or the main dial while pressing a button to adjust the aperture. Then, press the shutter release halfway or press the exposure lock button on your camera, and the exposure scale in the viewfinder shows you how far your chosen setting diverges from the metered exposure.

Manual exposure mode is a popular option among more advanced photographers who know what they want in terms of exposure, and want to make the settings themselves. Manual lets you set both shutter speed and

aperture. There are several reasons for using Manual exposure:

◆ **For a specific exposure to create a special effect.** Perhaps you'd like to deliberately underexpose an image drastically to produce a shadow or silhouette look, as shown in Figure 2.9. You can fiddle with exposure compensation settings or override your camera's exposure controls in other ways, but it's often simpler just to set the exposure manually.

◆ **When using an external light meter under tricky illumination, or for total control.** Advanced photographers often fall back on their favorite hand-held light meters for very precise exposure calculations. For example, an incident meter (described later in this chapter), which measures the light that falls on a subject rather than the light reflected from a subject, can be used at the subject position to measure the illumination in the highlights and shadows separately. This is common for portraits, because the photographer can then increase the fill light, reduce the amount of the main light, or perform other adjustments.

Those enamored of special exposure systems, like the marvelously effective and complex Zone System of exposure developed by Ansel Adams for black-and-white photography, might also want the added control an external light meter provides.

◆ **When you're using an external flash that's not compatible with your camera's TTL (through-the-lens) flash metering system.** You can measure the flash illumination with a flash meter, or simply take a picture and adjust your exposure in Manual mode.

◆ **When you're using a lens that doesn't couple with your digital camera's exposure system.** Several digital SLR models can use older lenses not designed for the latest modes of operation, although they must be used in Manual focus/exposure mode. I have several specialized older lenses that I use with my dSLR in Manual focus/exposure mode. They work great, but I have to calculate exposure by guesstimate or by using an external meter. My camera's exposure system won't meter with these optics under any circumstances.

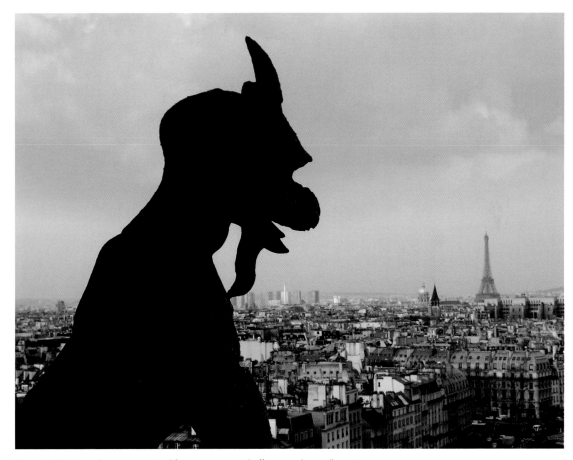

Figure 2.9 Manual exposure simplifies some special effects, such as silhouettes.

Adjusting Exposure/EV

Sometimes you'll want more or less exposure than indicated by the camera's metering system. Perhaps you want to underexpose to create a silhouette effect, or overexpose to produce a high key look. It's easy to use the camera's exposure compensation system to override the exposure recommendations. This option is usually available in any mode except Scene modes and Manual.

Exposure compensation, often abbreviated EV (for exposure value), tells the camera to start with whatever f/stop and shutter speed settings it calculated using the current metering method, but to *add* or *subtract* a given amount, as specified by you. These amounts are measured in positive or negative EV numbers. A setting of +1EV doubles the exposure, while −1EV cuts the total exposure in half. In EV terms, it doesn't matter whether

the change was accomplished by opening the lens one f/stop larger, or by halving the shutter speed (to add 1EV), or by closing down the lens one f/stop or doubling the shutter speed (to subtract 1EV). You'll recall from Chapter 1 that, by convention, a *one stop* change in exposure represents one whole shutter speed or f/stop increment; a *one f/stop* change means you've actually adjusted the aperture.

So, if you dial in a +1EV adjustment, your camera will take the calculated exposure and open the aperture one stop, or cut the shutter speed duration in half. If the basic exposure was 1/500th second at f/11, the camera might change to 1/250th second at f/11, or use 1/500th second at f/8 instead. That would be the case if the camera was set to P (Program) exposure, and the setting used (shutter speed or f/stop)

would be selected by the programming in the camera. In P mode, the camera's "smarts" may choose to add or subtract EV by adjusting the shutter speed (perhaps to avoid using an extra-large or extra small f/stop such as f/2.8 or f/22) or decide, instead, to change the f/stop an equivalent amount (to avoid dropping down to a slow shutter speed that could aggravate camera shake problems).

If the camera is set for Aperture Priority mode, the f/stop you

have selected will remain, and EV adjustments will be made by changing the shutter speed. It's up to you to make sure that the shutter speed doesn't stray into an undesirable range, and prevent that by changing your mandated aperture. Should the camera be set for Shutter Priority mode, the shutter speed remains fixed, and any EV adjustments will be made by opening or closing the aperture. (The same warning about monitoring your settings to avoid undesirable f/stops applies.)

REMEMBER TO CANCEL EV

If your camera retains EV changes until you cancel them (some preserve the EV setting even if the camera is turned off and then on again), be sure to dial the EV adjustment back to zero when you're no longer shooting under the conditions that called for the modification. A large percentage of "wrong" exposures that some photographers complain about end up the result of forgetting to turn off an EV change.

In practice, you'll rarely want to make EV changes in whole stops, unless you need a dramatic change in exposure from the value metered by your camera. Usually, you'll dial in one-third or two-thirds stop adjustments, which are displayed on your camera's status screens/viewfinder as +0.3/–0.3 and +0.6/–0.6 (if your camera makes exposure and EV changes in one-third stop increments). If your model applies exposure changes in half-stop increments, you'll see +0.5/–0.5 and +1.0/–1.0 options. Most cameras allow making EV adjustments only within a particular range, such as +/–2.0 or 2.5 stops.

Figure 2.10 shows how EV can be useful when photographing subjects that mislead your camera's exposure meter. The giant 30-foot stainless steel gavel by sculptor Andrew Scott is, as you might expect, highly reflective, and the specular highlights (actually glare from the sun) caused the camera to underexpose the image, as you can see at left. I dialed in an EV correction of +0.6 (two-thirds of a stop) to produce the more pleasing exposure shown at center. Then, just for the heck of it, I added another 2/3 stop to achieve the luminous rendition shown at right. There are always several ways to do anything with a sophisticated digital camera, and I could have done the same thing with bracketing (discussed next) or manual exposure (described in the previous section).

To adjust EV, with most cameras you hold down a button that's usually conveniently located on the top panel somewhere in the vicinity of the shutter release, and marked with a plus/minus sign and/or an EV symbol. Then rotate a dial or press another control to change the EV.

Figure 2.10 The original exposure was too dark (left), but adding +0.6EV (center) and +1.3EV (right) provided more interesting renditions.

Bracketing

Bracketing is a method for shooting several consecutive exposures using different settings, as a way of improving the odds that one will be exactly right. Before digital and electronic film cameras took over the universe, it was common to bracket exposures, shooting, say, a series of three photos at 1/125th second, but varying the f/stop from f/8 to f/11 to f/16. In practice, smaller than whole-stop increments were used for greater precision. Plus, it was just as common to keep the same aperture and vary the shutter speed, although in the days before electronic shutters, film cameras often had only whole increment shutter speeds available.

Today, many digital cameras can bracket exposures much more precisely, and bracket white balance as well. While WB bracketing is sometimes used when getting color absolutely correct in the camera is important, auto exposure bracketing (AEB) is used much more often. When this feature is activated, the camera takes three consecutive photos in the order you select. Perhaps the first is taken at the metered "correct" exposure, one with less exposure, and one with more exposure. (Some cameras allow changing the order in which these bracketed shots are taken.)

Figure 2.11 shows three versions of a view of the Columbus, Ohio skyline taken at about half an hour before dusk. The middle picture provides the most accurate representation of what the scene actually looked like when this trio of images was taken. They were snapped as a bracketed set with my camera's Continuous Shooting mode, and bracketing adjusted for 2/3rds of a stop difference between them. In that regard, these pictures resembled the photographs of the gavel sculpture in the previous section.

But, in this case, all three were fired off in less than a second, and a bit more conveniently, because the exposure adjustments were automatic and didn't require fiddling with the EV settings. The shot at top looks almost as if it were taken in daylight, and the one at bottom could pass for a night photograph. Bracketing is an excellent tool when you want to experiment with the different effects you can get just by changing the exposure.

Using AEB is trickier than it needs to be, but you can follow these steps:

◆ **Small steps.** Use small bracket increments when you just want to fine-tune exposure. Using small amounts between bracketed shots provides subtle differences. You might find that all your shots are acceptable, but one will be exactly right.

◆ **Large steps.** Use larger increments when you want to see dramatic differences between shots. A one stop bracket set may give you

BRACKET FOR HDR

In addition to fine-tuning exposure, bracketing can be useful when you're planning on doing so-called HDR (high dynamic range) mergers in your image editor. HDR is an image-editing tool that's beyond the scope of this book, but, in brief, it's a way of taking several shots at widely different exposures, and then combining them in the editor to arrive at one picture with the greatest possible range of tones. You may, for example, shoot one picture that is greatly overexposed with no highlight detail, but which has abundant detail in the shadows. A second picture that is heavily underexposed may have no information in the shadows, but rich highlight detail. Using HDR techniques, the shadows of the first image can be combined with the highlights of the second image to produce one optimum exposure. For best results, bracketed shots should be taken using a large increment (one full stop or more) and with the camera mounted on a tripod so the multiple images that will be combined are otherwise identical in framing and content.

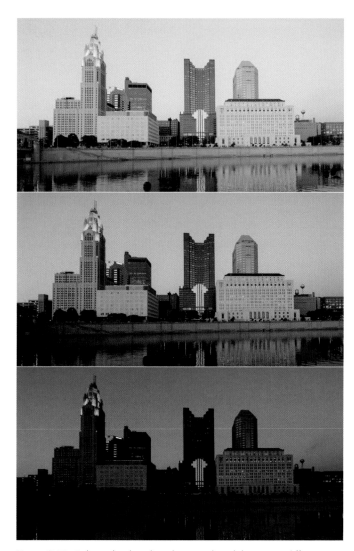

Figure 2.11 A three-shot bracketed set produced three very different looks of the same scene.

a normal shot, an interesting silhouette version, and a high-key (or maybe washed-out) shot within a three-shot bracket.

◆ **Many steps.** Your camera may allow bracketing more than three shots in a set (one of my cameras can bracket up to seven consecutive exposures). Large bracketed sets are most useful when you're using small bracket increments, because they give you subtle changes over a larger range of exposures. For example, a seven-shot bracket set using half-stop steps would give you seven pictures spanning 3.5 stops of exposure.

◆ **Cluster effectively.** While some cameras force you to bracket an equal amount over and under the basic exposure (say, the metered exposure, plus one over and one under that setting), others are more flexible. You may be able to cluster your bracketed shots in a specific direction, either over- or underexposure. For example, if you feel the camera's exposure setting is a little too much for a scene, you can set bracketing so that individual shots are taken at that exposure, plus several more at reduced exposure settings. Instead of *plus one* increment, *metered* exposure, *minus one* increment, you can capture images at *metered* exposure, *minus one* increment, *minus two* increments.

◆ **Mode matters.** In Aperture Priority mode, bracketing will be done using the shutter speed; in Shutter Priority mode, bracketing adjustments will be made using the lens's aperture. That's important to remember if the particular shutter speed or f/stop used during bracketing is important to you.

◆ **Use your Continuous Shooting mode.** A handy way to shoot a bracketed series is to turn on your camera's Continuous Shooting mode. At, say, a 3 frames-per-second shooting rate, you can snap off a series of three bracketed shots in one second, assuming that the shutter speed you're using is shorter than about 1/30th second (of course).

TURNOFF

When finished bracketing, remember to turn the feature off. Several times I've been puzzled when I turned my camera on and began shooting, and noticed that the exposures were varying widely. I neglected to turn bracketing off, and failed to notice the warnings on the LCD and in the viewfinder. This goof is almost as bad as forgetting to cancel EV compensation.

Histograms

Although you can often resurrect badly exposed photos in your image editor, it's smarter to get the right exposure in the first place. That's because not every exposure mistake can be fixed in post-processing. Detail that's lost in the highlights is gone forever, and underexposed shadows may or may not be fixable. Often, when you try to extract shadow detail in an image editor, you end up boosting noise as well.

Of course, confirming that your exposures are correct isn't simply a matter of reviewing the images on your camera's LCD after the shot is made. Ambient light may make the LCD difficult to see and vary the appearance of the image that you do view. With cameras that have LCD brightness adjustments, the brightness level you've set can also affect the appearance of the playback image. Nor can you get a 100 percent accurately exposed view

prior to the shot using the camera's Live View feature. Some cameras don't even pretend that their live image resembles the actual exposure you'll get; the goal is to present a viewable preview image, and the LCD "exposure" is pumped up to give you that optimum preview. Only a few cameras with Live View have an "exposure simulation" mode that mimics what the actual exposure at the current settings will look like.

The most reliable way to monitor exposure in the camera is to use your model's *histogram* feature. A histogram is a chart displayed on the camera's LCD that shows the number of tones being captured at each brightness level. You can use the information to provide correction for the next shot you take. There are two kinds of histograms available. One, found in virtually all digital SLRs, is the *brightness histogram*, which

shows the overall brightness levels for an image. A second type of chart, the *RGB histogram*, separates the red, green, and blue channels of your image into separate histograms.

Histogram display on your LCD is usually an option provided after

the shot is taken, as you review your images. You may be able to press a button to cycle through various information display options, and they should include a basic brightness histogram and, perhaps, an RGB histogram as well, as shown in Figure 2.12.

Figure 2.12 Many cameras offer both RGB histograms (upper right) and brightness histograms (lower right).

As I mentioned, both types are charts that include a representation of up to 256 vertical lines on a horizontal axis that show the number of pixels in the image at each brightness level, from 0 (black) on the left side to 255 (white) on the right. (A camera's LCD doesn't actually have enough pixels to show each and every one of the 256 lines, but, instead provides a representation of the shape of the curve formed.) The more pixels at a given level, the taller the bar at that position. If no bar appears at a particular position on the scale from left to right, there are no pixels at that particular brightness level.

A typical histogram produces a mountain-like shape, with most of the pixels bunched in the middle tones, with fewer pixels at the dark and light ends of the scale. Ideally, though, there will be at least some pixels at either extreme, so that your image has both a true black and a true white representing some details.

Learn to spot histograms that represent over- and underexposure, and add or subtract exposure using an EV modification to compensate.

For example, Figure 2.13 shows the histogram for an image that is badly underexposed. You can guess from the shape of the histogram that many of the dark tones to the left of the graph have been clipped off. There's plenty of room on the right side for additional pixels to reside without having them become overexposed. Or, a histogram might look like Figure 2.14, which is overexposed. In either case, you can increase or decrease the exposure (either by changing the f/stop or shutter speed in Manual mode or by adding or subtracting an EV value in other modes) to produce the corrected histogram shown in Figure 2.15, in which the tones "hug" the right side of the histogram to produce as many highlight details as possible.

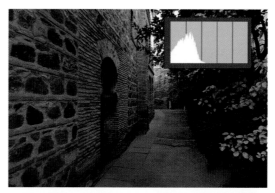

Figure 2.13
Histogram of an underexposed image.

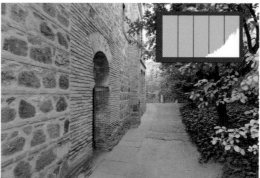

Figure 2.14
Histogram of an overexposed image.

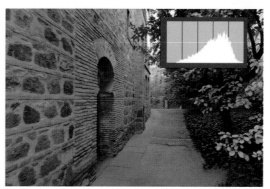

Figure 2.15
Histogram of an image that has been properly exposed.

Gray Cards, Light Meters, and Do-It-Yourself Exposure

Your camera's automated and semi-automated exposure systems will do a fine job most of the time, particularly if you use a little intelligence to override the camera as needed by applying exposure compensation where needed (and indicated by histograms), by bracketing where appropriate, and maybe by using your camera's Spot metering system to meter specific areas of your image when the overall illumination may mislead your camera's exposure system.

But if you want the absolutely most accurate and *consistent* exposure, you may have to be prepared to go the do-it-yourself route, and that can involve things like hand-held light meters, neutral gray cards, and other steps that can be time-consuming and rewarding. Even in this digital age, there remain devotees of Ansel Adams' Zone System, which details methods for measuring light and calculating the optimum exposure under a wide

range of differing illumination, using a variety of different subjects. If you aspire to be a pictorial or fine art photographer, you may well want to study Adams' *New Basic Photography Series,* last updated in 1981, shortly before his death.

Fortunately, you don't need to immerse yourself in the Zone System to fine-tune exposure using the basic tools available to you. Your digital camera can be used to measure light off a card (or even your hand) to derive some useful exposure information. Or, you can find inexpensive hand-held light meters/flash meters that will give you new

insights into how optimum exposure *should* be figured.

Here are some of the things you can do. This list is intended simply as an introduction; any good book that covers everything there is to know about exposure will have more detail:

◆ **Measuring exposure from a gray card.** You can purchase a Kodak gray card that reflects 18 percent of the light that reaches it, and use the information to determine the correct exposure. Set up the card under the same illumination that will be used to take the picture (you can even include it in the frame as in Figure 2.16) and measure the light from the card.

(Take one shot, and then remove it from the frame; you can use the gray card in your image editor to check exposure or color balance.) You can fill up the frame with the card by getting in close, temporarily, or use your camera's Spot metering function to measure the exposure off the card. If you take the reading you arrive at, *and then add one-half stop of exposure,* your picture should show the gray card at its proper tonal level. Highlights and shadows may be lighter or darker than you wish, but that's due to the limited tonal range of the digital camera's sensor. But once you have the correct exposure for the middle tones, you can add or subtract exposure to favor the highlights or shadows in your image.

THE MYTH OF THE 18 PERCENT GRAY CARD

It's common notion that digital cameras are calibrated to provide a correct exposure equivalent to the middle gray tone found in an 18 percent gray card, like those sold by Eastman Kodak Company. That's a myth. In reality, digital cameras are typically calibrated to "see" middle gray as a 12 to 13 percent tone. That's why, when you measure illumination from an 18 percent gray card *with a camera meter,* nit-pickers need to add one-half stop of exposure to account for the difference. So, why is the standard gray card produced to reflect 18 percent? Some say it's because that's the value that is the standard middle gray in the *printing* industry.

Figure 2.16
Include a gray card in your scene, and you can spot meter off the portion not in shadow, and use the gray tone as a reference when adjusting color balance in your image editor.

Figure 2.17
Placed at the subject position, the dome of an incident meter mimics the actual lighting and shadows on the subject when calculating exposure.

♦ **Measuring exposure from your hand.** Instead of a gray card, meter off the palm of your hand, and then reduce the exposure by one-half to one stop. The palm of the human hand (regardless of race) is generally twice as reflective as a gray card, so cutting exposure a little will provide similar results.

♦ **Using a hand-held incident meter.** An incident meter is an exposure device with a hemispherical light collector that simulates the typical shape of a subject. If you hold it at the subject position pointed at the camera, it will measure the light actually falling on the subject. An incident meter eliminates the inaccuracies of reflective light meters, which, after all, don't know whether the light reaching their sensor is coming from a black cat (indicating one exposure to reproduce the cat's fur), a white cat (which would require quite a different exposure), or a gray cat (calling for an exposure somewhere in between). Incident meters, like the one shown in Figure 2.17, are available for both continuous illumination, flash illumination, or in a combo model that measures both.

♦ **Using a hand-held incident meter to measure highlights and shadows separately.** If you're lighting a portrait (as described later in this book), you may want to know how the illumination in the shadows compares to that in the highlights (the *lighting ratio*, as described in Chapter 5). Move an incident meter to measure both highlight and shadow illumination, and compare the two to calculate your lighting ratio. (Much more on this later.)

♦ **Using a hand-held spot meter.** Meters that measure reflected light, like the spot meter shown in Figure 2.18, are useful when you can't walk up to your subject and thrust an incident meter in the light path. But, as with the light metering system built into your camera, a reflective meter doesn't know what type of subject is producing the light that it "sees."

You'll need to make some adjustments to accommodate subjects that are brighter or darker than the middle tones the meter is calibrated for.

Figure 2.18 To use a hand-held spot meter, "sight" through the optical viewfinder at top left, then calculate exposure based on how much the needle is deflected by the reflected light.

3 Available Light

Strictly speaking, any sort of light that can be used to illuminate a photo can be considered "available" light. That includes daylight, moonlight, existing light indoors, supplementary lights you provide, your camera's built-in flash, candles, plummeting meteorites—anything that's available. But, photographically speaking, available light is generally considered only as the light that is already present at a scene, usually not moveable or adjustable in brightness by the photographer. It's *available*, but not necessarily *convenient*. But, as you've probably learned, inconvenience goes by other names, including *challenge*, *opportunity*, or *creative boundary*. How you handle available light, and how you manipulate and supplement it, often is a major factor in the success of your image.

Available light can be sparse and require special effort on your part to eke out a picture from the fleeting photons. Back in the 1960s (and before) there was an entire school of photographic endeavor dedicated to capturing photos under (non) existing light. The rage was for crazy-fast lenses with apertures as fast as f/0.95, and darkroom manipulations like "push" processing, which tended to do little but increase grain and contrast while elevating sensitivity settings to the equivalent of today's ISO 1600-3200. Today, in the digital domain, low light can still be a challenge, and tools like f/1.4 or f/1.2 lenses are valuable, along with image stabilization/vibration reduction/anti-shake technology that allows the use of slower shutter speeds without a tripod. But the biggest breakthrough in available light photography has been modern sensors, many of which can capture images at ISO 3200 and beyond to a mind-bending ISO 25,600—in full color—that black-and-white bleeding-edge photographers of 40 years ago could only dream about.

Of course, available light photography isn't limited to low-light environments. You'll find that available light can be plentiful, too, but still restrained by excessive contrast, unwanted reflections, awful color balance, and other limitations. In this chapter, I'm going to provide some tips for taming available light as you raise the bar on the technical and aesthetic qualities of your photographs.

White Balance

The visible light that we see by is actually a continuous spectrum ranging from the shortest wavelengths our eyes can discern (at the blue-violet end of the scale) to the longest reddish wavelengths that peter out at the near-infrared portion of the spectrum. But our eyes can't directly perceive this continuous spectrum. Instead, our color vision derives from three types of cone cells in our retina (remember "rods and cones" from high school biology?) that overlap to collect light that peaks in the blue, blue-green, and green-yellow (and red) portions of the spectrum, respectively, as you can see in Figure 3.1. The "burst" icons indicate the peak response of each type of cone cell, but you can see that the S-, M-, and L-cones each respond to a range of colors that cover the blue, green, and red portions of the spectrum.

Humans have mimicked the way our eyes divide the spectrum up into three ranges in creating film, sensors, scanners, display monitors, and other devices that combine blue, green, and red light to produce the full range of colors. These hues are generally listed in reverse alphabetical order, or RGB. (That's just a coincidence as, say, French- or Spanish-speakers will notice immediately.)

The relative balance of each of those three colors varies, depending on the kind of illumination you're using. That ratio is commonly called *color balance* or *white balance*. For most types of continuous lighting and electronic flash, the white balance is measured in degrees Kelvin, because scientists have a way of equating temperature with the relative warmness and coolness of the light. (That's why white balance is also called *color temperature*.) Common light sources range from about 3,200K (warm indoor illumination) to 6,000K (daylight and electronic flash). Fluorescent

Human Color Perception

Figure 3.1 The eye's three types of cone cells each perceive blue, green, or red light—and then some.

light doesn't have a true color temperature, but its equivalent "white balance" can be specified nonetheless.

Digital cameras can make some good guesses at the type of lighting being used and its color temperature, and for non-critical work you can set your camera's white balance to Auto and forget about it. If you're smart enough to be shooting RAW, you can always correct for bad guesses later on in your image editor. If you are shooting critical JPEG files (for sports, a wedding, or other application where you don't want to end up with hundreds of RAW files to process), it's often a good idea to explicitly tell your camera exactly what kind of light it is working with. Or, to specify the white balance as closely as you humanly can. That will produce pictures with more accurate colors and less correction required later.

Figures 3.2 and 3.3 show two sample images with the white balance gone terribly wrong. At left in Figure 3.2 is a JPEG image of an indoor scene photographed with the white balance set to Daylight. The color balance is frightfully red-yellow, producing a horrible color cast. Luckily, I had taken this picture using my camera's RAW+JPEG setting (available with Nikon, Canon, and many other dSLR models). So, I was able to change the WB setting from "As Shot" to "Tungsten" to produce the more realistic rendering shown at right in Figure 3.2.

The flip side of the equation can be seen in Figure 3.3. At left is a daylight shot of a flower, but with the white balance set for Tungsten illumination. It's excessively blue. When the WB is adjusted for daylight, the improved version seen at right emerges.

Figure 3.2 Shooting indoors with the white balance set for Daylight produces an excessively warm image (left). The Tungsten setting creates a more realistic look (right).

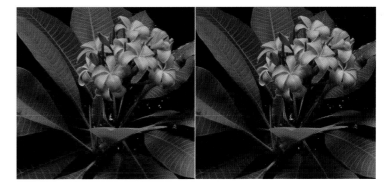

Figure 3.3 A photograph exposed under daylight is much too blue when the Tungsten WB setting is used (left); the correct setting (right) produces the correct color balance.

45

Manual White Balance

If you'd rather not use Auto white balance, your digital camera should have an option to let you choose a white balance preset manually, either using a menu entry or a button that can be held down while white balance is adjusted using a command dial or the cursor pad control. In either case, you'll be presented with preset values that you can choose instead of the default Auto. The number of different choices may vary, but you'll have Daylight/Direct Sunlight, Incandescent, Electronic Flash, Fluorescent, Cloudy, and Shady as a minimum. Your camera might offer several different Fluorescent settings for the different kinds of fluorescent lights (cool white, warm white, etc.) as well as options to dial in the exact color temperature in degrees Kelvin, or change the "bias" of the white balance in the blue/yellow/green/magenta

directions. It's also common to have a "fine-tuning" option that allows you to dial in some extra warmth or coolness, usually plus or minus, say 10, from the nominal neutral value.

I used that option for Figure 3.4, taken at dusk on a winter day. I knew the image would be very warm because of the waning sunlight, but I wanted to catch the coolness of the snow on the roof

of the barn and shed. So, I used my camera's white balance "bias" setting to change the Daylight setting to produce a bluer rendition.

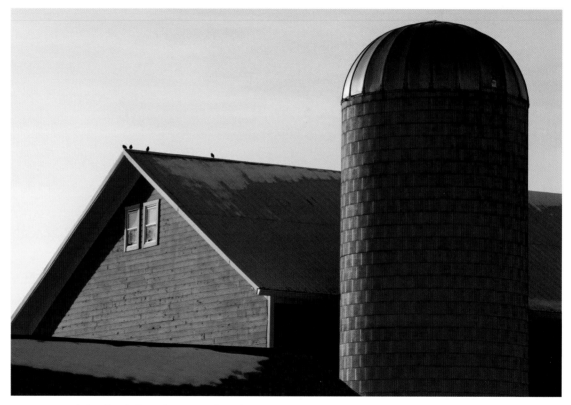

Figure 3.4 A slight white balance bias towards the blue reduced the reddish cast in this picture taken at dusk.

Creating Your Own White Balance Settings

Most cameras allow you to measure white balance of continuous light sources yourself and save it as a "custom" setting. The white balance of a current scene can be measured by taking a photo of a neutral surface (such as a white or gray wall). White balance will be set to render this subject in a colorcast-free way. There may be an option for storing the measured white balance in a menu memory "slot" as a preset, so you can retrieve the setting at a later date. You may also "adopt" the white balance of an existing image on your memory card, so that can be applied to your current shooting session or stored as a preset.

As I mentioned earlier in this section, if you shoot RAW, you can adjust the white balance when the image is imported into your image editor, changing it from the "as shot" value to any other value available in the conversion program, like as shown in Figure 3.5. The green overlay box shows the options available in Adobe Camera Raw, including the Custom setting, which allows choosing both color balance and tint (or bias).

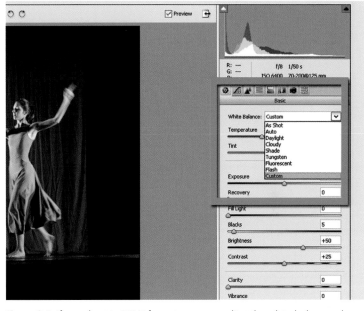

Figure 3.5 If you shoot in RAW format, you can adjust the white balance when the image is imported into your image editor.

Color and Mood

If you understand color balance and white balance, you already know that available light comes in many "colors." However, you can also add colors to your image, or tweak the color that is there, and take advantage of the hues to create a mood. Figure 3.6 is an example of a photograph deliberately manipulated to produce a specific atmosphere—in more ways than one.

It's actually a composite of three images taken on a hill overlooking Pittsburgh, Pennsylvania one drizzly night. The scene was somewhere between bleak and dreary, with a light fog obscuring most of the skyline. I set up my camera on a tripod, set it for Daylight color balance (to emphasize the blue of the scene), and took three separate exposures, one after another. (I used a cable release and my camera's Continuous Shooting mode, with a manual exposure setting of four seconds.) In Photoshop, I copied the Red Channel from one image, the Green Channel from the next image, and the Blue Channel from a third, and pasted each down into the Red, Green, and Blue Channels of a new, blank image.

Using this technique, the non-moving parts of the image received the same red, green, and blue exposures they would have gotten in a single image, but the headlights and taillights of the vehicles seen in the lower right were in different positions in each exposure, and so were separated into red, green, and blue streaks. This added a welcome splash of color to an otherwise mundane image.

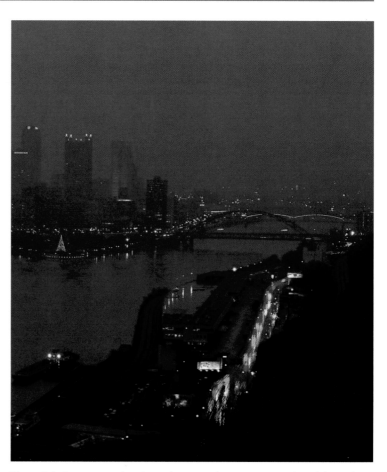

Figure 3.6 Swapping color channels among three images produced this multi-color effect.

The range of colors can help set a mood. Figure 3.7 shows blues guitarist Jimmy Johnson. At left, Johnson is shown with the color balance set correctly for the stage illumination at the venue. At right, I nudged the color balance a bit towards the blue when the RAW image was imported into my image editor. You might have to cover the left side, and then the right side, with your hand to view the two versions separately, without one affecting your perceptions of the other. I happen to like the right, "bluesy" rendition better. To me, it evokes the atmosphere of a smoky blues club. You might prefer the left-hand version—and that's the point. Colors affect our moods, and when using lighting to create your pictures, you can use those colors as your creativity demands.

Figure 3.7 The "correct" color rendition (left) might not be as effective in setting a mood as the bluesier version at right.

You'll find that the colors in a scene can be very different at different times of day, or even different times of year, with each color scheme producing a different mood. Figure 3.8 shows the same scene in autumn (left) and winter (right). The bright, golden colors in the fall scheme produce a much different atmosphere than the somber, blue-tinted snow scene. You can accentuate—or counter—each type of mood by making adjustments in your camera, or in an image editor. For example:

◆ **Increase saturation.** If you want a lively or festive mood, consider increasing the saturation produced by the available lighting. Digital cameras have a Vivid or Saturated mode that boost the richness of the colors. You can accomplish the same thing in an image editor.

◆ **Increase contrast.** A polarizing filter can increase apparent contrast by darkening the sky and removing highlights from non-metallic reflective surfaces (such as water). When contrast is adjusted, colors can appear more saturated. Again, an image editor can allow you to make this sort of adjustment.

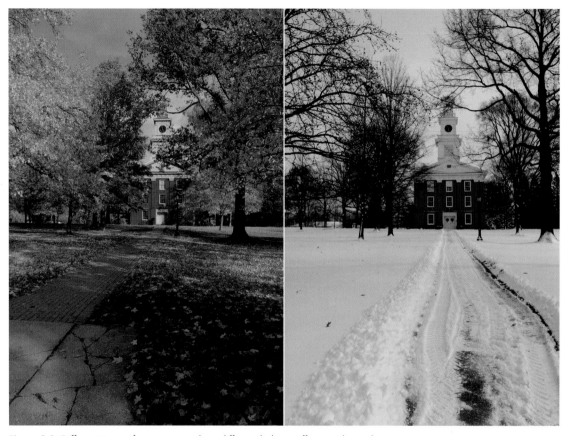

Figure 3.8 Different times of year can produce different lighting effects and moods.

◆ **Use colored filters or in-camera color effects.** Many film photographers always traveled with an array of color filters. They still can be useful, but you may be able to add color filter effects using an option tucked away in your camera's menus. These include red, yellow, blue, green, or other filters that add a tint to a color image, as well as color filters that change the rendition of black-and-white pictures you shoot (including sepia and bluish cyanotype settings). As always, check your image editor to see if filter effects can be added *after* the image is captured.

◆ **Filter your lighting.** When you're shooting by available light, you may be able to provide some filtration of the light source, particularly if you're shooting indoors. If so, the color possibilities are endless. Figure 3.9 shows a ballet dancer illuminated by filtered stage spots.

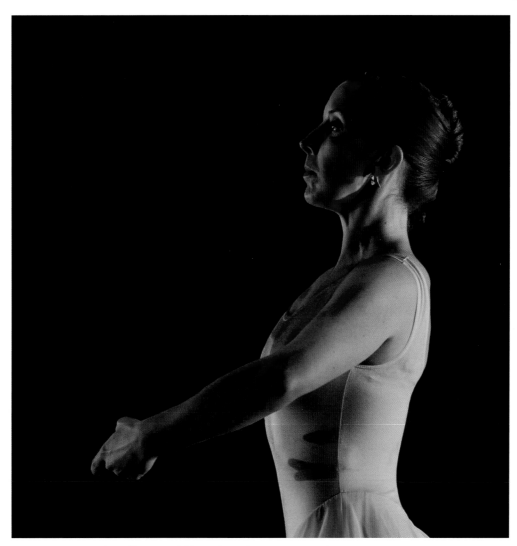

Figure 3.9 Stage lighting filters are deliberately used to create a mood.

Filling in Shadows

Shadows aren't an unavoidable evil. As you'll discover in Chapters 5 and 6, shadows work in concert with highlights to provide shaping, texture, and character to your subjects. When dealing with shadows, you simply need to make sure that the darker portions of your image do more than just obscure details in your subject. You'll want to make sure that the shadows perform the functions I just listed, emphasizing the shapes, surface, and inherent nature of your subject matter. That said, shadows are one of the reasons you'll find that working with available light is very different from what you might encounter in the more controlled conditions of an informal (or formal) studio environment.

The term "studio" implies a lot of control over light, with two or more individual lights at your disposal, as well as light modifiers such as umbrellas, soft boxes, and reflectors to produce the

qualities of light that you want. Outside the studio, these tools, especially reflectors and, at times, auxiliary flash units, are even more important. They can serve both as lighting tools and protect flowers, plant life, and other moveable subjects from breezes that can spoil your shot.

Outdoors, both reflectors and electronic flash are useful for filling in the shadows. I recently covered a Civil War re-enactment, and several of the important battles, parades, and assemblies over the three-day event took place between the hours of 1 and 3 p.m., which is about as far from the "golden hour" as you can get. Even so, if I wanted to photograph the activities when the sun was brightest and harshest, I knew I'd need some help filling in the shadows I expected. Although you can always pray for rain (or, better, a slight overcast), sunny days do happen.

For the images shown in Figure 3.10, I used a 2 × 3-foot piece of white cardboard that I had a friend hold for me off to my left. The version at left shows a sturdy (if aging) Confederate private waiting for inspection. The harsh light cast his face in shadow. For my second shot (right), I took advantage of the soft fill-in light of the reflector, and added about half an f/stop's worth of

exposure using my camera's Exposure Compensation (EV) option. While the portions of Johnny Reb's uniform in the direct sunlight are a little (more) overexposed, his face is no longer cloaked in darkness.

A few minutes later, I encountered the soldier shown in Figure 3.11. The shadows were so deep on his face that I used fill-in flash

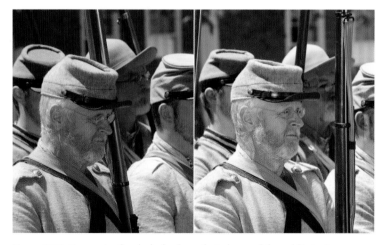

Figure 3.10 To counter the dark shadows that obscured the soldier's visage (left), I used a reflector to bounce some light onto his face.

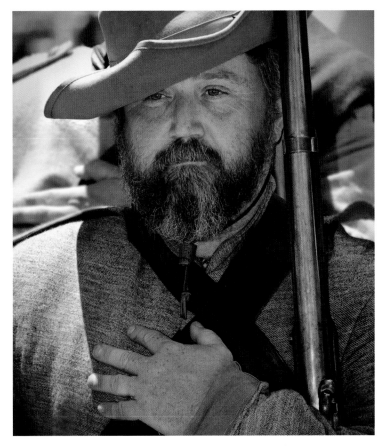

Figure 3.11 Exceptionally dark shadows in this mid-day outdoor portrait were vanquished with fill-in electronic flash.

instead of a reflector. (Check out the shadow cast by his gun to the right of the firearm, and the catch-light in the gentleman's eyes, caused by the flash.) I used just enough flash to illuminate the shadows, while not washing out the character lines in this re-enactor's expressive face.

So, how do you decide whether to use reflectors or fill flash outdoors? Here are some things to consider:

◆ **Get help.** Reflectors may require an assistant to hold or position the surface used to bounce the light. Wedding shooters, environmental portraitists, or senior photographers working alone may enlist a member of the party, a friend of the subject, or Mom or Dad as a "light stand." One trick is to have your "helper" (especially if it's a Mom) hold the reflector in such a way that they have it in front of their own face and direct the light on your subject. That prevents them from viewing the pose, so they can't offer suggestions that interfere with your own direction. I'm not kidding; I know photographers who do this all the time.

◆ **Portability.** Reflectors are great when you're shooting in one location for a period of time, but if you're moving around a lot, as I was at the Civil War re-enactment, a flash unit attached to your camera may be more practical. That's particularly true if you're using an accessory flash unit that can be positioned on top of the camera (mounted to the flash shoe) or off-camera. You have complete freedom to wander around, using fill-flash for any picture you want to take.

◆ **Reflectors operate at any shutter speed.** When shooting outdoors, you need to take your camera's top flash sync speed into account. (More on that in Chapter 4.) Most digital cameras allow conventional use of flash only at speeds of 1/250th second or slower (depending on the camera). So, with an ISO setting of 100, in bright sunlight you'll be using an exposure combination of 1/200-1/250th second at around f/11. (Remember the "Sunny 16" rule? Exposure in daylight is the reciprocal of the ISO setting at f/16.) If your camera has ISO 200 as its lowest setting, you'll need to use f/16 instead. That's not great if you wanted to work with selective focus at a larger f/stop, say, to throw your background out of focus. No such restrictions affect reflectors, which operate exactly the same at any shutter speed/lens opening combination.

Using Reflectors

Although fill-flash is great, for many available light situations, the best and most versatile light tool is a reflector that you buy or make yourself. Buying a reflector intended for professional photographers is certainly an option, and there are wonderful collapsible boards, disks, and other units, as well as things like *scrims,* which are thin screens of translucent material, often made of cotton and supported in a frame, and used in both theatrical and photographic lighting. (One kind of scrim is actually inserted in front of a light fixture to attenuate the light, but that's not what I am talking about.) But, you may find that the homemade tools are a lot less expensive, and perhaps even more flexible in the things they can do.

In this section, I'm going to share some of my favorite reflector tricks.

White Poster Board

White poster board is cheap, disposable, and you can do dozens of things with it. Here are a few ideas on using white cardboard:

◆ Fold it up into quarters to make it more compact. Having a few creases won't hinder your cardboard's utility as a reflector in the least. You can unfold only as much as you need for your photograph.

◆ Use white shades, but mix in some colors. Most of the time you'll want a neutral white board, but you can carry orange and light-blue versions to warm up or cool down the shadows of your picture. You might find, for example, that the highlights of an object are illuminated by diffuse sunlight, but the shadows are filled in by reflections off a bluish object. An orange reflector can balance the color quickly.

◆ Use the cardboard to block light, too. While you'll generally use the cardboard to reflect light onto your subject, you'll find you can use it to block direct sunlight and create soft shadows where none existed before.

◆ Cut holes in the cardboard for special effects. Motion-picture lighting often uses "cookies" to create special lighting shapes and effects. What? You thought those shadows on the wall were cast by *real* Venetian blinds? Use your imagination and cut some holes in your cardboard to create a halo around your subject or some other effect. Move the cardboard closer to the subject to make the highlight harder, and farther away to soften it.

Foam Board

Foam board can make a great soft-light reflector, whether you're outdoors or shooting in your home studio. Those ultra-light boards of plastic foam sandwiched between paper or plastic sheets are commonly used to mount photos or to construct exhibits. They make great reflectors, too, especially if you need larger sizes that are rigid but also light in weight. They don't fold easily, and are probably more useful for portraits and group pictures, but if you have a small hunk of foam board, keep it handy. Foam board with one black side can be used as a background.

Aluminum Foil

Aluminum foil provides a bright, contrasty reflection that can sharpen up soft lighting (if that's what you need). Tape aluminum foil to a piece of white cardboard (use the reverse side of your main cardboard reflector if you want). If you need lighting with a little less snap, just reverse the cardboard to expose the non-aluminum side. Be sure to crinkle the aluminum foil so it will reflect the light evenly; you don't want shiny hot spots.

Mylar Sheets

I love finding new (photographic) applications for products intended for some other purpose. Those Mylar space blankets can do more than keep you warm at your campsite or in an emergency. They can be used as a handy high-contrast reflector, yet still folded up and carried in a pocket of your gadget bag. Every photographer should get two: one for the emergency kit in the trunk of your car, and another for photographic purposes.

Auto Sunscreens

Those aluminum reflective sunscreen gadgets sold to keep your vehicle from heating up faster than a Space Shuttle returning from orbit are one of my favorite serendipitous discoveries. The circular or rectangular variety, like the two shown in Figure 3.12, are absolutely *perfect* as photographic reflectors. I'm going to need a list of bullet points to tell you just how cool these are.

◆ **Small, transportable.** When you buy them, they are collapsed down to the size of a dinner plate (see lower right in Figure 3.12). With a simple twist, they expand to their intended size, which can be two to three feet across the longest dimension. When you're done shooting, grip the outer edge, fold like a taco, and then twist. The framework has a "memory" and the reflector collapses down to plate size again.

◆ **Dual surfaces.** Most of the ones I've seen have a Mylar or shiny aluminum surface on one side, and a dull matte metallic gray surface on the other. A single reflector can serve two purposes. I've even gotten a can of fabric paint and sprayed the reverse side of one of my reflectors with a black coat to turn it into an effective light blocker. Faced with a subject who was illuminated almost entirely by light coming from behind her, I used a gold-painted reflector to bounce light into her face, as you can see in Figure 3.13. The warm glow adds a romantic look to the portrait, which I augmented by adding some diffusion in Photoshop.

Figure 3.12 Collapsible automobile sunshields make perfect reflectors.

Figure 3.13 A gold reflector added a warm tone to this backlit portrait.

◆ **Multiple sizes.** Auto sunscreens typically come in small, medium, and jumbo sizes for use with compact cars, family sedans, and SUV/Humvee-level behemoths. You can find one that's perfect for the reflective applications you have in mind.

◆ **Inexpensive.** The small size I purchased at my local mega-mart were priced at two for $5.98. Then I discovered the jumbo size at two for $7.98. What other photographic accessory that's this useful can you buy for $3 to $4 *each?* I bought a set for each of my cars (which also have their own dedicated tripod and monopod in a duffle in the trunk). In a pinch, I could probably put them on my dashboard to block the sun from my windshield.

Umbrellas

Photographic umbrellas used in the studio, available in white, gold, or silver surfaces, are compact enough to carry with you on outside close-up shooting expeditions. However, I favor white purse-sized rain umbrellas, like the one shown in Figure 3.14, that telescope down to six or eight inches in length (I've seen some

Figure 3.14 Purse- or pocket-sized umbrellas are perfect for macro shooting in the field.

mini models that go even smaller), yet unfold to a respectable size. You can use these as a reflector to bounce light onto your subject, or as a translucent diffuser to soften the light that passes through them (perfect for use in bright sunlight when you can't find any open shade). And if it rains, you won't get wet!

The only complication is that the white ones can be difficult to find. You may have to look for them. (Even a search of eBay produced only a full-sized white umbrella, with a ruffle around its edge, for Pete's sake.) The black ones, targeted at manly men, are easy to locate, followed by beige and festive colors favored by anyone, of either sex, who finds black rainwear depressing. The white umbrellas are more of a challenge, either because they are less popular (they do get dirty more easily than, say, the black models), or because photographers like me snatch them up whenever they are offered for sale. (I purchased six the last time I found some.)

Your go-anywhere white umbrella can be held in the left hand as a reflector while you're shooting with your right hand, used as a diffuser in bright sunlight, or applied anywhere you might use a reflector, but want a softer type of illumination. That's what I did for Figure 3.15, which was taken outdoors just after the rain had stopped and the light was apallingly dull. With an umbrella and flash in my left hand, I took this portrait while balancing my camera in my right hand.

Black Cardboard or Cloth

Sometimes you need to block light from a glaring source to produce softer illumination. A sheet of black poster board works, although even black board reflects some light. For extra light absorption, consider a small piece of black velour. If you're trying to take photos of seashells in their natural habitat, a black cloth will help—or even may be pressed into duty as a backdrop.

Figure 3.15 Flash and a white rain umbrella improved the lighting of this rainy day portrait.

Polarizing Filters

Most of us were introduced to the effect of polarizing filters through our use of polarized sunglasses, which simultaneously darken bright sunlight, provide richer and more vibrant colors, and reduce glare. Polarizing filters can provide the same effects to photographic images, but to use them, you need to follow a few rules. I'll lay out the rules first (so you can rush out and begin using your filter right away), and then explain why.

◆ **Use only circular polarizers.** All polarizing filters are in a general sense circular, of course. In this context, the term refers to the way in which these filters handle polarized light. You'll want to use a *circular polarizer* (abbreviated CPL) rather than a *linear polarizer.*

◆ **Keep the sun at your right or left side.** Polarizers work best if the sun is at a 90-degree angle from the lens axis, and low in the sky. At other angles, the effects are reduced.

◆ **Watch your exposures.** Polarizers can affect the exposure metering system of most cameras, although a circular polarizer shouldn't fool your meter too much, but you may need to adjust your settings.

◆ **Not all glare can be reduced.** You'll find that polarizers reduce glare from semi-transparent shiny objects, such as water or plastics. They may be of little or no help with other surfaces, particularly metallics.

◆ **Polarizers are problematic with wide-angle lenses.** The filter itself may appear in the image, and cause dark corners (vignetting). Worse, you may get uneven polarization across your frame when using extreme wide-angle lenses.

◆ **Polarizers are neutral density filters.** You'll need a stop or two more exposure with a polarizer attached to your lens. When I want to use a longer shutter speed under bright conditions to produce blur, I sometimes use a polarizer simply for its neutral density effect.

A typical polarizing filter is shown in Figure 3.16. Such filters consist of two connected pieces: a ring that screws into the filter thread of your lens, and an interlocked ring containing the polarizing filter itself, which can be rotated to maximize/minimize the effect. As with most filters, a polarizer is designed to fit the thread of a particular lens diameter. You can often use the same filter with multiple lenses through the use of step-up or step-down adapters, as shown in the figure. However, be cautious when using these adapters to mount a filter (any type) to a wide-angle lens, as the extra thickness is likely to produce vignetting.

Figure 3.16 Step-up and step-down rings can let you use the same filter on lenses with different filter threads, but they can lead to vignetting when used with wide-angle lenses.

These filters operate on the principle that light waves normally vibrate, or oscillate, equally in all directions, unless they have been scattered or polarized by reflection off shiny transparent objects, such as dust and water vapor in the atmosphere, liquid surfaces, glass, or plastics. The resulting illumination tends to vibrate in only one plane (rather than every which way), and polarizing filters contain what you might think of as louvers (as in a window shade) that remove the light that is not oscillating in the same direction as the filter's slits. That's why rotating the filter changes the effect: You're changing the orientation of the louvers so they can admit more or less vibrating light waves. In one position, the polarized light passes through the filter (causing glare in your image). Rotated 90 degrees, the polarized light is blocked, and glare is reduced. Non-polarized and partially polarized light passes freely through the filter to produce your image.

To use a polarizer, mount it on your lens, look through the viewfinder, and rotate the outer ring until the polarizing effect is most pronounced (or, produces the degree of polarization you want). As I mentioned, these filters are most effective when the sun is 90 degrees from your subject (that is, the sun is coming from your left or right side). You can take photos using other angles, but the polarizing effect will be reduced. The correct shooting angle can be tricky when you're using a very wide-angle lens. (See the sidebar later in this section.) Blue sky and water, which can contain high amounts of scattered light, can be made darker and more vibrant as glare is reduced. You can also reduce or eliminate reflections from windows and other non-metallic surfaces.

Choose your subjects carefully. Light striking, passing through, and reflecting off water becomes polarized. The same is true of many other types of objects, including foliage, and the paint on your car, which is also partially transparent (otherwise, the automobile would require only a single coat of paint). Shiny metallic objects, like the chrome on an automobile, aren't transparent, and thus don't inherently provide any polarization of the light. *However*, if the light reflecting from the metal has already been partially polarized (that is, it is reflected skylight), you can see some glare-reduction from the polarizing filter. The effect is much less than with most non-metallic shiny objects, however.

Sometimes, a polarizer won't produce the exact effect you want, as you can see in Figure 3.17. At left is a landscape scene taken

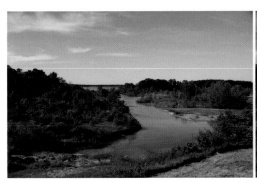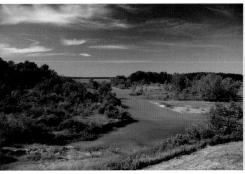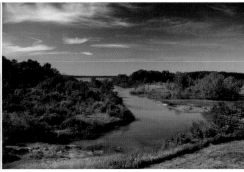

Figure 3.17 Scene without a polarizer (left); with a polarizer (middle); a combined shot with darker sky, but more attractive water image (right).

without a polarizing filter. In the middle, you can see the same scene shot with a polarizer: The sky is darker, the foliage more vibrant, and the reflections are gone from the water in the inlet. In this case, though, the water without reflections looks dull and lifeless. Some effects of the polarizer were good, others, not so much. To fix this, I combined both versions in an image editor, erasing the reflection-free inlet to allow the more interesting rendition to show through. Reflections themselves aren't necessarily bad: It's the *glare* that is distracting in a photograph.

Polarizers and Wide-Angle Lenses

Another thing to watch out for is the use of polarizers with wide-angle lenses. Such filters produce uneven results across the field of view when using lenses wider than the equivalent of about 28mm (which would be a 17-18mm lens on a camera with a 1.5X to 1.6X crop factor). As I mentioned earlier, polarizers work best when the camera is pointed 90 degrees away from the light source, and provides the least effect when the camera is directed 180 degrees from the

light source, as when the light source is behind you. The field of view of normal and telephoto lenses is narrow enough that the difference in angle between the light source and your subject is roughly the same across the image field.

But an extra-wide-angle lens may have a field of view of about 90 degrees. It's possible for subjects at one side of the frame to be oriented exactly perpendicular to the light source, while subject matter at the opposite side of the frame will actually face the slight source (at a 0-degree angle). Everything in between will have an intermediate angle. In this extreme case, you'll get maximum polarization at one side of your image, and a greatly reduced polarization effect at the opposite edge, as you can see in Figure 3.18. Use caution when using a polarizer with a very wide lens.

This phenomenon may not even be a consideration for most photographers. Many people don't know how to use a polarizer correctly, anyway, and end up pointing the camera in a direction that's greater than 90 degrees from the light source, which tends to minimize the polarization effect and, at the same time, the unevenness. In addition, many polarizers intrude into the picture area of wide-angle lenses, causing vignetting, so photographers tend to avoid using them entirely with the very widest lenses. Most users avoid them with such lenses not only because of the vignetting they cause, but also because super-wide lenses usually call for super-large filters, which can be expensive. Finally, the problem is sometimes "solved" because a very wide-angle lens can't use filters in any case. For example, the front element of Nikon's 14-24mm f/2.8 ultra-wide zoom has such a pronounced curve that filters are impractical (as well as impossible, as the lens lacks a filter thread).

LINEAR VS. CIRCULAR POLARIZERS

Both linear and circular polarizers transmit linearly polarized light that is aligned in only one orientation. However, circular polarizers have an additional layer that converts the light that remains into circularly polarized light (never mind what *that* is; it's not important unless you're fascinated with helixes/helices). What *is* important is that the metering and autofocus sensors in digital SLRs are mightily confused by linearly polarized light, but they work just fine with circular polarizers (also referred to as CPL filters). Make sure the polarizer you purchase is a circular polarizing filter.

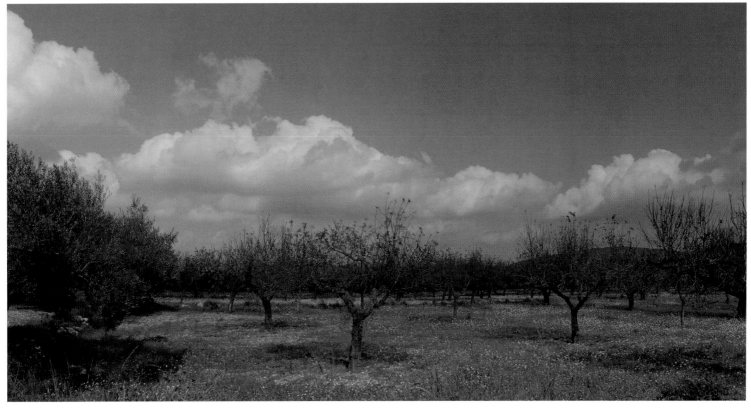

Figure 3.18 Because of the wide-angle perspective, the cloud-contrast effects of the polarizer are most pronounced at the right side of this image, and progressively less at the left side.

Lighting and the Sky

One of the most vexing things about shooting outdoors by available light is getting the sky to look right. We've all done it. There's a scene with a beautiful sky, full of fluffy clouds that hover above a stunning foreground landscape. We take the photo, and when it's loaded into our computer, it looks like the horrid image at top in Figure 3.19. The sky is completely washed out. But some of our pictures look like the one at the bottom of the figure. The questions run through our minds. Why can't they all turn out like that? What has happened? And, more importantly, what can we do about it?

The bane of most digital cameras today is the reduced *dynamic range* (the range of brightness from dark to light that can be reproduced), compared to film. Many of us came to the digital realm from shooting color negative film that wound up as prints, and color neg film could often be

Figure 3.19 Washed out skies (top) don't have to happen, as you can see in the image at the bottom.

counted on to capture the equivalent of seven stops worth of detail. That is, if the correct exposure was 1/250th second at f/11, we could expect to see some detail even in the brightest areas that might call for an exposure of f/22, as well as the darkest areas that might have required an aperture of f/2.8. The brightest and darkest areas might not be *well* exposed, but detail was there.

Digital cameras typically have a narrower dynamic range. It's difficult to pin down an exact figure, because a lot depends on the design of the camera and sensor, including such esoterica as the size of the pixels. The most common outdoor result of this reduced range is the difficulty of capturing both the sky and foreground so that both are properly and pleasingly exposed. Fortunately, there are several solutions.

Here are some tips:

◆ **Change your angle.** There's one chief difference between the top and bottom images in Figure 3.19. In the top picture, the sun was positioned in front of me, producing a backlighting effect. In the bottom version, the sun was more overhead and slightly behind me. If you can avoid having the sun at a 45-degree angle to either side of the lens axis, you'll improve the odds that the sky and clouds won't be washed out.

◆ **Wait until the sun is low.** Even backlighting can work if the sun is low enough in the sky, as shown in Figure 3.20.

◆ **Adjust your exposure.** Your washed-out sky might be due, at least partially, from overexposure. See if a little less exposure might help, while retaining detail in your foreground.

◆ **Try a polarizer.** Check out the section preceding this one for information on how to darken the sky and make those fluffy clouds more visible with a polarizing filter. In Figure 3.21, the sun was low in the sky (it was just a few hours before dusk) and off to the left. A polarizer darkened the sky and made the clouds more visible.

Figure 3.21 Lighting conditions were perfect for using a polarizer for this shot.

Figure 3.20 A backlit sky can still be dramatic if the sun is near the horizon.

◆ **Try HDR photography.** High Dynamic Range photography is currently the rage among those who spend half their time in Photoshop. HDR is time-consuming, but not difficult. You need to set the camera up on a tripod and take a series of exposures bracketed at least one f/stop apart. Then, use Photoshop's Merge to HDR feature (or similar features available in other software applications) to create a single photo that combines the highlight detail, middle tones, and shadow detail from several different shots.

◆ **Use a graduated filter.** A graduated neutral density (ND) filter is clear at one end, and has density at the other, and reduces the exposure in the sky (at the top of the frame) while allowing the foreground (at the bottom) to be exposed normally. I'll explain more about this option next.

Using Graduated Neutral Density Filters

Experienced landscape photographers most frequently resolve the washed-out-sky problem with the use of graduated neutral density filters, like the one shown in Figure 3.22. As I noted, these

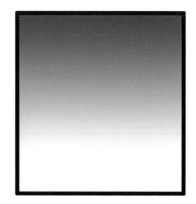

Figure 3.22 A graduated neutral density filter usually has density at one end, and is clear at the other.

filters have density at one end and are clear at the other end, and are graduated, so the filter removes a lot of light from half of the image (most often the top half), while allowing the other half to be exposed normally. Here are some things to learn about graduated ND filters:

◆ **Square/rectangular are best.** These filters are available in screw-in circular styles that fasten directly to your lens, but those are not the best option. With a circular filter, the middle of the gradation is always smack dab in the middle. That might work if your horizon is always in the center of the frame, but, if you follow the conventional

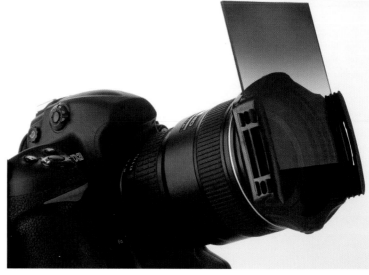

Figure 3.23 A filter holder with a square or rectangular filter allows positioning the neutral density at any point in the frame.

compositional rules, the horizon will *never* be in the center of the frame for landscape photos. It will most often be in the upper third (if you want to emphasize the foreground) or in the lower third (if you want to emphasize the sky). With a square or rectangular filter, used with a holder like the Cokin filter frame shown in Figure 3.23, you can push the filter up or down to position the gradation anywhere you want.

◆ **They come in colors.** Although the most common graduated ND filter has a neutral gray tone, you can buy them in many different color combinations. One popular type has a warming filter at one end, and a cooling filter at the other, so you can color your sky with one of those tones, while adding the other to the foreground.

Figure 3.24 At top, the original scene. At bottom, a graduated ND filter rescued the overexposed sky.

◆ **Watch your orientation.** Even if you're using a filter frame, it's easy to accidentally rotate the graduated ND filter so the gradation no longer lines up with your horizon. You want an even transition, as shown in the "before and after" images in Figure 3.24.

◆ **Reverse the filter.** There's no law that says a graduated neutral density filter has to be used with the density on top and the clear area at the bottom. When I took the shot shown in Figure 3.25, I found that the flowing stream was too bright, and exposing for the water made the foliage too dark. So I flipped my graduated ND filter upside down, and made the water darker while the plant life in the background was exposed normally.

Figure 3.25 In this case, the water was too bright, so I flipped my graduated neutral density filter to produce a dramatic "black water" effect.

Electronic Flash Fundamentals

Compared to continuous lighting—like sunlight, moonlight, or the lamps you may find in a room—electronic flash is both more convenient and less convenient; more powerful and less powerful; more consistent and less consistent; able to leap tall buildings at a single bound; or stumble when you need your flashy light source the most. As you'll see in this chapter, electronic flash is obviously not perfect, but for some applications it is the best light source we have available.

Think of the alternative: continuous lighting, which is low in cost, has a built-in "modeling light" that previews the lighting effect you're going to get and can be easily measured to calculate the best exposure. But electronic flash is better at stopping action (unless you have enough continuous light to allow a very fast shutter speed), doesn't lock you to a tripod when available light is scarce, can provide powerful bursts of illumination (with some limitations), and delivers (mostly) consistent color balance.

How Flash Works

The surge of light we call electronic flash is produced by a burst of photons generated by an electrical charge that is accumulated in a component called a *capacitor* and then directed through a glass tube containing xenon gas, which absorbs the energy and emits the brief flash. Electronic flash is notable because it can be much more intense than continuous lighting, lasts only a brief moment, and can be much more portable than supplementary incandescent sources. It's a light source you can carry with you and use anywhere. Flash is useful for everything from studio photography (see Figure 4.1) to sports, to full daylight as shadow fill-in.

For most flash units, the full burst of light lasts about 1/1,000th of a second and is triggered at the instant of exposure, during a period when the sensor is fully exposed by the shutter. As I mentioned in Chapter 1, the typical

Figure 4.1 Electronic flash can be used for studio photography (as shown), sports, or even in full daylight to fill in shadows.

dSLR has a vertically traveling shutter that consists of two curtains. The first curtain opens and moves to the opposite side of the frame, at which point the shutter is completely open. The flash can be triggered at this point (so-called *front-curtain sync*—more on that later in this chapter), making the flash exposure. Then, after a delay that can vary from 30 seconds (or longer) to as brief as 1/250th second (depending on your camera), a second curtain begins moving across the sensor plane, covering up the sensor again. If the flash is triggered just before the second curtain starts to close, then *second-curtain sync* is used. (I'll describe these in more detail later in this chapter.) In both cases, though, a top shutter speed of 1/160th to 1/250th second (more, or less, depending on your camera) is ordinarily the maximum that can be used to take a photo.

Consider this sequence of things that can take place when you take a photo using electronic flash, either the unit built into your camera or an external flash:

❶ Sync mode. Before taking the picture, you choose the flash sync mode. I'll describe sync modes later in the chapter.

❷ Metering method. If you're relying on your camera's automatic through-the-lens flash exposure system, you need to choose the metering method you want, from Matrix/Evaluative, through Center-Weighted, and Spot metering, again depending on the options your camera provides.

❸ Activate flash. Press the flash pop-up button to flip up the built-in flash, or mount (or connect with a cable) an external flash and turn it on. A ready light usually appears in the viewfinder or on the back of the flash when the unit is ready to take a picture.

❹ Check exposure. Select a shutter speed when using your camera's Manual, Program, or Shutter Priority modes (always using the maximum sync speed, or slower); select an aperture when using Aperture Priority and Manual exposure modes.

❺ Preview lighting. With some cameras and flash units, you may be able to preview the lighting effect with the modeling flash. Some Nikon cameras, for example, produce a modeling burst when the depth-of-field button is pressed.

❻ Lock flash setting (if desired). Optionally, if the main subject is located significantly off-center, you can frame it so the subject is centered, press a designated button or control to lock the flash at the exposure needed to illuminate that subject, and then reframe using the composition you want.

❼ Take photo. Press the shutter release down all the way.

❽ Preflash emitted. Most dSLRs using through the lens (TTL) electronic flash metering emit one or two pre-flash bursts prior to taking the photo. One burst can be used to control additional wireless flash units, while another burst can be used to measure and determine exposure. I'll describe this process further in the flash exposure section later in this chapter.

❾ Exposure calculated. The preflash bounces back and is measured by the camera's exposure sensor, which uses brightness and contrast of the image to calculate exposure, using the exposure sensors, such as those shown in Figure 4.2.

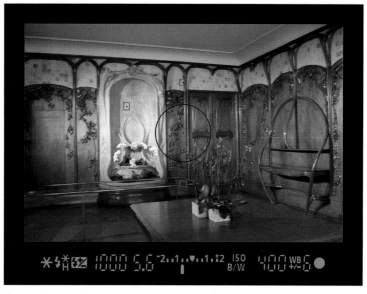

Figure 4.2 A preflash emitted when you press the shutter button all the way bounces back through the lens, where it is measured by your camera's flash exposure system.

❿ Mirror up. The mirror flips up. At this point exposure and focus are locked in.

⓫ Flash fired. At the correct triggering moment (depending on whether front or rear sync is used), the camera sends a signal to one or more flashes to start flash discharge. The flash is quenched as soon as the correct exposure has been achieved.

⓬ Shutter closes. The shutter closes and the mirror flips down. You're ready to take another picture.

⓭ Exposure confirmed. Ordinarily, the full charge in the flash may not be required. Some cameras provide a blinking indicator that shows that the entire flash charge was required, and it *could* mean that the full charge wasn't enough for a proper exposure. Be sure to review your image on the LCD to make sure it's not underexposed, and, if it is, make adjustments and shoot again.

Types of Portable Electronic Flash

You may hear electronic flash units called by various names. They are often referred to as *strobes*, after the electronic *stroboscope* invented by Dr. Harold Edgerton, who used a rapidly flashing lamp to study motion. Flash units are also called *speedlites* or *speedlights*, which, if you've spoken to anyone who ever used flashbulbs to take pictures, you'll know why strobes are considered "speedy" in comparison. Electronic flash comes in several different varieties that are built into many digital cameras, available as separate portable flash units that can be mounted on a camera's *accessory* or *hot* shoe, or as *studio* flash, which are powered by AC current or separate flash power packs.

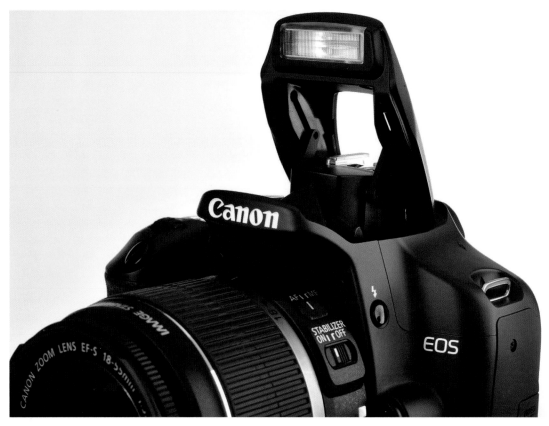

Figure 4.3 Flip up your built-in flash by pressing a button. In some modes, the flash will pop up automatically.

Built-in Flash

These are the flip-up units found in digital SLR cameras (point-and-shoot cameras also have built-in flash), as shown in Figure 4.3. They draw power from the camera's battery, and thus are available for use any time there's enough juice for the camera itself. These units always integrate tightly with the operation of the camera, offering accurate, through-the-lens exposure, interlocking features (with some models, the camera won't fire until the flash has recharged), and, with some vendors, they function as a focus-assist light to illuminate dim subjects to help the camera's autofocus system.

However, built-in flash have some disadvantages, too:

◆ **Camera battery drain.** In-camera flash uses a lot of power, more than even the most power-hungry LCD display. Indeed, camera battery life is measured and specified relative to how many of the shots taken used flash. If you use your camera's flash a lot, you'll want to carry more batteries with you.

◆ **Limited power.** In a futile attempt to reduce the impact of an internal flash on the camera's battery, most such units are relatively low in power. If you need a beefier flash unit, you'll want to use an external unit (which will go easier on your camera's battery, too).

◆ **Red-eye problems.** While your camera's flash flips up to elevate the flash tube a few inches above the lens, you'll probably still get the demon-eye effect caused by the flash reflecting back into the lens off your subjects' retinas. Red-eye reduction preflashes or other remedies are rarely perfect, and who wants to depend on an image editor to cancel red pupils? As you'll see, using an off-camera flash instead of the built-in unit may help solve this problem.

◆ **Wide-angle shadows.** If you're using a wide-angle lens with a lens hood attached, your camera's flash will probably cast a shadow on your subject. The elevation of the flash unit simply isn't enough to avoid creating a dark hemisphere at the bottom of every shot you take. Figure 4.4 shows this syndrome at work in a flash shot that has several different problems besides the errant shadow. Removing the lens hood might help, but it may not solve the problem completely.

◆ **Unwanted bursts.** This is more of a user "error" than a fault of the flash or camera. Many digital SLRs have "scene" mode settings that fully automate the picture-taking process (other than the need for you to point the camera and press the shutter release). One or more of these modes may pop up the flash at inopportune times, and you can get an unwanted burst of light in a museum, at a concert, or during a religious ceremony, when you'd intended to take the photo by available light. These same cameras have "no flash" or "museum" modes that disable the flash—but you have to remember to use them.

◆ **Limited studio use.** If you want to use flash in a studio environment, your camera's built-in flash is not your best choice, because you have no control over where it is aimed. While such flash units are good as fill-flash outdoors, in the studio they are best used as a very limited fill, when their power output is dialed down, or as a wireless trigger to control off-camera flash. Indeed, some cameras allow setting the built-in flash so that it does not contribute to the exposure, but, instead, will fire only a preflash to trigger compatible external flash units automatically.

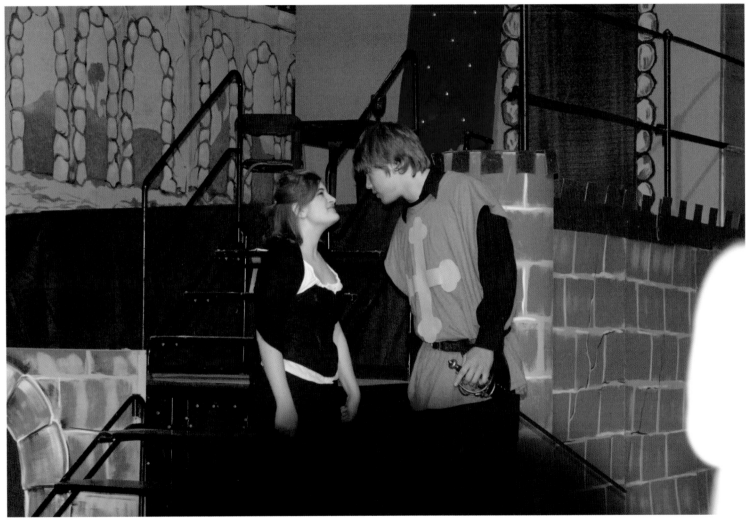

Figure 4.4 The shadow of a lens hood is probably not something you want in your shot. Remove the hood before you shoot if it interferes with your image.

Add-on Flash

Virtually every dSLR vendor offers an add-on flash you can purchase that solves most of the problems listed previously. While most flash units of this type fit in a camera's hot shoe, as shown in Figure 4.5 (or, optionally, on a flash bracket or frame as "off camera" flash connected to the camera with a cable), they can also be mounted on light stands or other supports and used as inexpensive studio illumination. Basic flash also are still available as "handle mount" or "potato masher" flashes, which are more powerful and used in professional photojournalism applications, often with separate battery packs.

There are three drawbacks to external flash units. One is that, like a camera's internal flash, they are designed to operate on battery power. An AC adapter might be available for a basic

Figure 4.5 External flash units clip onto the accessory or "hot" shoe on top of digital SLR cameras.

flash, but it might not. The second drawback to an add-on flash unit is the possible lack of a modeling light. Some have them; some don't. A few shoe-mount flashes (and some internal flashes) have a modeling light feature, which flashes the unit many times at low power to provide a sort of continuous illumination you can use to judge the lighting effect. If all other room lights are dim, you might be able to use this effect. However, these multiflashes are too weak to overcome significant available light and may provide a nearly invisible modeling light effect. Instead, you might be able to rig a small incandescent light next to your flash to serve as a modeling light substitute.

The final problem with using an external flash is the relatively long recycling time between flashes. When using such a flash on battery power, recycle times may be five to eight seconds or more, which can put a real crimp

in your photography. If you're shooting portraits, I can guarantee that in every session you'll shoot one picture and your subject will immediately break into a smile a half-second later that you'll want to capture for posterity. A five-second delay will seem like half an hour in those cases.

Many flash units of this type can be attached to a beefier battery pack, made by Quantum or other vendors, which not only extends shooting time, but reduces recycling time as well.

Studio Flash

These are specialized units that are designed to function in photo studios and on location, often tethered to AC power sources, or totable battery packs. I'll explain the selection and functions of studio flash in more detail later in this chapter.

Using Flash Creatively

Part of the reason that flash photography sometimes is given a bad rap is that too many photos are taken using the built-in flash or with a direct on-camera auxiliary flash unit that would have been better served by off-camera flash. Flash on the camera is often too direct, too harsh, casts unpleasant shadows, and can promote undesirable red-eye effects. You'll find that strobes can be used in more creative ways to provide more attractive lighting. Here are some suggestions:

Bounce Flash

If you have a flash unit mounted on your camera's accessory shoe, tilt it upwards at an angle to bounce off the ceiling, or to one side to bounce off a reflector or wall. The light will spread and diffuse against the reflective surface and return with a softer texture that is much more flattering than direct flash. Bounce flash works well when you're photographing people indoors, especially when your subjects are near walls that would show ugly shadows from direct flash.

However, bounce flash must be used with caution:

◆ **Watch for shadows under the eyes.** If you're fairly close to your subject, having all the illumination coming from directly overhead can produce shadows under the eyes. Many add-on flashes have a slide out white card reflector that bounces a little direct flash at your subject as a sort of fill light to counter those shadows. Or, you can try bouncing your flash off a different surface, as shown in Figure 4.6. The version at left was a misguided attempt at ceiling bounce, and I ended up with a picture that never would have seen the light of day had I not needed an example of what *not* to do. The bride's eyes are shadowed, dark, and lifeless. The version at right was taken a few seconds later, with flash bounced off a white surface to the left. It's still not a prize-winning shot, but the lighting is a bit more flattering for the young woman.

◆ **Beware bald heads.** Light from overhead accentuates bald heads. Ceiling bounce may not be your best choice if your subjects are follicly challenged. Even if they aren't sensitive about their bare pates, they probably won't find a photograph with their dome gleaming brilliantly to be very flattering.

◆ **Keep that inverse square law in mind.** I'll address the inverse-square law once again in Chapter 6, but you should remember that bounce flash produces much more light on parts of your subjects that are closest to the (reflected) light source than those that are farther away. A shining head of hair that's two feet from the ceiling bounce-source will receive four times as much light (two f/stops) as the head's owner's waist, two feet closer to the floor.

◆ **Watch those colors.** If you bounce your light off a ceiling that's painted yellow or green (or most any other color), you probably won't like the results.

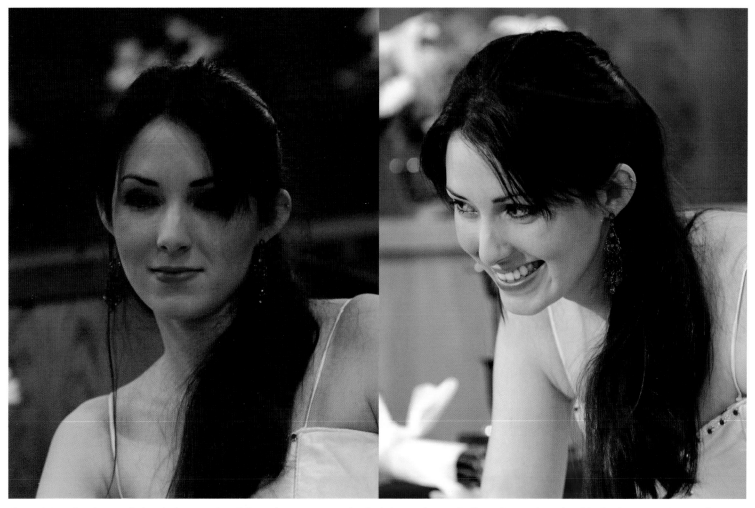

Figure 4.6 Ceiling bounce led to dark eye sockets (left); in the version at right, the light was bounced off a surface to the right of the bride, to provide more flattering lighting.

Flash on a Bracket

Move the flash off the camera and mount it on a bracket that moves the flash above or to one side, as shown in Figure 4.7. Then, should you be forced to use direct flash, you'll enjoy several advantages over having the strobe mounted directly on the camera. First, shadows will fall behind or to one side of your subject, even if they are fairly close to a wall, rather than provide a sharp silhouette directly behind them. Second, if the flash is located farther from the lens, the chances of evil red-eye effects are virtually eliminated.

You'll find many different kinds of flash brackets available from vendors like Custom Brackets (www.custombrackets.com), which produces the CB Junior that I own, and StroboFrame brackets from Tiffen (www.tiffen.com). They are available with left and right grips, can be used to mount your flash beside or above your camera, and can even include rotating frames that allow great flexibility in positioning your unit.

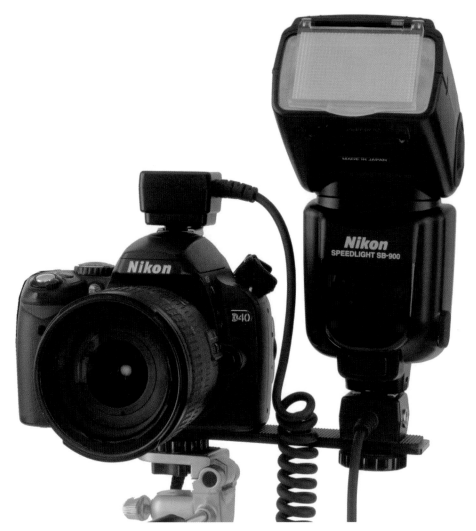

Figure 4.7 Moving the flash off the camera and onto a bracket can eliminate red-eye and reduce the shadows cast by the strobe.

Off-Camera Flash

For the greatest freedom, detach your flash from the camera entirely. You can hold it in your left hand, point it at your subject at an angle, or bounce it off the surface of your choice. My favorite technique is to hold a small white umbrella (I use a Totes rain umbrella) in my left hand, while gripping my electronic flash, pointed back into the umbrella, with the same hand. Presto! Your left arm becomes a light stand and you can aim the soft umbrella light anywhere you please while you compose your shot through the viewfinder and take your photos with your camera held in your right hand. With an autofocus/autoexposure camera, this technique is easy. I actually used the rain umbrella/flash combination for 18 years when I was a roving photojournalist for magazines—without benefit of autofocus technology. (It was possible—but not easy—to focus my favorite lens manually with the fingertips of the right hand. The 35mm film cameras of the day were much smaller and easier to hold than today's digital models.)

Multiple Flash

Archimedes claimed that given a lever and a place to stand, he could move the Earth. My more modest goal is to have a couple flash units and a place to put them in order to illuminate a smaller portion of the planet. Even when you're using portable flash units, you can usually find a place to put them within most scenes, and provide impromptu lighting using one main flash and a couple "slaves." You don't need to be working in a studio to use more than one flash simultaneously—you just need to be creative in your thinking and in spotting ways to illuminate your subject with multiple strobes. But, if studio shooting is your game, I'll provide more tips on using multiple flash in Chapters 5 and 6.

Paint with Light

Put your camera on a tripod in a dark location, open the shutter for a long exposure, and then walk around the scene triggering your flash to "paint" the scene with the light. Fire off several flashes using your unit's Test or Open Flash button. Keep your body between the camera and the flash so the flash itself won't appear in the picture, and remain moving at all times. With an exposure of 30 seconds or longer, you will become invisible, but your flashes can illuminate even large areas easily.

Determining Exposure

Calculating the proper exposure for an electronic flash photograph is a bit more complicated than determining the settings for continuous light. The right exposure isn't simply a function of how far away your subject is (which some cameras' flash exposure systems can figure out based on the autofocus distance that's locked in just prior to taking the picture). Various objects reflect more or less light at the same distance so, obviously, the camera needs to measure the amount of light reflected back and through the lens. Yet, as the flash itself isn't available for measuring until it's triggered, the camera has nothing to measure.

Automatic TTL Flash Exposure

Modern cameras are able to measure the flash (or a preflash surrogate) through the lens that is used to take the picture, for nifty TTL (through-the-lens) automatic flash exposures. Of course, the flash can't be measured during the actual exposure, as I noted. For most dSLR camera systems, the solution is to fire the flash twice. The initial shot is a *monitor preflash* that can be analyzed, then followed virtually instantaneously by a main flash (to the eye the bursts appear to be a single flash) that's given exactly the calculated intensity needed to provide a correct exposure. As a result, the primary flash may be longer in duration for distant objects and shorter in duration for closer subjects, depending on the required intensity for exposure. This through-the-lens evaluative flash exposure system operates whenever the pop-up internal flash is used, or you have attached a compatible dedicated flash unit, like the one used off-camera for Figure 4.8.

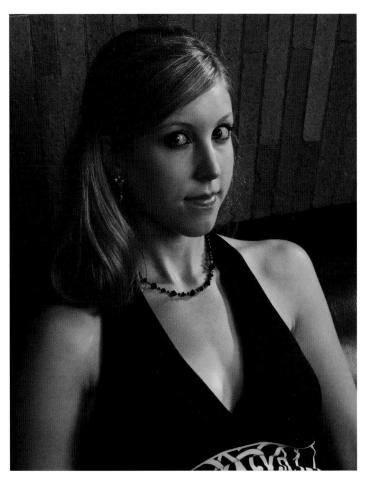

Figure 4.8 Even though the external flash was held off to the right, the camera was able to calculate the correct exposure.

Guide Numbers

Guide numbers, usually abbreviated GN, are a method of specifying the power of an electronic flash in a way that can be used to determine the right f/stop to use at a particular shooting distance and ISO setting. In fact, before automatic flash units became prevalent, the GN was actually used to do just that. A GN is usually given as a pair of numbers for both feet and meters that represent the range at ISO 100. For example, one typical camera's built-in flash has a GN in TTL metering mode of 17/56 (meters/feet) at ISO 200.

Using that camera's built-in flash as an example, at ISO 200 with its GN of 56, if you wanted to shoot a subject at a distance of 10 feet, you'd use f/5.6 (56 divided by 10). At 5 feet, an f/stop of f/11 would be used. Some quick mental calculations

with the GN will give you any particular electronic flash's range. You can easily see that the built-in flash would begin to peter out at about 20 feet, where you'd need an aperture of f/2.8 at ISO 200. Of course, in the real world you'd probably bump the sensitivity up to a setting of ISO 800 so you could use a more practical f/5.6 at that distance.

Today, guide numbers are most useful for comparing the power of various flash units, rather than actually calculating what exposure to use. You don't need to be a math genius to see that an electronic flash with a GN in feet of, say, 174 (like one unit I own) would be *a lot* more powerful than a built-in flash. At ISO 200, you could use f/9 instead of f/2.8 at 20 feet, an improvement of about 3.5 stops.

Flash Meters

External flash meters are an option that serious flash photographers often avail themselves of. These meters are hand-held devices, like the one shown in Figure 4.9, that measure the light emitted by the flash during a test shot. You'll find them put to work most often in a studio environment, where it's important to measure and compare the light from the main illumination source with that of other lights used in a scene, such as the fill light (used to illuminate the shadows) or hair light (which provides an accent to the hair of a portrait subject).

Flash meters aren't necessarily expensive, and learning to use them is fairly easy. But they may be overkill for most flash situations with a digital camera, because you can easily take a test shot and review your lighting and exposure using the LCD and the camera's histogram feature. But, if you want the most accurate flash exposures, a flash meter can be extremely helpful. Some models can measure flash and continuous light, so that one meter can do double duty, although these models can be relatively pricey.

Figure 4.9 A hand-held flash meter can measure the flash levels for individual lights in a multi-light setup.

Choosing a Flash Sync Mode

Most digital SLRs have as many as five electronic flash synchronization modes. They determine exactly *when* the flash is fired, and may control which shutter speeds are used. In many situations, only the light from the electronic flash contributes to the final exposure, but if ambient light levels are high enough, the existing light may also become a factor. In those situations, the sync mode becomes especially important.

I briefly explained how focal plane shutters work in Chapter 1. You'll recall that when the shutter begins to open, the first or *front* curtain exposes the sensor and starts to travel to the top of the frame, as shown in Figure 4.10.

At shutter speeds equal to or longer than the camera's maximum sync speed (typically 160th to 1/250th second), the second or *rear* curtain doesn't begin to move until the sensor is fully exposed, as in Figure 4.11.

Figure 4.10 At the beginning of the exposure, the first curtain starts to uncover the sensor.

Figure 4.11 When the sensor is fully exposed, the flash can be triggered to make the exposure.

Sometime while the shutter is completely open, the flash is triggered. The operation of these curtains comes into play when flash sync is considered. Here are the primary sync modes used in most digital SLR cameras.

◆ **Front-curtain sync.** This setting should be your default setting. In this mode the flash fires as soon as the front curtain opens completely. The shutter then remains open for the duration of the exposure, until the rear curtain closes. If the subject is moving and ambient light levels are high enough, the movement will cause a secondary "ghost" exposure that appears in front of the flash exposure (in relation to the apparent direction of movement of your subject). I'll explain this in more detail next.

◆ **Rear-curtain sync.** With this setting, which can be used with Shutter Priority, Aperture Priority, Program, or Manual exposure modes, the front curtain opens completely and remains open for the duration of the exposure. Then, the flash is fired and the rear curtain closes. If the subject is moving and ambient light levels are high enough, the movement will cause a secondary "ghost" exposure that appears behind the flash exposure (trailing it).

◆ **Slow sync.** This setting allows the typical digital SLR to use shutter speeds as slow as 30 seconds with the flash to help balance a background illuminated with ambient light with your main subject, but which will be lit primarily by the electronic flash. You'll want to use a tripod at these slower shutter speeds, of course. It's common that the ambient light will be incandescent illumination that's much warmer than the electronic flash's "daylight" balance, so, if you want the two sources to match, you may want to use a warming filter on the flash.

◆ **Red-eye reduction.** In this mode, there is a slight lag after pressing the shutter release before the picture is actually taken, during which the camera's red-eye reduction lamp (an LED on the front of the camera) or a strobe pre-flash is triggered, causing the subject's pupils to contract (assuming they are looking at the camera/flash). This reduces potential red-eye effects.

◆ **Red-eye reduction with slow sync.** Some cameras have this additional mode, which combines slow sync with red-eye reduction behavior.

Ghost Images

The difference might not seem like much, but whether you use first-curtain sync (the default setting) or rear-curtain sync (an optional setting) can make a significant difference to your photograph *if the ambient light in your scene also contributes to the image.* At faster shutter speeds there isn't much time for the ambient light to register, unless it is very bright. It's likely that the electronic flash will provide almost all the illumination, so first-curtain sync or second-curtain sync isn't very important.

However, at slower shutter speeds, or with very bright ambient light levels, there is a significant difference, particularly if your subject is moving, or the camera isn't steady. In any of those situations, the ambient light will register as a second image accompanying the flash exposure, and if there is movement (camera or subject), that additional image will not be in the

same place as the flash exposure. It will show as a ghost image and, if the movement is sufficient, as a blurred ghost image trailing in front of or behind your subject in the direction of the movement.

As I mentioned earlier, when you're using first-curtain sync, the flash goes off the instant the shutter opens, producing an image of the subject on the sensor. Then, the shutter remains open for an additional period (which can be from 30 seconds to your maximum sync speed). If your subject is moving, say, towards the right side of the frame, the ghost image produced by the ambient light will produce a blur on the right side of the original subject image, making it look as if your sharp (flash-produced) image is chasing the ghost. For those of us who grew up with lightning-fast superheroes who always left a ghost trail *behind them*, that looks unnatural (see the top image in Figure 4.12).

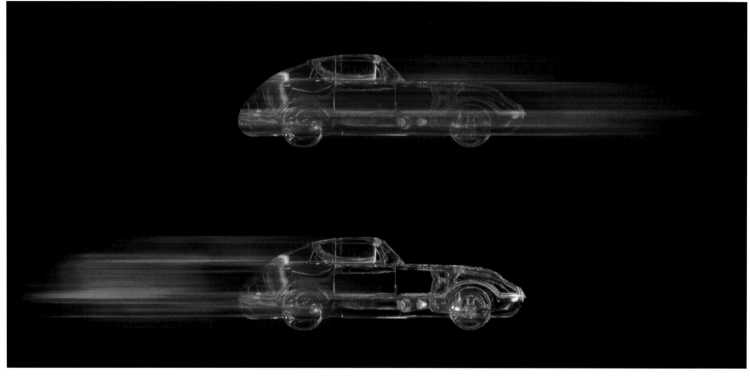

Figure 4.12 With front-curtain sync (top), the ghost image "precedes" the moving object; with rear-curtain sync (bottom), the ghost "follows" the moving object.

So, your camera provides rear-(second) curtain sync to remedy the situation. In that mode, the shutter opens, as before. The shutter remains open for its designated duration, and the ghost image forms. If your subject moves from the left side of the frame to the right side, the ghost will move from left to right, too. *Then*, a few milliseconds before the second shutter curtain closes, the flash is triggered, producing a nice, sharp flash image *ahead* of the ghost image. Voilà! We have the subject "outrunning" its own trailing image, as you can see at bottom in Figure 4.12.

High-Speed (FP) Sync

Triggering the electronic flash only when the shutter is completely open makes a lot of sense if you think about what's going on. To obtain shutter speeds faster than the maximum flash sync speed, your camera exposes only part of the sensor at one time, by starting the second curtain on its journey before the first curtain has completely opened. That effectively provides a briefer exposure as a slit passes over the surface of the sensor. If the flash were to fire during the time when the first and second curtains partially obscured the sensor, only the slit that was actually open would be exposed.

However, some cameras and compatible flash units provide a partial solution, called *high-speed sync* or *FP sync* (focal plane sync). Those flash units can fire a series of flashes consecutively in rapid succession, producing the illusion of a longer continuous flash, although at reduced intensity. These multiple flashes have a duration long enough to allow exposing the area of the sensor revealed by the traveling slit as it makes its full pass. However, the reduced intensity means that your flash's range is greatly reduced.

This technique is most useful outdoors when you need fill-in flash, but find that, say, 1/250 second is way too slow for the f/stop you want to use. For example, at ISO 200, an outdoors exposure is likely to be 1/250 second at, say, f/14, which is perfectly fine for an ambient/balanced fill-flash exposure if you don't mind the extreme depth-of-field offered by the small f/stop. But, what if you'd rather shoot at 1/1600 second at f/5.6? High-speed sync will let you do that, and you probably won't mind the reduced flash power, because you're looking for fill flash, anyway. Check your camera manual to see if high-speed sync is available for your model.

Studio Flash

If you're serious about using lighting creatively, you should consider adding simple studio electronic flash units to your gear kit. While they are more expensive than incandescent lights used in a studio environment, such flash are cooler, free you from needing to use a tripod (most of the time), and, unlike most other flash options, include an incandescent modeling light that gives you an exact preview of what your lighting effect will look like.

Their other advantages include greater power output, much faster recycling, multiple power levels, and ruggedness that can stand up to transport, because many photographers pack up these kits

and tote them around as location lighting rigs. Studio lighting kits can range in price from a few hundred dollars for a set of lights, stands, and reflectors, to thousands for a high-end lighting system complete with all the necessary accessories.

Because they can use AC power, studio flash don't have to be frugal with the juice, and are often powerful enough to illuminate very large subjects, or to supply lots and lots of light to smaller subjects. The output of such units is measured in watt seconds (ws), so you could purchase a 200ws, 400ws, or 800ws unit, and power pack to match.

The traditional pro studio flash is a multi-part unit, consisting of a flash head that mounts on your light stand, and is tethered to an AC (or sometimes battery) power supply. A single power supply can feed two or more flash heads at a time, with separate control over the output of each head. This type of flash has the most rugged construction, so you can pack them up in hard cases, transport them anywhere (even by airplane), and set them up on location, confident that they'll do the job as expected.

For someone who is not a full-time location-shooting professional, *monolights,* like the one shown in Figure 4.13, are probably a better choice. These are "all-in-one" studio lights that have the flash tube, modeling light, and power supply built into a single unit that can be mounted on a light stand. Monolights are available in AC-only and battery-pack versions, although an external battery eliminates some of the advantages of having a flash with everything in one unit.

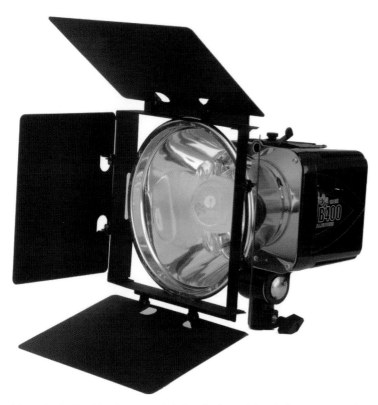

Figure 4.13 This Alien Bee monolight has flash, modeling light, power supply, and all electronics in a single compact housing.

Monolights can be considerably more economical, with 200 to 1600 watt-second units available for about $200 to $400. They are certainly more portable, because all you need is a case for the monolight itself, plus the stands and other accessories you want to carry along. Because these units are so popular with photographers who are not full-time professionals, the lower-cost monolights are often designed for lighter duty than professional studio flash. That doesn't mean they aren't rugged; you'll just need to handle them with a little more care, and, perhaps, not expect them to be used eight hours a day for weeks on end. In most other respects, however, monolights are the equal of traditional studio flash units in terms of fast recycling, built-in modeling lamps, adjustable power, and so forth.

Here are some features to look for in your studio flash units:

◆ **Build quality.** Some units are more rugged than others, and you'll pay extra for that durability. You'll want flash units that have lightweight bodies of polycarbonate or some other tough material (up to and including aluminum), with all fittings (especially the adjustments for angle) tough enough to withstand frequent changes. If you plan to set up your lights in a studio and never move them, you can go with slightly less sturdy equipment and save some money.

◆ **Built-in slave trigger.** Virtually all new units have a sensor that triggers the flash when it detects the burst of another strobe. You should be aware that there may be a small lag before the additional flash units fire; it's often wise to set your camera's sync speed one setting slower than the max (say, 1/200th second instead of 1/250th second) to allow for this.

◆ **Wireless option.** If you want to avoid a long cable between your camera and the primary flash unit, look for strobes with a wireless option. Mine uses a radio trigger that mounts on the hot shoe of my camera and sends a signal to the main flash to fire it. The remaining units can be set off in response to the main flash or, optionally, can be attached to their own wireless receivers so that they all fire at the same time.

◆ **Adjustable power levels.** Some older studio flash I own have a limited number of power settings set by toggle switches, so that only 1/2 and 1/4 power can be selected. Newer units may allow continuous settings with a slider, all the way from full power to 1/32 power, like my Alien Bee unit, shown in Figure 4.14. However, reducing power may change the color temperature of the flash, as I'll explain in Chapter 6.

Figure 4.14 The power levels of this monolight can be adjusted from full power to 1/32 power with this slider control.

◆ **Modeling light options.** A modeling light is a given. But does the flash unit use an inexpensive incandescent bulb, like the monolight shown in Figure 4.15, or does it require a special light source?

Can you set the modeling light to "track" the flash's power setting, or does it remain at the same brightness level? Are the modeling lights proportionate among units from the same vendor with different power capabilities? The modeling light for an 800ws unit should be twice as bright at full power than the light for a 400ws unit, and half as bright as the modeling light of a

1600ws flash from the same company. Can you set the modeling light so that it turns off briefly after the flash has fired, as a confirmation that the unit has, indeed, done its job? Or, if you'd rather avoid the distraction, can the modeling light be set to remain on at all times?

◆ **Power options.** Some flash are AC-only units. Others can be fitted with an optional battery pack. If you shoot in locations where no power is available, the battery pack option may be important.

◆ **Accessory options.** You'll find that life is easier if you can get all the accessories you need for your flash from the same company that builds the flash unit. You'll want a source for soft boxes, speed rings that attach the soft boxes directly to your flash, snoots, barndoors (like the ones shown in Figure 4.13), and "beauty dishes" (large reflectors that soften the light, but not as much as umbrellas or soft boxes). I'll explain the use of these tools in more detail in Chapter 5.

Figure 4.15 This monolight uses an inexpensive household bulb as a modeling light.

Fill Flash

One of the most useful applications for electronic flash is to fill in inky shadows, brightening up subjects to reveal detail that would otherwise be obscured in the murky depths. As you've learned by now, shadows themselves are not a bad thing: They provide modeling and shape to subjects by emphasizing contours and texture. Nor are dark shadows always evil; properly used, shadows with no detail can make a suitable image look more dramatic, imposing, or threatening.

Somewhere between shadowless lighting and light-eating black holes are shadows that contain enough detail to show us something about our subject, without distracting from the main focus of the image (which is almost always to be found in the brightest areas of the photo). Because digital cameras (and film cameras before them) are incapable of reproducing detail in both the brightest highlights and darkest shadows, a secondary source of illumination is often used as a

fill-in. Reflectors can do the job in some cases, but I've found that one seriously underused and valuable tool is fill flash.

Fill flash is closely related to the *fill lights* I'll describe in the studio lighting sections in Chapters 5 and 6. Outside the studio, however, electronic flash fill is almost always used outdoors, in bright daylight, using the flash built into the camera. Because of the environment in which it is used, fill flash is both easier and more complex to apply than studio fill. Here are some considerations when using fill flash:

◆ **Must supplement sunlight or main source of illumination.** You don't want your fill flash to overpower your main source of illumination. If it does, the fill flash becomes your *main* light, and you probably won't like the effect, particularly outdoors. Your shot will end up looking like a publicity still from *Baywatch*—or worse. However, sometimes an overpowering fill flash can work. Figure 4.16 shows a picture I grabbed at a Civil War re-enactment on an excessively

Figure 4.16 Heavy use of fill flash can completely wash out the existing illumination, even in daylight.

bright summer's day. "General Grant" was largely in shadow, so much so that the background completely washed out. I used fill flash but ended up with too much, so that the main illumination of the photo came from my flash.

◆ **Use balance fill setting.** If your flash or camera has a "balanced fill setting" automatic exposure mode, use it. The camera will calculate the correct overall exposure for the scene, then instruct the electronic flash to emit a scaled-back burst of light of sufficient strength to fill in the shadows without overpowering the highlights.

◆ **Consider Manual exposure mode.** Remember that proper application of fill flash means adjusting the *flash* exposure, not the *overall* exposure, which you want to remain at its normal setting. So, if you don't have a balanced fill option, consider setting your flash to Manual exposure and increasing or reducing the flash's output as required to produce the proper amount of fill.

◆ **Watch lighting ratios.** The relationship between the main light and your fill is important. The fill light should be half or one-third as potent, which you can ensure by reducing your flash's output, perhaps to one half or one quarter its normal value. I'll discuss lighting ratios in more detail in Chapters 5 and 6.

◆ **Sync speed limits use outdoors.** The biggest limitation of working with fill flash outdoors is that your shutter speed generally can't be higher than your camera's fastest sync speed (described earlier in this chapter). That speed may be as slow as 1/160th second, or as high as 1/500th second, but is generally in the 1/200th-1/250th second range. With that constraint, you'll have to use a low ISO setting (which may be good, because it reduces the "power" of your flash at a given distance), and exposure combinations like 1/200th second at f/16 at ISO 200 in bright sunlight. As you can see, action photography with fill flash can be tricky—or impossible—unless you're willing to risk a little subject motion blur.

◆ **Great for adding catchlight.** One of my favorite applications of fill flash outdoors is to add a little catchlight to my subjects' eyes.

◆ **Use with hats.** Hats cast shadows. Fill flash can illuminate the face under those shadows, as shown in my shot of "General Robert E. Lee" in Figure 4.17. Unlike my "Grant" photo, this image provides a good balance between available light and fill flash, and did a great job of lighting up the shadows cast by the Confederate general's broadbrimmed hat.

Figure 4.17 Fill flash is a great tool for lighting up shadows cast by broadbrimmed hats.

In Chapter 6, I'm going to show you how to set up and use some of the most popular portrait lighting techniques. But, before we can jump into that topic, it's necessary to define some of the tools that you'll work with (such as main lights, fill lights, or background lights) and the characteristics of those tools. In this chapter, I'm going to explain (or review) some of the properties of light that are especially important when working with these techniques, and show you exactly how to think of the different kinds of lighting equipment you'll be using.

When you've absorbed everything here, you can jump directly to the next chapter and begin applying the techniques that I recommend there. I'll start off with a review of the *character* of light, which can be just as important as the direction it comes from. You probably already know that light can be hard and harsh, or soft and gentle. Neither end of the spectrum is "good" or "bad." Each type of light, and all the gradations in between, has its own advantages and disadvantages. Some portrait subjects benefit from a softer light, while others call for a harder, more direct light. You should learn to use both.

Soft Lighting and Distance

A spotlight or a lamp in a reflector, or an electronic flash pointed directly at a subject is highly directional and produces a hard effect. Hard light is harsh because all the light comes from a relatively small source. This kind of light can be good if you want to emphasize the texture of a subject and are looking for as much detail and sharpness as possible. Many portraits of men use more direct lighting, although it's easy to be *too* harsh if you're not careful.

Most portrait subjects, especially of females and teens, benefit from a softer light. People rarely look their best under a direct light, because even a baby's skin is subject to imperfections that we don't see under home illumination. You can soften portrait light in many ways, using umbrellas, diffusers, and other techniques. It's even possible to add a little softness in Photoshop.

Most portraits are made using slightly softer illumination, such as that produced by passing the light through a diffuser such as a soft box, or by bouncing it off an umbrella. You can even shoot *through* a translucent umbrella. As the light strikes the umbrella (or other soft reflector), the light scatters. It bounces back towards the subject and appears to come from a much larger source—the umbrella itself rather than the bulb or flash unit that produced it. Soft boxes operate in the same way, spreading the light as it is diffused by the fabric cover of the box.

You can understand the effect by first looking at looking at Figure 5.1, which is a bird's-eye view of a fanciful representation of an imaginary "cone" of light cast by a light bouncing off an umbrella onto a seated subject. Of course,

the light is bouncing in all directions and spreading out, but my illustration shows just the cone of light falling on the seated subject. The blunt "apex" of this cone gets smaller the farther away you move the light, and larger the closer it gets.

But you probably already guessed by now that the distance of the light source from the subject also has a bearing on the quality of light. In Figure 5.1, the umbrella is fairly far from the subject, so the light source seems to come from a relatively small area, even though it's bouncing off an umbrella. The effect is less harsh than direct light, of course, but still not as good as we can achieve.

For Figure 5.2, I moved the imaginary umbrella in much closer to the subject, making the blunt end of the cone of light larger. The

apparent source of the light is now much broader, relatively speaking, and correspondingly softer. You'll need to keep this characteristic in mind as you set up your lights for portraiture. If you need to move a light back farther from the subject, you'll also need to take into account the changing nature of the light. A larger umbrella may help keep the lighting soft and gentle. Or, you simply might want to have slightly "edgier" lighting for your subject. As long as you are aware of the effect, you can control it.

So, keep in mind that moving a light closer to your subject makes it softer; moving it farther away makes it harsher. That movement also increases or decreases the amount of light falling on your subject, and that's the subject of the section that follows this one.

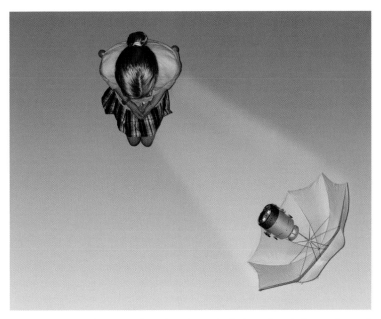

Figure 5.1 The farther away from the subject the light is placed, the smaller and harsher the cone of illumination it casts.

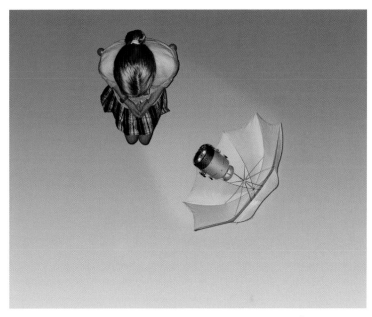

Figure 5.2 As the light source is moved closer to the subject, it becomes larger and more diffuse.

Balancing Light

As you'll see in this chapter and the next, you'll often be using multiple illumination sources to light your portraits. It's important to understand some of the principles that go into balancing light from several different sources in a single photograph. The first thing to understand is the *inverse square law*, which will govern what happens when you move lights around as you create your setups.

The Inverse Square Law

When setting up portrait lights, you may find yourself moving a given light source closer to or farther away from your subject, if only to change the softness/ harshness of the light. You might want to bring a light in very close to create a soft, wrap-around lighting effect. Or you might want to move the light farther back to create a harder light that emphasizes texture and detail. But you need to simultaneously remember that this movement provides a change in the *amount* of light on your subject—in a non-intuitive way.

You see, moving a light source twice as far away doesn't cut the light in half, as you might expect. Instead, doubling the distance reduces the light to *one-quarter* its original value. That translates into *two* f/stops worth of light, not one f/stop. A light source placed four feet from your subject will provide *four times* as much illumination as the same source located just eight feet from the subject. After moving the light twice as close, you'd have to close your aperture by two f/stops to keep the same exposure, as shown in Figure 5.3.

You can make the inverse square law work for you or against you. If you find a source is too strong, either by itself or relative to other light sources you're using, simply moving it twice as far away will reduce its strength to one-quarter its previous value. Or, should you need more light, you can gain two f/stops by moving a light source twice as close.

The big problem with this approach is that this movement will increase/decrease the softness of the light source. That may not be a factor for some types of lights, such as the light cast on a background or used to illuminate your subject's hair. You can move the light closer or farther away in either case to reduce or increase its intensity. However, for the main lights used for portraits, you're usually better off changing the actual intensity of the light. This can often be done by using a lower power setting on your flash.

Using Lighting Ratios

Another consideration when arranging lights is the *balance* between the multiple sources of illumination used in a portrait setup. As you'll learn, most techniques call for one *main* light that provides the primary light source for the scene. Sources called *fill* lights do what you might expect: fill in or brighten the shadows cast by the main light. Other *accent* lights may be used to illuminate specific parts of the scene. The relationship of the intensity of these lights is important, with the chief concern being the *lighting ratio* between the main light and fill light(s).

For example, suppose that the main light for a portrait provides enough illumination that you would use an aperture of f/11. The supplementary or fill light is less intense, and would require, all by itself, an exposure of f/5.6.

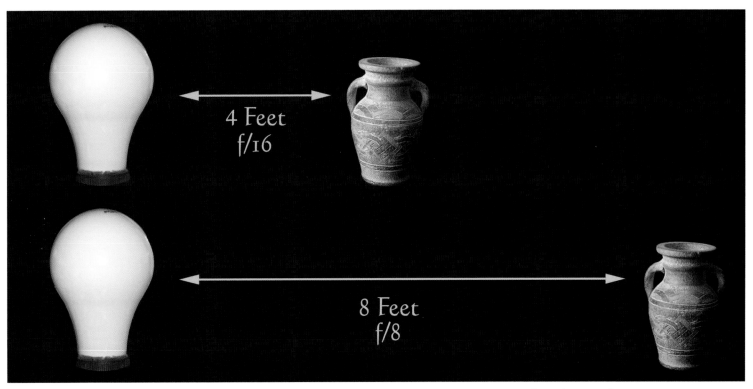

Figure 5.3 A light source placed four feet from a subject provides four times as much illumination as the same source located twice as far away.

That translates into two f/stops' difference or, putting it another way, the main light source is four times as intense as the fill light. You can express this absolute relationship as the ratio 4:1. Because the main light is used to illuminate the highlight portion of your image, while the secondary light is used to fill in the dark shadow areas left by the main light, this ratio tells us a lot about the lighting contrast for the scene.

In fact, that 4:1 lighting ratio is quite dramatic and can leave you with fairly dark shadows to contrast with your highlights. Most of the time, a lighting ratio of 4:1 will be too high for a satisfactory portrait. The most common ratio is a 3:1 relationship, with the fill light about 1 2/3 stops less than the main light (in our example, that would be about f/6.3). Some portraits may call for a 2:1 ratio, with the main light twice as bright as the fill, for an f/11 to f/8 relationship. You want to have shadows that define the shape of your subject without cloaking parts in inky blackness. Figures 5.4-5.7 illustrate various lighting ratios.

Measure your lighting ratios using one of these methods:

◆ **Visually.** If you use incandescent lighting or electronic flash equipped with modeling lights, in practice you will rarely calculate lighting ratios while you shoot. Instead, you'll base your lighting intensity settings on how the subject looks, making your shadows lighter or darker depending on the effect you want, and which you gauge by eye. This usually works, and you'll become better at it the more you practice.

◆ **Use your camera's meter.** If you're working with incandescent or flash with a modeling light that is proportional to the flash it is coupled with, you can switch off each light in turn, and measure the actual light reflected from the shadow and highlight areas of your subject, respectively. Use your camera's "Spot" metering setting so you can zero in on one area, then switch the lights and measure the other. If you have a handheld light meter, preferably an incident model that is held at the subject's position, you can measure the light/modeling light with that.

◆ **Use a flash meter.** There are handheld "spot" and incident flash meters designed to measure the light emitted by an electronic flash. Use the meter, and trip each flash in turn to evaluate the light, and then calculate a lighting ratio.

◆ **Use your dedicated flash's features.** If you're using the dedicated flash units sold for your camera, they probably have an intelligent flash feature that measures actual light from multiple flashes and balances the light for you, so that one unit can function as a main light, while the second is used as balanced fill. Such units also have a manual feature that allows you to set the main flash for full power (or less), while dialing down the second flash to a lower power level. I recommend the second option if you're forced to use electronic flash without a modeling light. It's relatively easy to place both units at equal distances from your subject, bounce them off similar diffusing surfaces, and simply have one flash fire at half power to give you an easy 2:1 ratio. The automated balanced flash routine may be too difficult to remember how to implement unless it's a regularly-used part of your repertoire.

◆ **Use a tape measure.** If you're mathematically inclined, you can take a tape measure and determine the actual distance between each flash and subject, and divide that value into the guide number of your flash. (Your flash's manual will tell you what the guide number is for a particular flash at a given ISO setting.) Remember to compensate for light lost to any diffusers or bouncing surfaces involved. For example, if your main light has a guide number (GN) of 55 at the ISO you are using, at a distance of five feet, the exposure will call for an aperture of about f/11. For a fill flash of similar power located six feet from your subject, the correct aperture would be f/9. Set the flash to half power, and you'd end up with a recommended exposure for the fill light of f/6.3—giving you a perfect 3:1 ratio. This method is a bit more work, but you can learn to make your calculations quickly as you gain experience.

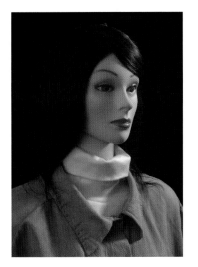

Figure 5.4 A 2:1 lighting ratio.

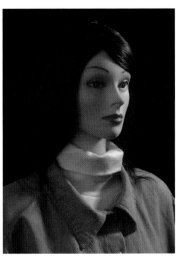

Figure 5.5 A 3:1 lighting ratio.

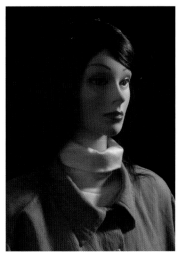

Figure 5.6 A 4:1 lighting ratio.

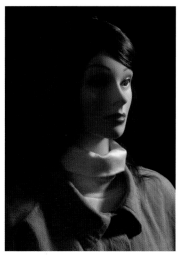

Figure 5.7 A 5:1 lighting ratio.

HOW IT'S LIT

For the images illustrating lighting ratios, I placed a main light to the right of the subject, and slightly behind her, with a fill light next to the camera. The fill was adjusted in brightness to produce the different ratios. This setup is called *short lighting*, and will be explained in Chapter 6.

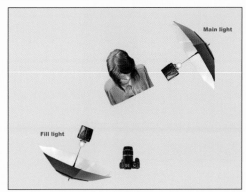

Figure 5.8
The same setup was used for all four lighting ratio illustrations.

Using a Main Light

The best portrait lighting often involves at least two, and sometimes three or more light sources, all set up using the techniques I outline for you in Chapter 6. The main, or key, light that sets the stage for all the other light sources used in these setups is, amazingly enough, called the *main* or *key* light. You'll find the terms used interchangeably, but I'm going to stick to "main" light for most of this book, to help you remember that it is, indeed, the main light you need to be concerned with.

The main light is the primary light source used to illuminate a portrait. It may, in fact, be the only light you use, or you may augment it with other light sources. The main light is most often placed in front of the subject and on one side of the camera or the other, as shown in Figures 5.9 and 5.10. It's not usually placed exactly at the camera position, as this would create very flat lighting, unless the main light is

raised up relatively high overhead to produce certain kinds of *glamour* lighting, explained in the next chapter.

Placed to the side, at a 90-degree angle from the camera's axis, the main light becomes a sidelight that illuminates one side or the profile of a subject who is facing the light. Placed behind

the subject, the main light can produce a silhouette effect if no other lights are used, or a backlit effect if additional lighting is used to illuminate the subject from the front. I'll show you how to create lighting effects using the main light in Chapter 6.

Usually the main light is positioned at roughly a 45-degree

angle from the axis of the camera and subject. The main light should be placed a little higher than the subject's head—the exact elevation determined by the type of lighting setup you're using. Some kinds of lighting setups do call for the main light to be placed relatively high, above the subject's eye-level, or lower at eye-level. You usually won't put a

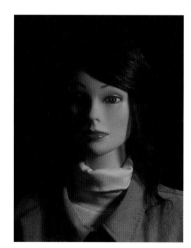
Figure 5.9 The main, or key, light provides the primary illumination for a lighting setup.

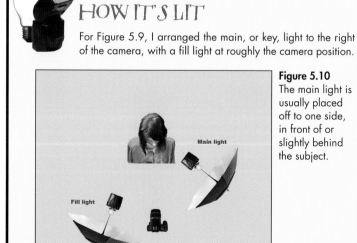
HOW IT'S LIT

For Figure 5.9, I arranged the main, or key, light to the right of the camera, with a fill light at roughly the camera position.

Figure 5.10 The main light is usually placed off to one side, in front of or slightly behind the subject.

Main light

Fill light

main light *lower* than that, unless you're looking for a monster/crypt-keeper effect.

One thing to watch out for is the presence or absence of catch lights in the subject's eyes. You want one catch light in each eye, which gives the eye a slight sparkle. If you imagine the pupils of the eyes to be a clock face, you want the catch lights placed at either the 11 o'clock or 1 o'clock position. You might have to raise or lower the main light to get the catch light exactly right.

You most definitely do not want *two* catch lights (because you're using both main and fill lights) or no catch light at all. If you have two catch lights, the eyes will look extra sparkly, but strange. With no catch light, the eyes will have a dead look to them, as at left in Figure 5.11, where I retouched the catch lights out of the image, compared to the original version (at right) with the catch lights left alone. Sometimes you can retouch out an extra catch light, or add one with Photoshop, but the best practice is to place them correctly in the first place.

As you set up your main light and begin posing your subject, you'll want to keep these tips in mind.

◆ **Eyes have it.** The eyes are the most important component of any portrait, as they will always be the center of attention. They must be sharp and lively, even if you're going for a softer look in the rest of the portrait. Make sure your main light properly illuminates your subject's eyes.

◆ **Hands down.** Depending on how close you're shooting to your subject, you may need to illuminate/feature the hands or (worse) bare feet. So, remember that the edges of hands are more attractive than the backs or palms of hands. You can sometimes de-emphasize hands by using less main light on them. Of course, the bottoms of feet are downright ugly, but you can sometimes get away with side views if the feet are young enough and there are other things to look at in the photo.

◆ **Bare pates.** Bald heads are pretty cool these days, but if your subject is sensitive about a naked cranium, make sure the main light doesn't glare off that bare pate. As I'll show you in Chapter 6, you can elevate your victim's chin and lower your camera slightly.

◆ **Nose knows.** For long, large, or angular noses, try having your subject face directly into the camera, and arrange your main light so that huge shadows are not cast on their faces.

◆ **'Ear, 'ear.** To minimize prominent ears, try shooting your subject in profile, or use short lighting, discussed in Chapter 6, so the ear nearest the camera is in shadow.

◆ **Wrinkle me this.** If you want to minimize wrinkles or facial defects such as scars or a bad complexion, use softer, more diffuse lighting for your main light. Or take a

step backwards and photograph your subject from the waist up to reduce the relative size of the face; keep the main light at eye-level so it doesn't cast shadows; consider using a diffusing filter (or add diffusion later in your image editor).

◆ **Glasses passes.** If your subject is wearing glasses, be wary of reflections of the main light off the glass. Have him or her raise or lower his chin slightly, and make sure your main light is bouncing off the face at an angle, rather than straight on.

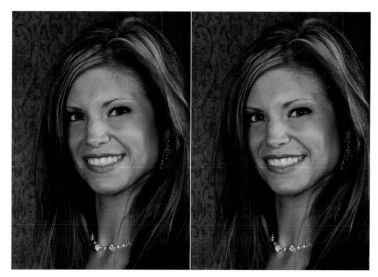

Figure 5.11 At left, the catch lights have been removed. The eyes look dull and lifeless. At right, with the catch lights restored, the eyes sparkle.

Fill Light

The fill light is usually the second-most powerful light used to illuminate a portrait. Fill light lightens the shadows cast by the main light, as you can see in Figure 5.12. Fill lights are usually positioned on the opposite side of the camera from the main light.

The relationship between the main light and fill light determines, in part, the contrast of a scene, as you learned in the section on calculating lighting ratios. If the main and fill are almost equal, the picture will be relatively low in contrast. If the main light is much more powerful than the fill light, the shadows will be somewhat darker and the image will have higher contrast. Fill lights are most often placed at the camera position so they will fill the shadows that the camera "sees" from the main light. Figure

5.13 shows a main light and fill light in a typical lighting setup. I'll show you the effects of using main and fill lights in the sections that follow.

As I noted, you normally place the fill light on the opposite side of the camera from the main light. The fill light usually needs to be a much lower power unit than the main light. If you use too

much fill, you'll lose the effect of the lighting style. The purpose of the fill light is to add just enough light to soften the shadows created by the main light.

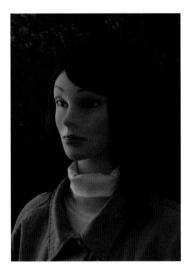

Figure 5.12 The fill light illuminates the shadows on the right side of the subject's face.

HOW IT'S LIT

For the Figure 5.12 example, the main light was located to the left and behind the subject (in the traditional short lighting setup I'll show you in Chapter 6), while the fill light is a less intense light placed to the right of the camera.

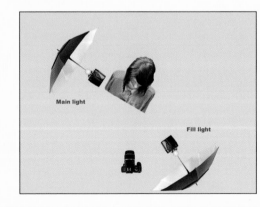

Figure 5.13 The main light and fill light in this example use the traditional short lighting setup.

The fill light is used to control contrast. By increasing the power of the fill, you reduce the contrast in the photo. By decreasing the amount of light from the fill, you will increase contrast. When setting the distance of your fill light, watch how noticeable the shadow from the main light is. This will be your guide to how noticeable it will be in the final image. The fill light will almost always add a second lower pair of catch lights. This is usually objectionable because it gives the impression that the subject has a directionless stare. This second pair of catch lights should be retouched from the final photo. Also watch for reflections if your subject wears glasses. You may have to reposition the fill light slightly to eliminate eyeglass reflections, as described in the previous section, or ask your subject to tilt his head up or down slightly until the reflections disappear.

LIGHT INTENSITIES AND COLOR TEMPERATURE

"Dirty little secrets" are unfortunate things that should be more widely known than they actually are. That term is usually a gimmick to get you to read a Top Ten Problems list. For electronic flash units that incorporate modeling lamps and which have variable light outputs, the "secret" is that as you dial down the intensity of the light, it's quite common for the color temperature to change. In truth, this is not really being kept a secret. It's just that the flash unit manufacturers aren't listing this tendency in their feature list, and most photographers purchasing these lights aren't doing quite enough research. But the effects are important, nevertheless. If you reduce the output of many "studio" type flashes, the color temperature of the flash changes, too—sometimes significantly. That can lead to mixed lighting effects that you *don't* want to contend with in Photoshop.

Not all studio flash units have shifting color temperatures. It's possible to design electronic flash units that have a constant color temperature, but it is more expensive. For dedicated non-studio flash units, the camera vendor often includes a provision that allows the flash to tell the camera what the true color temperature is for any given burst, because the amount of light these units emit will vary for just about any exposure. With studio flash, it's a different story. The worst color shifts come when you dial down the flash to its lowest power levels, while keeping other units in the same setup at full power. There's not a lot you can do that's easy to implement. (Who wants to put color filters on their flashes?) What I do is purchase studio flash units with a couple different power ratings, and use the ones that are most appropriate for a setup, reducing the need to cut intensity with a switch. You've been warned.

Other Lights

Once you get beyond the main and fill light, the other lights in a setup, often called *accent lights*, may be optional. Certain subjects and compositions may call for them; others may not. This section will introduce you to the most popular auxiliary light sources, including the *background light* and *hair light*.

Background Light

A light illuminating the background is another common light source used in portraits. Background lights are low power lights that provide depth or separation in your image, as shown in Figures 5.14 and 5.15. Place the background light low on a short light stand about halfway between your subject and the background, so that the subject hides the actual light from view. This light can also provide interesting lighting effects on the background when used with colored gels or cookies. You can even turn the background light towards

the back of the subject, producing a halo or backlight effect.

Background lights can be used to illuminate the background, gaining more depth or separation in your image. This light is usually placed low to the ground on a small stand about halfway

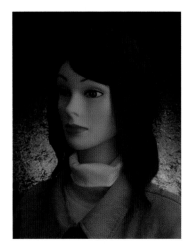

Figure 5.14 I've exaggerated the amount of background light used to illustrate how such illumination can provide separation between the subject and her surroundings.

between your subject and the background. A low-power light is generally used. You can dramatically change the look of the shot by adding a gel to background light. Just remember when using gels you have to use a stronger light to compensate for the illumination being lost through the gel.

Hair Light

A hair light is usually a small light directed at the hair of the subject to provide an attractive highlight. Often, a snoot or barndoor is used to keep the hair light from spilling down on the subject's face. A hair light must be controlled carefully so it doesn't form an overexposed

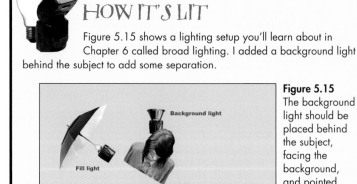

HOW IT'S LIT

Figure 5.15 shows a lighting setup you'll learn about in Chapter 6 called broad lighting. I added a background light behind the subject to add some separation.

Figure 5.15 The background light should be placed behind the subject, facing the background, and pointed upwards.

hot spot on the subject's head. A low-power light like the background light, the hair light also provides separation from the background, which can be very important if your subject has dark hair and is posed against a dark background. Place the hair light in a high position shining down on the subject's head, then move it forward until the light spills over slightly onto the subject's face. At that point, tilt the light back again until it is no longer illuminating the subject's face.

If you get daring enough to use a hair light, cones and snoots will allow you to control the light so

that it only illuminates the hair and doesn't spill onto the shoulders and face of your subject.

For Figure 5.16, I used no hair light (at right), which caused the subject's head to blend into the background, as only a single main light (placed at left) was used to illuminate the photo. At right in the figure, I positioned a hair light high up and behind the subject, brushing a little light across the back of her head, with some spilling over onto the background to illuminate it and add even more separation. Figure 5.17 shows the lighting setup.

Reflectors

Even if you're using electronic flash or incandescent lights, you can still benefit from an inexpensive standby light source: reflectors. You've got your main and fill lights in place, have illuminated the background, and accented your subject's pate with a hair light. Then you look at the scene and still find areas that are too

dark. That's where reflectors come in. A simple card can be inserted somewhere out of frame to bounce a little light into a murky area. Some of these have a gold and silver side, so you can choose between neutral light or a golden glow. Check Chapter 3, and Figure 3.12 for more about reflectors.

HOW IT'S LIT

For the images illustrating lighting ratios, I placed a main light to the right of the subject, and slightly behind her, with a fill light next to the camera. The fill was adjusted in brightness to produce the different ratios. This setup is called *short lighting*, and will be explained in Chapter 6.

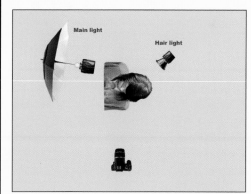

Figure 5.17 The hair light is normally placed on the same side of the subject as the main light, but I wanted to accentuate the back of the head, so I moved it to the opposite side and raked the light across the crown of her head.

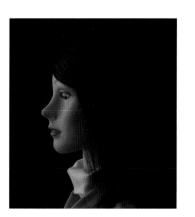 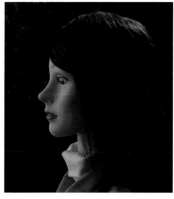

Figure 5.16 With no hair light (at left), the subject blends into the background in this single-light portrait. A hair light (right) separates the head, and illuminates the background, too.

Umbrellas

You'll find mention of soft boxes and umbrellas throughout this book. They are my favorite light sources for a variety of subjects, both in the studio and on location. I worked extensively with umbrellas for many years, even when I was traveling around the country as a photojournalist. My handheld umbrella/flash technique for impromptu indoor portraits is legendary among friends and colleagues who wish I'd shut up about it.

As you've learned, direct flash is rarely useful, because it's too harsh, too direct, and too difficult to control. Umbrellas are an essential tool to let you shape the light so it has the qualities you need, while directing it into areas of the scene that need it. Photo umbrellas (like the one shown in Figure 5.18) are just that: large fold-out reflectors just like those you use to shield your form from the rain or sun, but with some

specialized qualities that make them especially suitable for photography. The advantage of umbrellas are many:

◆ **Cheap.** You can buy a 40-inch umbrella specifically designed for photography for $20 or less. I sometimes use actual white Totes rain umbrellas, which are even smaller when I'm in photojournalism mode. But true photo umbrellas are better for studio or location photography.

◆ **Transportable.** Umbrellas fold down to umbrella size, and can be stashed in a duffle. I don't even bother putting them in a protective case. A few smudges on an umbrella won't affect their reflective powers, and when one becomes too soiled, I just buy a new one.

◆ **Flexible.** You can move the light source closer to the umbrella's center, or farther away to change the size and diffusion of the light. Turn the umbrella around and shoot through it, if it's of the translucent variety.

◆ **Easy to set up.** Open the umbrella. That's it. I have owned soft boxes that put your life in danger when you attempted to flex their support rods to insert them carefully into the mounting holes in the speed ring that attached to the electronic flash. One was so vexing that I never dismantled it, and

carried it around, fully assembled, in the back of my vehicle. Another photographer saw me swearing at it during a fashion shoot and graciously offered to take it off my hands for a few dollars. Give me an umbrella, or one of the new soft boxes I've purchased, any day.

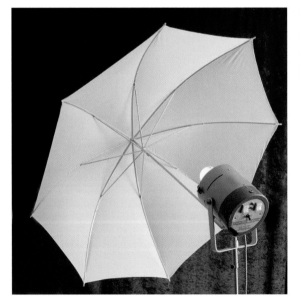

Figure 5.18
Umbrellas can be attached to electronic flash or incandescent lighting fixtures.

◆ **Aimable.** As you become skilled in the use of umbrellas, you'll find it easy to feather or aim the light, so it provides a soft light exactly where you want it to go. Feathering an umbrella is easiest if you have one of the pro models with a white or silver reflective inside surface, and a removable black outer cover that keeps light from escaping out the back of the umbrella. Thanks to your modeling light, you can see exactly where the edge of the umbrella's illumination stops, and, if desired, control the amount of spill on your subject.

The key attributes to be aware of when purchasing an umbrella are:

◆ **Size.** The larger the umbrella, the larger the area the light from your flash is spread over. That means softer light, but also the potential for reduced illumination—particularly if your umbrella is of the translucent variety. You can find umbrellas as small as 30 inches, but the 40-inch variety is among the most popular. If you want a very broad, diffuse light source, look for 50- and 60-inch umbrellas.

◆ **Translucency.** A significant amount of light can go right through a white umbrella, rather than reflect back at your subject. In addition, the light that keeps on going will eventually bounce off something and back towards your subject. You might not want that uncontrolled ambient light. There are white umbrellas with black outside surfaces that absorb the light that doesn't reflect back. The black outer cover may be removable so you can take it off when you do want the light to bounce around behind the umbrella, or when you want to turn the umbrella around and make an exposure using the even softer light that goes *through* the fabric onto your subject.

◆ **Contrast.** You can vary the quality of the light reaching your subject by choosing your umbrella's fabric carefully. A soft white umbrella provides the most diffuse illumination (see Figure 5.19). A silver inside surface will produce more contrast and sharper highlights in your images. Various silver surfaces are available, ranging from diffuse silver to very shiny.

◆ **Color.** Umbrellas are available in various colors, too. Gold umbrellas are prized for the warm skin tones they produce. Shiny blue-toned umbrellas are also available for a colder look. Once you become deeply involved with studio work, you'll probably want at least a few umbrellas in different sizes, textures, and colors.

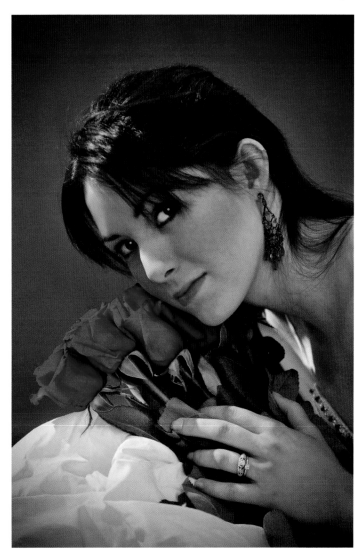

Figure 5.19 A photographic umbrella provides a soft, even light.

Soft Boxes

Although I still use umbrellas, today, I find that soft boxes have more flexibility, and I own several of them, ranging from a small 24 × 36-inch unit, through a jumbo 30 × 60-inch box that's taller than some of the kids I photograph. This section will tell you everything you need to know about soft boxes.

Soft boxes are large square or rectangular devices that may resemble a square or rectangular umbrella with a front cover, and produce a similar lighting effect. (Soft boxes are also available in octagonal and other configurations.) They can extend from a few feet square to massive boxes that stand five or six feet tall—virtually a wall of light, as you can see in Figure 5.20, which shows one of my Paul C. Buff soft boxes from Alien Bees. With a flash unit or two inside a soft box, you have a very large, semi-directional light source that's very diffuse and very flattering for portraiture and other people photography.

Soft boxes are also handy for photographing shiny objects. They not only provide a soft light,

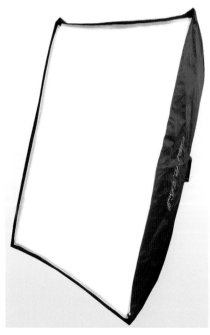

but if the box itself happens to reflect in the subject (say you're photographing a chromium toaster), the box will provide an interesting highlight that's indistinct and not distracting. You can buy soft boxes or make your own. Some lengths of friction-fit plastic pipe and a lot of muslin

Figure 5.20
Soft boxes are just that—large boxes that provide diffuse illumination.

cut and sewed just so may be all that you need.

Here are the key components of a soft box setup:

◆ **Soft box.** The soft box itself will be a rugged foldable fabric box that opens up into a square, rectangular, or other shaped box. The interior of the fabric will be a crinkled aluminum textured material that reflects all the light from your electronic flash around in the soft box, so it can escape only through the front of the box. The exterior of the fabric will be black matte to absorb light, so that it doesn't become a reflector itself. The box may have Velcro fasteners to help button it up tight, and perhaps flaps with Velcro closures, so you can open up peep holes in the side of the box to insert various light sources, or to allow heat to escape when using incandescent lights.

◆ **Support rods.** These stiffen the soft box and provide its shape, and fasten to the speed ring. You can see an interior view of a soft box in Figure 5.21.

Reflective interior fabric Supporting rods Speed ring Inner diffusing panel (peeled back)

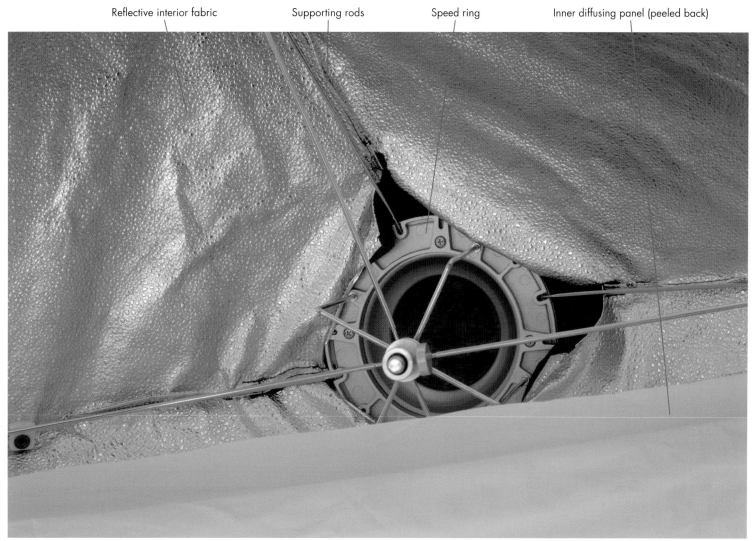

Figure 5.21 An interior view of a soft box.

◆ **Speed ring.** This is at the back end of the box and connects with the box's support rods, while connecting to the flash unit itself. Each speed ring will be designed specifically for the flash it mates to, which is why it's usually a good idea to buy the ring from the vendor of your flash. Personally, I prefer *foldable soft boxes*, like those from Alien Bees (www.alienbees.com), which have the support rods permanently attached to both the box and speed ring. You open the soft box like an umbrella, and secure the support rods to the speed ring using a thumbscrew.

◆ **Inside diffuser.** A translucent diffusing cloth will fasten inside the soft box, about halfway between the light source and the front of the box, using snaps or Velcro. Use this inside diffuser when you want the maximum amount of softness from your light. Remove it when you want a slightly harder light source.

◆ **Front diffuser.** This translucent cloth fits over the front of the soft box to provide the main diffusion. It usually fastens using Velcro strips on the cloth that mate with the opposite Velcro strips on the outer edges of the soft box.

◆ **Light modifiers.** Optional light modifiers are available that fasten to the outer edge of the front of the soft box, in front of the main diffuser panel. These include:

 ◆ **Grids.** These are black egg-crate modules that look just like grids, and which provide a slightly more directional light for the soft box.

◆ **Round modifiers.** These are black panels with a round opening that reduce the size of a square soft box while converting it to a rounded configuration. If you don't like square catch lights, this accessory produces the round catch lights like those created by umbrellas—with the advantage that, unlike umbrellas, the flat edges and ribs of the umbrella don't show in your subject's eyes.

◆ **Size reducers.** Is your soft box too large? Get one of these modifiers, which are black panels with a square or rectangular opening—just like your original soft box—but with a smaller aperture. They effectively convert your larger soft box into a smaller one.

Strip Lights

Strip lights are a special type of soft box. Unlike square or most rectangular soft boxes, strip lights are much taller than they are wide, effectively serving as a long, narrow soft box. (See Figure 5.22 for a look at my Alien Bees strip box.) After you've been using conventional soft boxes for awhile and become adept in their use, you'll find yourself wishing for something slightly different, something with the characteristics of a strip box.

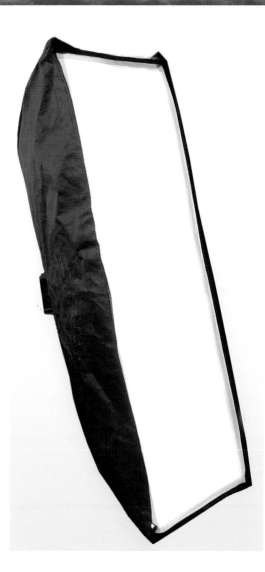

Figure 5.22
A strip box is a versatile alternative to a conventional soft box.

Here's why you've been yearning for this tool:

◆ **Soft boxes are hard to aim.** Whether you're using a square, round, or moderately rectangular soft box, you end up with a wraparound light that has soft edges. This illuminates your subjects with diffuse light, but it goes *everywhere* it's pointed. A strip light also creates soft light, but the illumination is in a thin strip that you can manipulate to light up only the portions of your subject that you want. For example, you can illuminate a portrait subject's face or figure with minimal spill onto your background. (More on portrait lighting in Chapter 6.)

◆ **Strip lights produce a more even lighting effect.** Although known for their—relatively—even light output, a conventional soft box, even with both diffusers mounted, still gives you a beam of light that's brighter in the center, and less bright at the edges. A baffle can be used to even out the light, but that cuts down the amount of light available from the box. A strip box gives you a long, narrow strip of light that's even and can be aimed where you want it.

◆ **Easier to transport.** I have a 36 × 36-inch soft box. I also own a 10 × 36-inch strip box. Guess which one is easier to fold up, transport, set up, and manipulate? If you absolutely don't need a huge, wraparound soft box, a strip light can be a useful alternative that gives you some creative options with its "aimability," too.

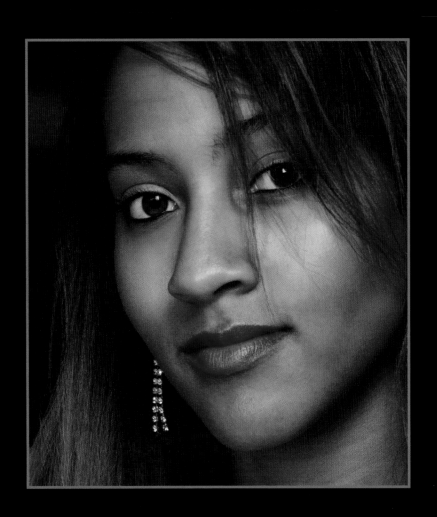

Portrait Lighting Techniques

Don't be misled by the title of this chapter. I could easily have called it "Lighting Techniques." Virtually everything you'll learn here can be applied to every other type of photography that you'll do in which you have some control of the lighting (indoors or out), and are close enough to your subject(s) to apply the tips I provide on positioning and modulating the lights.

The techniques in this chapter apply equally well to product photography, close-up tabletop photography, or photos of your pets. I titled the chapter "Portrait Lighting Techniques" in part because all the illustrations are of portrait subjects. The simple reason for that is by using the same type of subject for every example, you can clearly see how different techniques change the way the subject looks. Certainly, you can light a locomotive the same way you light a portrait, but when learning different kinds of lighting, you'll find it easier to visualize effects using that most common of subjects—human beings.

Of course, the title I did choose is a little broader than the content of this chapter, too, but "Techniques for Lighting Single (Not Group) Portrait Subjects with One or More Illumination Sources" may be accurate, but it's unwieldy. So I'm going to go with the title I settled on in this introduction to working with lights to illuminate your subject.

I'm going to provide lighting diagrams of the "How It's Lit" variety for every lighting setup in this chapter. I'm going to keep things simple and concentrate on the position of the main and fill lights. I'm concentrating on the lighting placement, not their intensity for the most part. If you want more information on lighting ratios, or how to add background and hair lights, or other accent lights, use the recommendations I provided in Chapter 5. I'm also going to provide real-world example shots using models that I've worked with.

Lighting Setup Basics

I explained about using one or more light sources as main (or key), fill, hair, or background lights in Chapter 5. Those sources are your basic tools for creating a lighting setup. In this chapter, I'm going to show you how to arrange lights (or, alternatively, reflectors that substitute for an actual light source) to create those setups. But, before I describe specific setup techniques, there are a few basics to get out of the way.

From a lighting and compositional standpoint, you need to be aware that portraits can be categorized by the view of the subject that you want to capture. The more you show of your subject(s), the more complicated the lighting potentially becomes. The "hierarchy" of subject matter looks something like this:

◆ **Groups (large and small).** When shooting more than one person, you have less control over the lighting of each individual. Indeed, your main concern may be simply to provide an overall even lighting

effect that doesn't cast shadows on anyone's face. You may picture some groups in full-length gang portraits (think glee club photos for the yearbook), or narrow your coverage down to a head and shoulders photo of fewer than half a dozen members of a wedding party. I'm not going to address lighting groups in this chapter, as the topic is beyond the scope of this introductory lighting book.

◆ **Full-length individual portrait.** A full-length photo, from head to toe, is an absolute necessity for, say, a model's portfolio or for portraits in which the subject's costume or clothing is an important part of the picture. You'll need to arrange flattering lighting for the individual's face, as described later in this chapter, while making sure that the outfit is well-lit, too. The background setting becomes especially important in a full-length portrait, because so much of it is visible, and you'll have to light that, too (but in such a way that it doesn't become the focus of attention). Of course, a full-length portrait needn't be taken with your subject standing up, as you can see in Figure 6.1.

◆ **Three-quarters portraits.** More intimate than a full-length portrait, the three-quarters view pictures your subject from head down to just above the knees. This type of portrait allows you to concentrate on lighting the individual's face. Often, the clothing from the shoulders down is given less

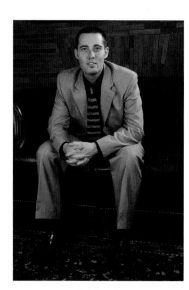

Figure 6.1 A "full-length" portrait can be taken with your subject in a seated position.

illumination, and takes on a more subordinate role in the image. Cropping a little more tightly to present your subject just from the waist up tends to be less interesting, and the person may appear to be cut in half. If you want a tighter composition than the three-quarters portrait, go directly to the head-and-shoulders portrait, described next.

◆ **Head-and-shoulders.** This is the most common portrait framing (see Figure 6.2). It allows you to concentrate lighting on the face, but enough of the subject's clothing appears in the shot to allow the outfit to contribute to the overall character of the image (formal, casual, festive, and so forth).

◆ **Face close-ups.** Regardless of the framing of the image, in a portrait, the focus is almost always on the face. Most of the references you'll find on portrait lighting concentrate on lighting the human face itself (the "mask"), plus neck, hair, and any accessories such as earrings or necklaces. That's because the face is the most important aspect of any portrait. In this chapter, I'm going to deal primarily with lighting the face for close-ups or head-and-shoulders portraits.

Lighting techniques are called by various names. You may see references to "loop lighting," which, in its various forms, encompasses several lighting techniques, such as the "short lighting" and "broad lighting" techniques described in the sections that follow. With loop lighting, the intent is to create a shadow from the nose that points down towards the corner of the mouth, without actually touching the corner of the mouth. This shadow may be more or less distinct, depending on the hardness or softness of the light.

Other lighting effects may be called "side lighting," "profile lighting," or "rim lighting." The names used aren't as important as what each kind of light does. The actual results you'll get depend on the position of the subject, the position of the camera, and the position of the lights themselves. You'll find that these three are all related, in the following ways:

◆ **Position of the subject.** The subject will be in front of the camera, of course, but will either have his or her face pointed directly at the lens or, as is most common and usually preferable, be pointing his/her nose to one side of the camera or the other. This angling of the face can be slight; the subject can be turned 90 degrees from the camera and photographed in profile, or have his/her back to the camera and be looking away, seen in profile, or looking over the shoulder at the camera.

◆ **Position of the camera.** The camera is most often placed at eye level to the subject, but there are some compositions and facial types that work better with the camera raised slightly. (It should go without saying that subjects with bald or thinning hair probably won't look their best with the camera elevated. The camera can also be lowered below eye level in special cases, but this perspective usually doesn't work, because a low angle emphasizes the underside of the chin and the subject's nostrils. Of course, if the subject isn't seated staidly on a stool, and is assuming a more casual pose (reclining, for example), all bets are off on the camera position.

◆ **Position of the lights.** For most lighting setups, the lights are positioned at subject level or higher, in an imaginary ring around the subject that includes the camera, both sides, and back. Lights positioned much lower than eye level result in "monster" lighting that is used only for special or dramatic effects.

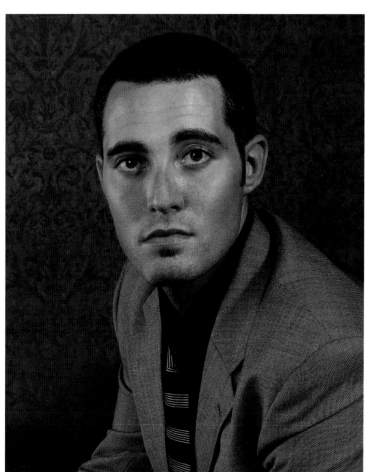

Figure 6.2 The head-and-shoulders shot is the most common portrait framing.

Split Lighting

Split lighting is a technique that emphasizes just one side of the face. With split lighting, the subject is, more or less, facing the camera with the main light placed 90 degrees to one side of the lens axis. You can use only a single light, or you can add a reflector or fill light to partially illuminate the shadows. The main (or only) light source can be soft and diffuse, or hard; each mode provides different effects.

You can achieve dramatic split lighting simply by lighting half the subject's face, from either side, leaving the other half in complete or near-complete shadow, as shown in Figure 6.3. You can use the technique for "half-face" effects like the Fab Four on the much copied/parodied cover of *Meet the Beatles/With the Beatles*. It also works very well with subjects who are wearing a hat. The drama comes from the shadows cast on the illuminated side of the face, which emphasize the texture of the subject's features.

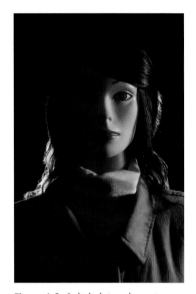

Figure 6.3 Split lighting shows just one side of the face, which can be useful even if your subject is not the Hunchback of Notre Dame.

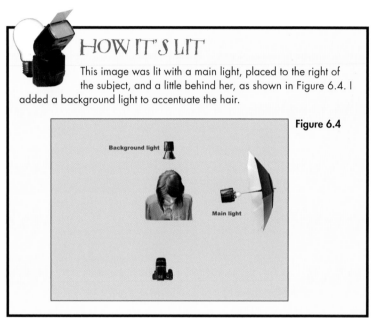

HOW IT'S LIT

This image was lit with a main light, placed to the right of the subject, and a little behind her, as shown in Figure 6.4. I added a background light to accentuate the hair.

Figure 6.4

If your subject has a less-than-perfect complexion, you'll want to use soft lighting, with your source bounced off an umbrella or through a soft box. The side of the face that you choose to illuminate may not matter, or you may discover that your subject has a "better" side and you can hide real or imagined facial imperfections by featuring the opposite side.

Position your lights as follows:

◆ **Main light.** You may want to place the main light slightly behind the subject to minimize the amount of light that spills over onto the shadowed side. Note that a subject with long hair that covers the cheeks may have most of the face obscured or in shadow when side lit in this way. Either comb the hair back or go for a mysterious look.

◆ **Fill light.** The amount of fill light determines how dramatic this effect is. Use none at all to create a stark look, or gradually increase the amount of fill to soften the effect. You can use a reflector to bounce a little illumination from the main light into the shadows, or, if you have lights with adjustable output, crank them down to a very low level. Use none at all to create a stark look, or gradually increase the amount of fill to soften the effect, as was done for Figure 6.5.

◆ **Background light.** Skip the background light altogether for the most stark, dramatic look. Or, point this light directly onto a plain background. The image will have slightly less drama, but will still be more distinctive than a traditionally-lit portrait. For my example illustration, I turned the background light around and used it as a backlight to create an interesting effect.

◆ **Hair light.** If you eschew a background light entirely, you might want to use a hair light to provide some separation between your subject and the background, especially with a dark-haired individual whose head will otherwise blend in with the surroundings. The hair light should always be on the same side as the main light, but placed closer to the background and feathered so it just brushes over the hair, with no light spilling onto the face to spoil the main light's effects.

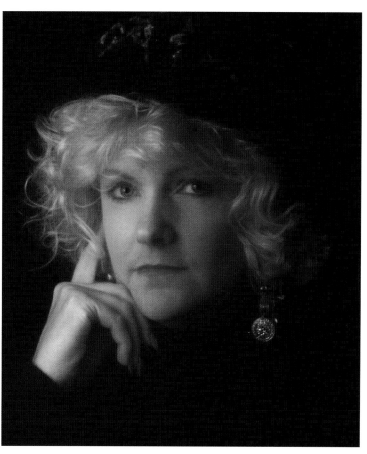

Figure 6.5 Some gentle fill light will soften the effects of split lighting.

Side/Profile Lighting

Profile lighting is another dramatic lighting technique that is very similar to split lighting when it comes to implementation: A single light is placed off to the right or left. However, the subject is photographed looking directly into that light, so that the edge of the face receives the most light, while the side facing the camera is in partial or complete shadow, as shown in Figure 6.6. As with split lighting, you can achieve this effect using only a single light, or you can add a reflector or fill light to brighten the shadows. The main light can be hard when you want to emphasize the facial texture (usually when photographing men or older adults who are proud/comfortable with their character lines), or use softer lighting for a more flattering or romantic look.

Choose your subjects for profile lighting carefully. Someone with a huge nose may not want to call attention to that feature, although for some, the "schnozz" can famously become a trademark.

Usually, the side of the face selected won't matter, but some folks do have a better side that you can choose to highlight instead of the other. Ask the subject to turn very slightly towards the camera, which will allow more of the pupil to show. Position your lights as follows:

♦ **Main light.** Although the main light will always be approximately at eye level or slightly higher, off to one side, where you position this source can change the look of the image dramatically. With the light at a 90-degree angle from the camera axis, there will be lots of light spilling over onto the side of the face closest to the lens, producing a less distinctive portrait that has less emphasis on the texture of the subject's face. It's more common to position the main light at a 45-degree angle from the side of the face that's farthest from the camera. The effect changes from strict side lighting to a rim or almost backlit effect, putting more of the near side of the face in shadow. One thing you usually want to avoid is having some light

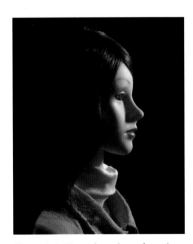

Figure 6.6 Have the subject face the main light, which is placed to one side, to achieve profile lighting.

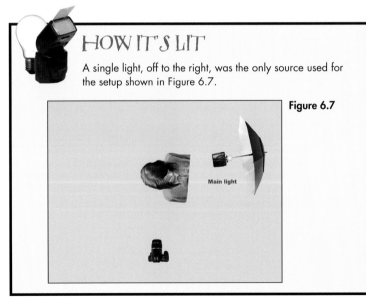

HOW IT'S LIT

A single light, off to the right, was the only source used for the setup shown in Figure 6.7.

Figure 6.7

Main light

spill onto your subject's ears, making them pop out of the shadows. If your subject has long hair, the ears can be tucked behind a strand or two.

◆ **Fill light.** Depending on where you place the main light, fill may be needed to illuminate the shadows. No fill, coupled with a direct/harsh light source creates a

stark look. More fill and a softer light generates a more romantic look. As with most lighting setups, you can use a reflector to fill in the shadows, or adjust the output of the source you are using as a fill light. For Figure 6.8, I positioned a reflector used as fill under the bride's chin to balance the main light coming from the upper right.

◆ **Background light.** As with split lighting, you can skip the background light entirely to create the most dramatic effect. This may be a good idea if you don't have an attractive background. I once shot a profile image with a kitchen sink in the background; it didn't receive any illumination, so the background was black and the sink invisible.

◆ **Hair light.** Unless the main light is elevated slightly, the top of the subject's head may have no illumination at all. A hair light, placed on the same side as the main light and slightly closer to the background, can separate the top of the head from the background. Watch to make sure the hair light doesn't spill over onto the shadow side of your profile.

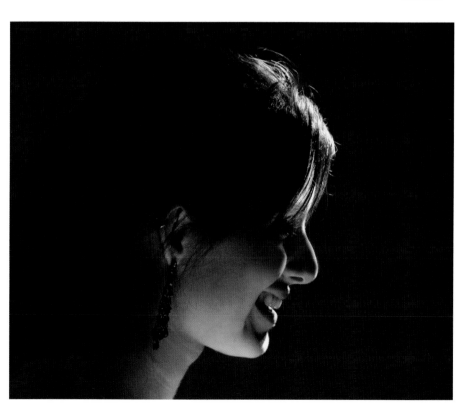

Figure 6.8
Profile lighting can be augmented with fill light in creative ways.

Backlighting

With a backlit photo, such as Figure 6.3, much of the illumination comes from behind the subject and doesn't really light the subject as much as it defines its edges. Use additional fill light to provide for detail in the subject's front. You can use the background light for backlighting, and put your main and fill lights to work in a subordinate role by reducing their intensity. Or, you can use the main light as the backlight, (place it below or above the camera's field of view), and fill in the shadows with your fill light.

45-Degree Lighting

Most portraits are taken with the subject's head turned slightly away from the camera. As you'll learn from later sections, that approach gives you the most flexibility in using creative lighting techniques, and in emphasizing or de-emphasizing your subject's facial features. But, there are situations in which your subject will end up looking directly towards the camera. Yearbook photos, head shots used on business cards or web pages, and other generic facial images are often taken full face. If that's your end product, you may find that a simple 45-degree lighting setup is your best bet.

Of course, there's no rule that says your subject has to face the camera, shoulders squared, as if for a mug shot, as in Figure 6.9. It's often a good idea to have the individual swivel his or her body at an angle to the camera, and then turn to look at the lens. Your 45-degree lighting can then be

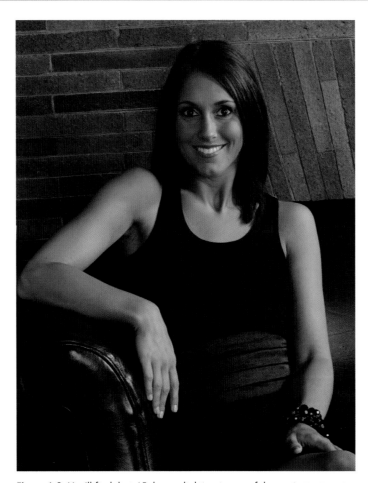

Figure 6.9 You'll find that 45-degree lighting is one of the easiest setups to work with.

applied to provide flattering illumination for the face, when compared to the flat lighting you'd get if the light were coming from the camera position. This technique is a good "beginner" arrangement that you can use before advancing to more sophisticated lighting setups described in this chapter. Position your lights as follows:

◆ **Main light.** This is a no brainer. Your subject is facing the camera, and the main light is placed at a 45-degree angle from the subject's nose, which will be the lens axis if the subject is looking directly at the camera, as shown in Figure 6.10. The main light should be placed slightly higher than eye level (remember, low lighting angles produce "monster" lighting). The lighting angle produces shadows on the face that provide shape and texture to the features. The effects you get should be satisfactory for most portraits; if you want to control the look and feel of these shadows, you'll use one of the more advanced setups described later. The important thing to remember is

that the 45-degree angle refers to the *subject's face*, not the camera. If the subject turns away from the camera, even slightly, then you'll have to move the light to maintain the 45-degree relationship.

◆ **Fill light.** As with the other lighting setups described so far, if you skip the fill light, the shadows will be relatively dark, and the image more dramatic. Usually, however, you'll want to brighten up the shadows with a fill light or reflector placed approximately at the

camera position, and on the opposite side of the camera from the main light. If you happen to be using a longer lens—longer than 105mm on a full-frame camera, or its 70-75mm equivalent on a camera with a sensor smaller than 24 × 36mm (i.e., *most* digital SLRs—place the fill light closer than the camera position to maintain the proper soft, diffuse quality you want from fill. Remember, the farther you move a light back, the harsher it becomes.

◆ **Background light.** It's often a good idea to have a background light to provide separation between your subject and the background. Most often, this light is placed low and behind the subject, pointing towards the background to provide a circle of light that fades off towards the corners. That gives you an automatic vignetting effect that draws attention to the subject's face. In Figure 6.12, I used a background light to brighten the area behind the model, to add some atmosphere to this location—not studio—shot.

◆ **Hair light.** If you want to use a hair light, it should be positioned behind the subject at about 90 degrees from the main light (which would put it at a 45-degree angle from the back of the subject's head). The hair light should be quite a bit higher than the main light, and angled down so it illuminates the back of the head without spilling over onto the face.

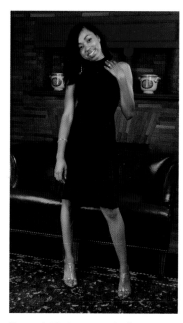

Figure 6.12 Augment 45-degree lighting with some subtle background lighting to create separation between the subject and her surroundings.

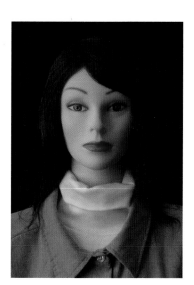

Figure 6.10 Just place the main light at a 45-degree angle to the subject's nose.

HOW IT'S LIT

As you can see in Figure 6.11, 45-degree lighting involves nothing more than placing main light at a 45-degree angle from the direction the model is looking. Use a fill light, if you like, to brighten shadows, and add hair or background lights using my recommendations in Chapter 5.

Figure 6.11

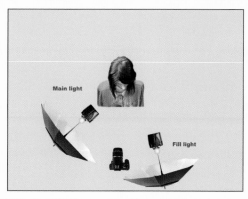

Main light

Fill light

Short Lighting

Short lighting and broad lighting (discussed next) are more advanced versions of the 45-degree lighting discussed in the last section. Together, they are sometimes referred to as "three-quarter lighting," because in both cases the face is turned to one side so that three-quarters of the face is turned toward the camera, and one-quarter of the face is turned away from the camera.

Short lighting, also called narrow lighting, is produced when the main light illuminates the side of the face turned away from the camera. You'll find that most people prefer short lighting for their portraits, as it is the most flattering style for everyone except those who have very thin faces. You can see in Figure 6.13 that the face of my "model" appears thinner than it does in both Figures 6.10 (a head-on shot) and Figure 6.16 (which uses broad lighting).

It's easy to set up short lighting, as you can see in Figure 6.14. With the subject facing 45 degrees away from the camera axis, place the main light behind the subject at a 90-degree angle from that (or a 135-degree angle from the camera axis), and

slightly above eye level, and have the subject angle his or her head so it is turned slightly towards the light. The side farthest from the camera will be fully illuminated, and the side closest to the camera will be in full or

partial shadow (depending on how much fill you use).

This technique is used with men, women, and children, and is excellent for highlighting those with average oval-shaped faces, or those with broader faces.

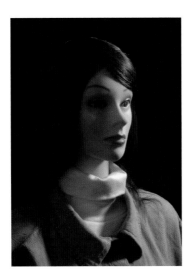

Figure 6.13 Short lighting has the effect of making a face appear narrower.

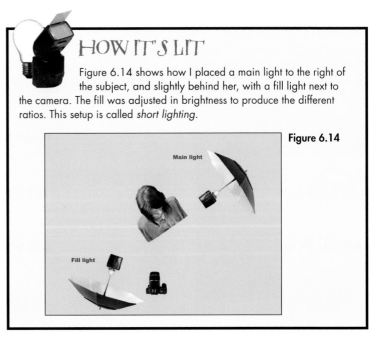

HOW IT'S LIT

Figure 6.14 shows how I placed a main light to the right of the subject, and slightly behind her, with a fill light next to the camera. The fill was adjusted in brightness to produce the different ratios. This setup is called *short lighting*.

Figure 6.14

Main light

Fill light

Because three-quarters of the face is in some degree of shadow and only the "short" portion is illuminated, this type of lighting tends to emphasize facial contours and narrow faces that are too wide—especially compared to shots in which a round-faced subject is looking directly into the camera. Short lighting tends to make faces look narrower because the "fat" side of the face is shadowed. Although I wanted a full face shot of the model in Figure 6.15, I had her turn her head slightly to my right so I could use a modified short lighting to make her face seem just a tad narrower.

To further slim round faces, elevate the camera slightly, which de-emphasizes the chin and lower portion of the face, where plumpness is most obvious. (Use caution when raising the camera with subjects who have bald heads or thinning hair.)

◆ **Main light.** Place the main light 135 degrees from the camera axis, with your subject facing about 45 degrees from the camera. Use a harder light to emphasize texture

with male subjects, and a softer light to flatter teenagers and female subjects. The main light should be placed slightly higher than eye level.

◆ **Fill light.** The fill light illuminates the shadows. Because the goal of short lighting is to de-emphasize the side of the face closest to the camera, use less fill light for most teen and female subjects, and even less with men.

◆ **Background light.** If you're using short lighting to de-emphasize the shape of a wide face, keep the background lighting somewhat subdued. Indeed, the background and shadow side of the face should be of similar tone so they will blend together. The illuminated portion of the face will automatically have separation from a darker background, but it's okay to brighten this portion of the background to reduce that contrast if you want.

◆ **Hair light.** If you want to use a hair light, it should be positioned behind the subject at about 90 degrees from the main light. The hair light should be quite a bit higher than the main light, and angled down so it illuminates the back of the head without spilling over onto the face.

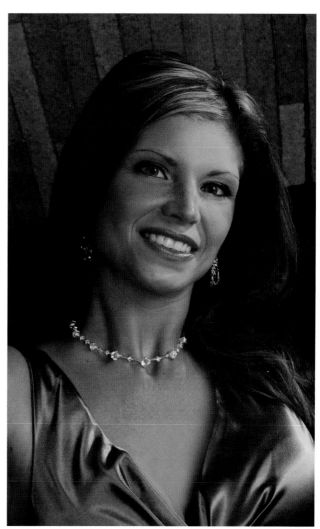

Figure 6.15 Turn the subject's head slightly to one side and illuminate that side to add a bit of the short lighting effect to a full-face portrait.

Broad Lighting

In many ways, broad lighting, the other three-quarter lighting technique, is the opposite of short lighting. The main light illuminates the side of the face turned toward the camera. Because most of the face is flooded with soft light (assuming you're using an umbrella or other diffuse light source, as you should), it de-emphasizes facial textures (teenagers may love this effect) and widens narrow or thin faces.

Broad lighting illuminates the larger portion of the face visible to the camera, as you can see in Figure 6.16. The area of the face that is highlighted is now larger than the area in shadow. Because of this, the face looks slightly larger and fatter, which those with thin faces may prefer. However, broad lighting can be used by those with wider faces if they have long hair that covers the side of the face closest to the camera.

To set up broad lighting, simply place the lights the opposite of how you would for short lighting. The subject will turn 45 degrees from the camera axis, and the main light will be located at a 45-degree angle on the opposite side of the camera. Have your subject turn his or her head away from the main light, to expose more of the illuminated area to the lens. Don't have a short-haired subject turn too far from the main light, or the ear will be illuminated sharply against a darker background.

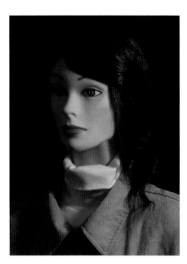

Figure 6.16 Broad lighting concentrates the main light on the side of the face closest to the camera.

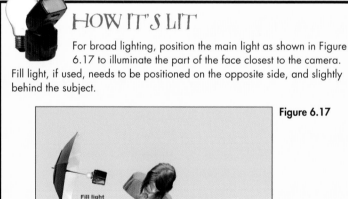

HOW IT'S LIT

For broad lighting, position the main light as shown in Figure 6.17 to illuminate the part of the face closest to the camera. Fill light, if used, needs to be positioned on the opposite side, and slightly behind the subject.

Figure 6.17

Fill light

Main light

Position your lights like this:

◆ **Main light.** Place the main light 45 degrees from the camera axis, with your subject facing about 45 degrees from the camera in the other direction. A softer light source is generally best, particularly for female subjects and teens. The main light should be placed slightly higher than eye level.

◆ **Fill light.** Use the fill light to illuminate the shadows on the side of the face away from the camera. Crank down the power of the fill light when shooting masculine subjects.

◆ **Background light.** Unlike short lighting, it's okay to have a slightly stronger background light, to differentiate the darker side of the face that's away from the camera, as in Figure 6.18. As with short lighting, the illuminated portion of the face will automatically have separation from a darker background, but it's okay to darken this portion of the background to increase that contrast if you want.

◆ **Hair light.** If you want to use a hair light, it should be positioned behind the subject at the side opposite the main light. As always, the hair light should be quite a bit higher than the main light, and angled down so it illuminates the back of the head without spilling over onto the face.

Figure 6.18 A small dose of background illumination can be helpful when using broad lighting.

Butterfly Lighting

Butterfly lighting, also called Paramount Lighting after the Hollywood studio that popularized the technique, was one of the original "glamour" lighting effects. The main light is placed directly in front of the face above eye level and casts a shadow underneath the nose. This is a great lighting technique to use for women, because it accentuates the eyes and eyelashes, and emphasizes any hollowness in the cheeks, sometimes giving your model attractive cheekbones where none exist. Butterfly lighting de-emphasizes lines around the eyes, any wrinkles in the forehead, and unflattering shadows around the mouth. Women love this technique, for obvious reasons. Butterfly lighting also tends to emphasize the ears, making it a bad choice for men and women whose hairstyle features pulling the hair back and behind the ears. It's a great technique for those with normal, oval faces.

Butterfly lighting creates the effect shown in Figure 6.19. Just place the main light directly in front of the subject's face, and raise it high enough above eye level to produce a shadow under, and in line with, the nose of the subject.

Don't raise the light so high the shadow extends down to his or her mouth. The exact position will vary from person to person. If a subject has a short nose, raise the light to lengthen the shadow and increase the apparent length of the nose. If your victim has a long nose, or is smiling broadly (which reduces the distance between the bottom of the nose and the upper lip), lower the light to shorten the shadow.

Figure 6.19

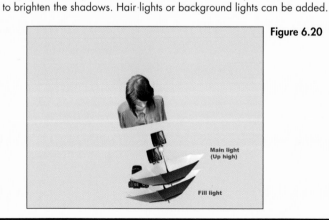

HOW IT'S LIT

For glamorous butterfly or "Paramount" lighting, position the main light directly in front of your subject, as shown in Figure 6.20, and raise it high until a shadow forms under the nose. A fill light at roughly the same position, but located at camera or eye level, can be used to brighten the shadows. Hair lights or background lights can be added.

Figure 6.20

Main light
(Up high)

Fill light

You can use a fill light if you want, also placed close to the camera, but lower than the main light, and set at a much lower intensity, to reduce the inkiness of the shadows. Notice that the ears aren't a problem with this portrait, because they are hidden behind the model's hair. Position your lights like this:

◆ **Main light.** Place the main light directly in front of the subject's face, raised high above the camera. I like to use a large soft box elevated above my head level, and positioned in the direction the model is looking (which can be directly at the camera, so you end up with the light *above* the camera itself). Be careful to avoid having the eyes in shadow, which is easy to do if you've placed the main light too high. A softer light source is generally best for this glamour lighting technique, as you can see in Figure 6.21.

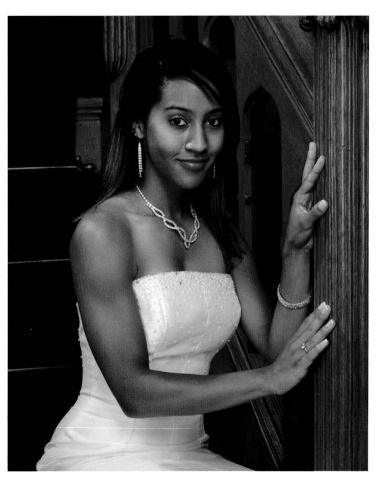

Figure 6.21 A single light in a soft box raised high above the model's head was the only illumination needed for this glamour portrait.

◆ **Fill light.** Use the fill light, if needed, to illuminate the shadows on the face. Locate the fill somewhat lower than the main light (usually directly under it, at eye level), but with a lower intensity. The fill illumination should be diffuse, too. Some photographers use a reflector instead of a fill light, often placing the reflector under the face to brighten the shadows under the chin.

◆ **Background light.** You'll find a lot of the light from the elevated main light may spill over onto the background, making a background light unnecessary. Consider using a light with dark-haired subjects to provide the necessary separation between subject and the background.

◆ **Hair light.** If you want to use a hair light, it should be positioned behind the subject at the side opposite the main light. As always, the hair light should be quite a bit higher than the main light, and angled down so it illuminates the back of the head without spilling over onto the face.

Rembrandt Lighting

Rembrandt lighting is another flattering lighting technique that is better for men. It's a combination of short lighting (which you'll recall is good for men) and butterfly lighting (which you'll recall is glamorous, and therefore good for ugly men). The main light is placed high and favoring the side of the face turned away from the camera. The side of the face turned towards the camera will be partially in shadow, typically with a roughly triangular highlight shaped like an inverted pyramid under the eye on the side of the face that is closest to the camera, as you can see in Figure 6.22.

To achieve the Rembrandt lighting effect, place the light facing the side of the face turned away from the camera, just as you did with short lighting, but move the light up above eye level. If you do this, the side of the face closest to the camera will be in shadow.

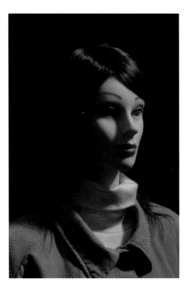

Figure 6.22 The hallmark of Rembrandt lighting is the triangular-shaped highlight on the cheek that's closest to the camera.

HOW IT'S LIT

For the Rembrandt lighting effect, I positioned the main light as if for short lighting, then raised it up high until the triangular highlight appeared on the cheek, as you can see in Figure 6.23. You may need to move the main light until the highlight has the proper shape—it should not extend down past the nose and touch the mouth. Some prefer a smaller and less distinct triangle highlight, but I made it big and sharp so you wouldn't miss it. A small amount of fill light was used, with the source positioned to the left of the camera.

Figure 6.23

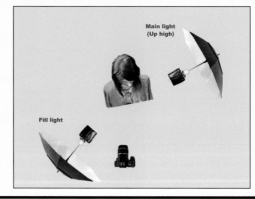

Main light (Up high)

Fill light

Move the light a little more towards the camera to reduce the amount of shadow, and produce a more blended, subtle triangle effect. Both eyes should be well lit, except when you want to break the rules, as was done in Figure 6.24. But most of the time you'll want to avoid having the triangular highlight reaching down past the nose and touching the mouth. Eliminate or reduce the strength of the fill light for a dramatic effect, or soften the shadows further with fill light.

As with short lighting, Rembrandt lighting is excellent for subjects who have scars or blemishes on their faces, because the shadows on the near side of the face de-emphasize any such defects. It's considered more dramatic than standard short lighting, and so may be excellent for character studies.

Position your lights like this:

◆ **Main light.** Place the main light about 45 degrees from the camera/subject axis. Raise or lower the main light until the catch lights in the subject's eyes are clearly visible at either the 1 o'clock or 11 o'clock positions, depending on which side of the subject the main line resides. That will prevent having the eyes in shadow, which can happen if the main light is too high. A softer light source is generally best for this lighting technique.

◆ **Fill light.** Use fill light cautiously to brighten shadows, but avoid overuse, as Rembrandt lighting is intended to be dramatic. You don't want to wash out that triangle of light on the cheek.

◆ **Background light.** If you think like Rembrandt, you'll minimize use of background light, because you don't want a lot of detail. The background light should be murky, at best, to retain the Old Masters look.

◆ **Hair light.** A hair light can be used behind the subject on the opposite side from the main light. Rake the light across the top of the head until it just spills over on the face, then retreat a little.

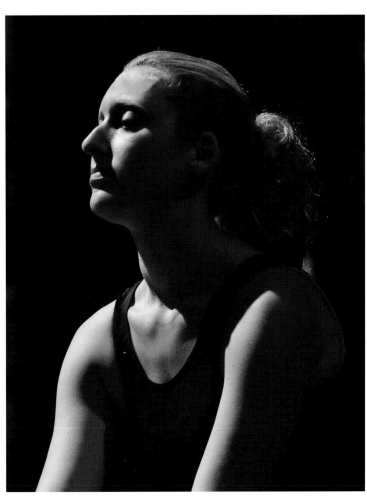

Figure 6.24 It's okay to break the rules sometimes. This "near" Rembrandt rendition includes a triangular shadow that extends down to the mouth, and the eyes aren't fully lit, but the effect is dramatic.

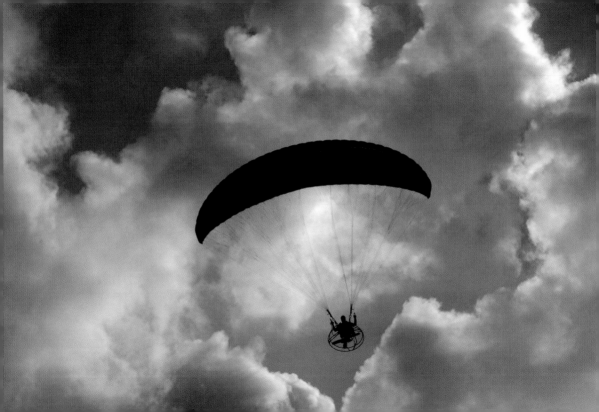

7 Lighting and Action

We'd all love to get sports and action photos like the "big guns" at *Sports Illustrated* and other publications. There's no reason why you can't get memorable pictures, even though the pro sports photographers have some significant advantages—access, equipment, experience, talent, and, in some cases, lighting tools. What we have going for us is persistence. For an amateur, the key to shooting great action pictures is to make the best of what you've got, and that includes working with the light that is available, rather than succumbing to its limitations.

Pros have access: They are provided choice locations next to the dugout, along the sidelines, or near the basket at professional sporting events. They may have better equipment: You can't beat a 600mm f/4 lens for isolating an athlete by throwing the background completely out of focus, and an 11 frames-per-second shooting rate has some advantages. Certainly, their experience and talent gives the pros a leg up, and, from a lighting perspective, the value of mounting powerful radio-controlled strobes from the rafters at an indoor event can't be argued.

So, for amateur photographers, photographing action may be more of a challenge. But isn't that what makes photography fun? This chapter will show you how to use the lighting you have at action-filled events to capture compelling photos.

Indoor Lighting

Indoor lighting for action usually means working in gymnasiums, indoor swimming pools, and similar sports-oriented venues. That almost always involves shooting by available light, too. While pro arenas allow pro photographers to mount remote-controlled electronic flash units pretty much wherever the shooter pleases, from the NCAA down to elementary school basketball, strobe is frowned upon or prohibited. That doesn't mean that plenty of parents won't be firing away with their point-and-shoot cameras and flash. They will. But you, as an avid photographer, probably will want to take more than the half-dozen shots the average parent shoots, and that's where the line is usually drawn. Plan on using available light for most of your indoor sports photography.

That's not necessarily a bad thing. Many venues are well illuminated (although, admittedly, there are some older facilities that are lit like a dungeon). Couple relatively high levels of light with

the improved high-ISO performance of the latest cameras, and you can safely shoot action at high shutter speeds and reasonable f/stops. A local Division III college gym where I shoot frequently has enough illumination to allow taking action photos at 1/800 second at f/4 with my camera set on ISO 3200. I find the color images I can capture are far superior to the newspaper sports photos I took many ages ago with (ASA/ISO 400) Tri-X film at 1/125th second and f/2.8.

Figure 7.1 shows a typical image taken in that gym. There was enough light from the overhead daylight fluorescent illumination for an action-freezing 1/1,000th second shutter speed, but I had an additional advantage. Both of the moving players—as well as the volleyball—were at the top of their arcs and moving relatively slowly. If either player had been smashing the ball, or if the ball itself had been just hit, there

would be a lot more blur. Some motion blur can add interest to action shots, but too much can render the photo either useless or nudge it into the realm of the abstract. (While abstract sports photos can be cool, too, most of us want to see at least a few sharp components in our action pictures.)

Figure 7.1 A brightly lit gymnasium allowed a high shutter speed for this volleyball shot.

Here are some things to keep in mind when working with light indoors at action events.

- **A high ceiling is your friend.** The higher the ceiling and the higher the placement of the lights in a venue, the better. The "inverse square" law discussed in Chapter 4 is the reason. With lights placed 40-feet overhead (or higher), a six-foot tall player's head will receive about one-third-f/stop's worth of light more than that player's feet, because the light fall-off is relatively small over that distance. But if the ceiling lights were mounted only 20 feet above the floor (which isn't gonna happen), the illumination difference between that player's head and feet is a full f/stop, enough to be visible in the photograph.

- **Time of day may make a difference.** My favorite gym has huge frosted windows (which you can see in Figure 7.2) placed high above the floor. They complement the overhead lights, which are fluorescents that produce illumination that is very close to daylight in color balance. So, if I have a choice, I prefer Saturday afternoon basketball games at that site over

Figure 7.2 Diffuse window light can provide strong illumination while filling in the shadows on the playing field.

their weekly Wednesday night contests, because the levels of light and the evenness of the illumination is a little better.

♦ **Don't allow the lights to intrude into the photo.** The ceiling and window light sources can be distracting. At basketball games, there is a tendency to want to sit on the floor behind the basket and shoot upwards at the action around the hoop. When I take that vantage point, I make sure that the strongest lights are behind the backboard supports, or otherwise not shining directly into the camera. Or, a photo can be cropped to eliminate the distracting light sources. While Figure 7.2 shows a taller player towering over the shooter, the cropped version in Figure 7.3 has, I think, even more impact, and focuses attention on the player with the ball who is, figuratively "up against a wall."

♦ **Watch color balance.** Take some time to evaluate the color balance of the indoor illumination. You may have daylight coming in through windows, added to overhead lamps of similar (or different) color balance. Or, you might be working strictly with tungsten or fluorescent illumination. Getting the right color balance can eliminate a lot of correction in your image editor later on.

Figure 7.3
If the light source appears in the photograph, sometimes cropping it out can produce a better photo.

Fast Shutter Speeds

Shutter speeds, at least those allowed by the lighting you have at your disposal, can be used to add or (in some cases) detract from the excitement of your action shot. Today's cameras allow shutter speeds as fast as 1/4,000th to 1/8,000th second, and as slow as an automated elapsed interval of 30 seconds or more (using Bulb) exposure. It wasn't that long ago that a shutter speed range like that wasn't very practical. Film cameras produced their best, grain-free results at ISO ratings of 125 or lower and ISO 400 was for many years the upper limit for quality work (unless you wanted to use grain as a creative element). The first digital cameras did their best work at ISO 80, and until recently even the top-end digital cameras produced excellent results at settings no higher than ISO 800 or lower. Unless you had a phenomenal amount of light available or a very fast lens,

or were willing to "push" your film or "boost" your digital camera's ISO sensitivity, shutter speeds indoors were usually limited to 1/250th second, and outdoors speeds of more than 1/1,000th second were rare.

That was then; this is now. We have a much broader range of shutter speeds to play with. At one end of the spectrum, there are fast shutter speeds that freeze motion, capturing an instant of

time that we might not be able to see at all if it weren't for the miracle of photography. Figure 7.4 shows a high jumper at 1/2,000th second, taken at the instant of passing over the bar, a

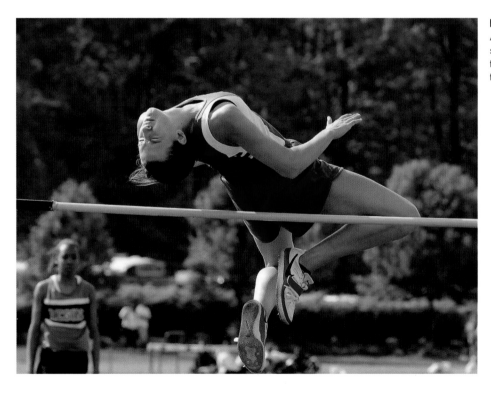

Figure 7.4
A high shutter speed captured this high jumper topping the bar.

moment that lasts a fraction of a second, and which is impossible to study without a still photograph or stop-motion video to evaluate.

You can find some specific tips for choosing an action-stopping shutter speed in Chapter 2 in the "Shutter Priority" section. To recap, you'll need faster shutter speeds to stop action that's closer to the camera and/or crossing the frame, while slower shutter speeds will suffice for movement that's farther from the camera and/or headed toward or away from the lens.

The speed you'll need will depend on whether you want to absolutely stop the action (as in Figure 7.5) or don't mind a little motion blur. As I'll explain in the next section, there are times when you *want* some blur to enhance the feeling of movement in the photograph. For Figure 7.5, I wanted to show the motocross jumper frozen in mid-air to emphasize the breathtaking

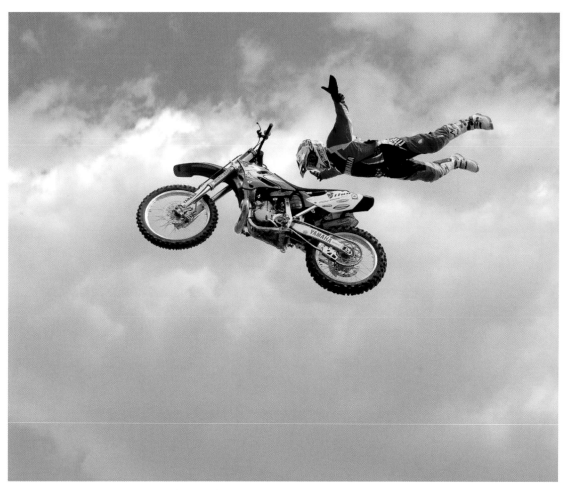

Figure 7.5 Freezing the motocross rider in mid-air made this breathtaking instant more compelling.

moment when he floated free, inches away from the "safety" of his bike. I used a 1/2,000th second shutter speed, which froze all motion, including the rotation of the bike's wheels. We still know that this is an action shot, and not some posed image, because it's obviously not possible to pose someone floating 30 feet in the air. The trickiest part of this shot was choosing an angle where the daredevil was illuminated (and not in shadow) so I could balance the exposure between the rider and the clouds that formed the backdrop.

You can decide whether a fast shutter speed will help or hurt your image by considering these factors:

◆ **Will the viewer know it's an action shot?** You don't want your picture to be mistaken for a posed shot, so look for other clues that will show that a sharp image is a true action image. While a person "floating in mid-air" as in Figure 7.5 is a good bet, the tip-offs need not be so blatant. We instantly know that Figure 7.6 was taken as the sport watercraft was skimming along the surface of a lake because the bow is raised, and a spray of turbulent water trails it.

◆ **Does freezing the moment heighten the tension?** A grimace on the face of a player, an awkward posture as a catcher thrusts an arm in to tag a runner out (see Figure 7.7), or other compositional elements can produce the kind of tension that adds to the excitement of a photo. Merely freezing a random moment in time may add nothing to the picture.

◆ **Will the fast shutter speed force you (or enable you) to use the right f/stop for the picture?** I love to shoot certain sports (particularly track) with a telephoto lens wide open at f/2.8. The large f/stop helps isolate the

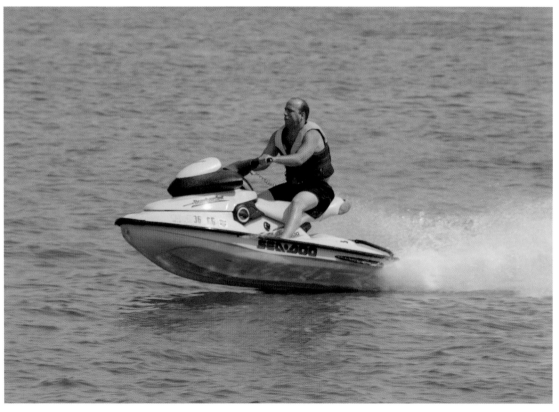

Figure 7.6 We know this is an action shot because of the raised bow and plume of water behind the sport craft.

athlete, while throwing the distracting background out of focus. (See Figure 2.5 in Chapter 2 for an example.) A fast shutter speed makes that wide aperture possible, while serving to counter camera shake and minimize blur from subject movement. On the other hand, if you're using a fast shutter speed to stop action under less than optimal lighting, you may be forced to use an aperture that doesn't provide sufficient depth-of-field.

◆ **Do you want to use flash?**
Electronic flash has its place in sports photography, if only as fill-in when shooting outdoors. If you really need to use flash, you may find that the shutter speeds you can use are limited. Most cameras synchronize with flash at 1/250th second or slower, while a few allow using speeds as fast as 1/500ths second. That limitation can reduce your flexibility when using flash for fill. If the flash happens to be your main source of illumination, the duration of its burst provides the effective ("real") shutter speed, but then when ambient (existing) light levels are high, you have to worry about the "ghosting" problems described in Chapter 4.

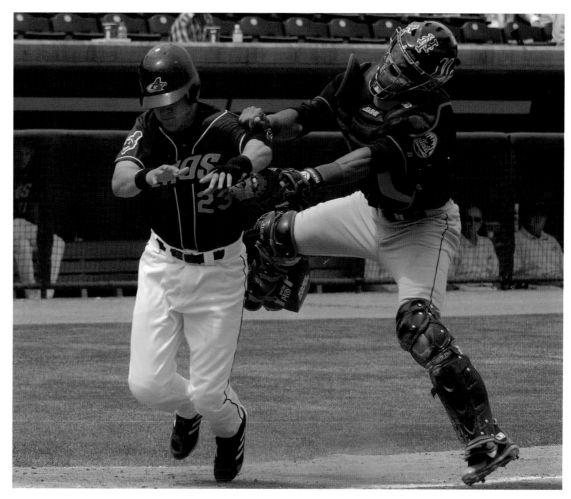

Figure 7.7 Freezing a moment can heighten the tension of an action shot.

Slow Shutter Speeds

As you must know by now, freezing movement in its tracks is not the only way to capture an action photo. So, you need not be distressed when the amount of light available limits the shutter speed you can use. Indeed, some types of action images benefit from using a slower shutter speed, even if the illumination levels allow a faster setting.

As I noted in Chapter 2, some subjects almost demand a lower shutter speed. A motocross biker leaning into a curve as he rounds a turn shouldn't be frozen in time. If you don't have at least a little blur in the wheels of the bike, it will look like the rider is stationary and parked, albeit at an odd angle. Although you might find a photo of a helicopter in mid-air with its rotors stopped interesting, others will probably look at your picture and wonder if the chopper crashed a few seconds after it was taken.

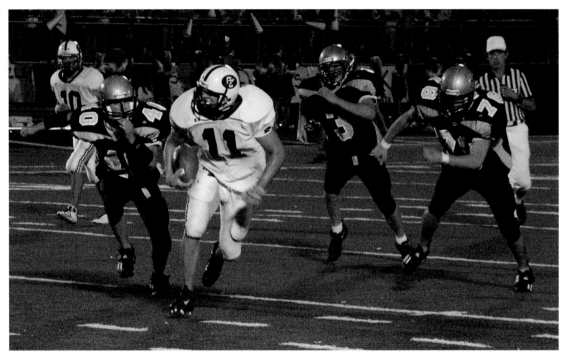

Figure 7.8 The slight amount of blur in this action shot adds a gritty feeling, but otherwise isn't an essential part of the image.

While slower shutter speeds may not be mandatory for some images, they may not detract from the picture, either. For Figure 7.8, I was forced by dim illumination and ISO setting constraints to shoot this football action photo at 1/500th second. There's a slight amount of blur visible, particularly in the ball carrier's hands. While the blurring didn't necessarily improve this particular picture, it didn't harm the effect, either.

Slow shutter speeds can enhance the feeling of motion when you use a technique called *panning*. For the image in Figure 7.9, I supported my camera with a monopod, which I planted firmly in the ground a few feet from the track where a distance runner would be racing past. I set the shutter speed for 1/4, which happened to produce an exposure problem: Regular exposure at my lens's smallest f/stop would have

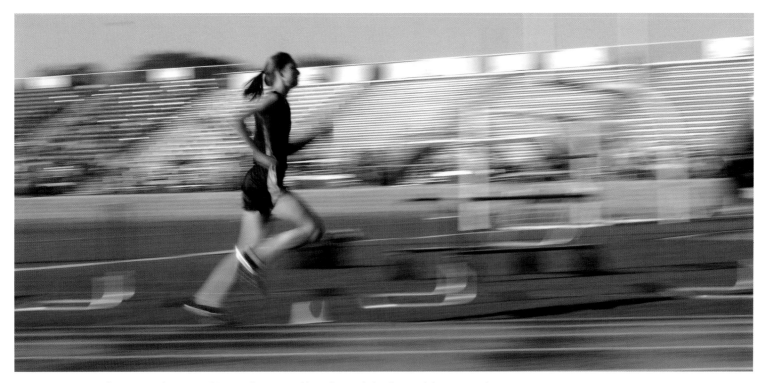

Figure 7.9 Panning the camera during a 1/4 second exposure blurred an ugly background, but captured a runner in motion.

been 1/50th second at f/22 when using an ISO 100 setting. An ND8 (three stop) neutral density filter would let me shoot at 1/8th second, which test shots told me was "too fast" for the amount of blur I wanted to create. So, I went ahead and shot at 1/4 second at f/22, and accepted that the picture would be overexposed. I'd fix it up as much as I could in my image editor.

I prefocused manually on the portion of the track the runner would pass over, then swiveled the camera to the left to follow her motion as she approached the area in front of me. Smoothly tracking her progress, I released the shutter at the right moment and continued the rotation of the camera on the monopod for the full 1/4

second exposure. (Actually, I tracked her for longer than that.) I ended up with the shot you see, in which the background is seriously blurred, and the runner is sharp(er). The blurring of her legs and arms really imparts a feeling of motion to this shot.

Not all action takes place in a sports venue, of course. Figure 7.10 shows a moment at a ballet, captured using the miracle of modern camera technology. I combined a relatively slow shutter speed with in-camera multiple exposures to simulate a photographic stroboscopic effect, without the use of a repeating flash unit. If your camera has multiple exposure capabilities, I urge you to experiment with this effect for your action photography.

Here's what you need:

- **A camera with multiple exposure capabilities.** Natch! Set your camera to expose three or four images simultaneously on the same frame. Some cameras let you specify whether each image in the sequence will receive the same amount of exposure (in which case, overlapping portions may overpower each other), or whether individual images receive a fractional, proportionate amount of exposure, which allows them to blend smoothly without overexposing any portion of the photo.

- **A subject against a dark background.** The dark background will allow multiple shots of your subject to be shown easily without clashing with the objects in the background. In this case, the dark curtain on the stage was perfect.

- **A solid tripod.** You want the camera to remain steady during the sequence, so the individual exposures are shown in their proper relationship, while the background remains constant.

- **A remote release.** You'll need this to trip the shutter without jiggling the camera.

- **Continuous Shooting mode.** Depending on how fast the action moves, you will want to shoot anywhere from two frames per second to five or more. Your camera may be locked into a specific continuous shooting speed, such as three frames per second. If you can adjust the interval between frames in the burst, you have extra flexibility.

- **Good timing.** Watch for some motion you want to capture with your "strobe." Trip the release at the beginning of the motion, as I did when the dancers began their maneuver. (I'm not conversant with ballet terminology; I'm sure this motion has a name.)

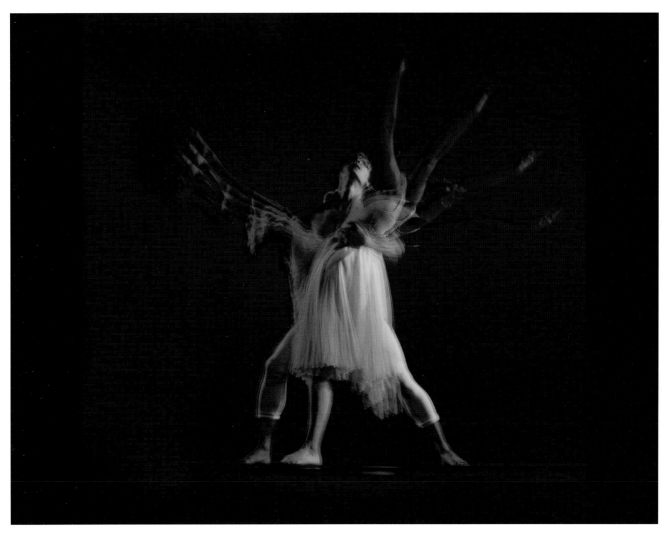

Figure 7.10
In-camera multiple exposures at a shutter speed of 1/60th second (for each "frame") produced this faux strobe image.

Outdoor Lighting

If you don't like the lighting you're faced with outdoors, wait a few minutes. It may change—for better or for worse. It's common for lighting to be too bright and contrasty at one moment,

and then a cloud passes in front of the sun and it's suddenly too dark and the light is bland and shadow-free. Or, a sunny day can turn into a torrential downpour, which may or may not

affect your shooting. Baseball games are called on account of rain, football contests are not.

You'll need to make the best out of any kind of lighting you encounter outdoors. Figure 7.11

was shot on an overcast day following a rain shower. The light was very dull and low in contrast, although the difference in the players' uniforms (bright white versus a very dark blue) made up

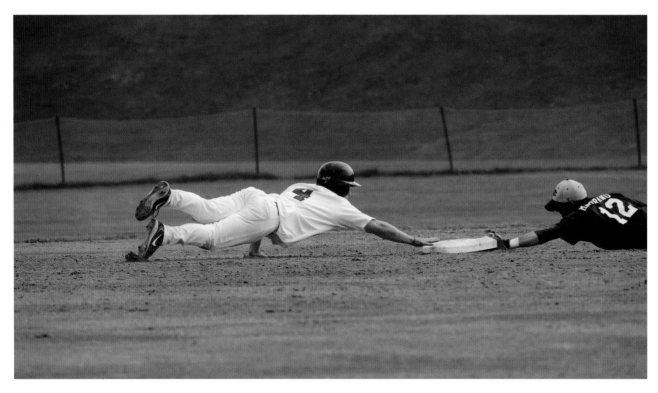

Figure 7.11
Flat lighting can still result in an image with contrast if your subjects wear contrasting clothing.

for the flat lighting. The good news was that there was sufficient light to allow a high shutter speed to stop the action as the base runner made a dive for second base. And, I was still able to use a large enough f/stop to blur the distracting fence in the background.

The image shown in Figure 7.12 is at the opposite end of the spectrum, from a lighting standpoint. It was a bright sunny day, and the football players were bathed with intense sunlight that cast deep shadows. I had to expose for the shadows to keep detail in the face of the running back with the ball, and allow the brightest highlights to become overexposed. Reflectors and fill light are obviously not possible with action shots of this sort, so you have to count on the latitude of your camera's sensor to provide enough detail in highlights and shadows to give you a useable shot.

Figure 7.12 In high-contrast lighting, expose for the shadows when details in the darkest portions of the image are important.

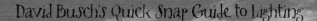

Even with high shutter speeds, you'll want to choose your angles carefully to optimize the action-freezing effect (if that's what you're going for). For Figure 7.13, I selected a curve rather than a straightaway portion of the track for two reasons. That angle allowed me to capture the runner going diagonally, partially toward the camera rather than across the frame, to stop her in a mid-step stance that emphasized the concentration on her face. The angle also made it possible to include an out-of-focus trailing runner in the frame to add a bit of competitive impact.

Aerial action adds one specific challenge: How do you picture the sky? The exposure latitude of most digital cameras makes it difficult to include fluffy clouds in the same picture as foreground subjects. Expose for the action subject, and the clouds may be overexposed; expose for the clouds, and the subject may be underexposed.

There are three ways to overcome this problem. The least desirable way is to use manipulations in your image editor to balance the clouds and other subject. It's easy to fix the photograph so much that it's ruined. The second way is to change your shooting angle so that the sun is behind you, or to the side rather than directly in front of you. It's possible to get balanced photos of clouds/foreground if you just change your position. A polarizing filter can help a little by darkening the sky—but such filters work best only when the sun is 90 degrees from the lens axis (to your right or left).

The third way is the method I used for Figure 7.14. I exposed for the sky (actually, underexposed it a little) and underexposed the subject, a powered paraglider, so it became silhouetted against the canopy of clouds. That solution is not always possible for action shots, but in some cases, like this one, it works well.

Figure 7.13 The angle you choose can help to improve the composition of your outdoor action picture.

Figure 7.14 To capture clouds realistically, you may need to let your main subject become a silhouette.

Flash or Existing Light?

With certain outdoor action activities, you have a choice whether the event is photographed at night or during the day. Until recently, nighttime events were definitely the most challenging, because most digital cameras performed poorly at the high ISO settings that are called for under low light conditions. Figure 7.15, which I took at a night baseball game under tungsten lights, is a bit flat and a lot grainier than I would have liked. It probably would have been a great shot taken in the daylight (or under higher illumination levels, or with a camera that performed better than this one did at ISO 800). As it is, it's clearly an "also ran."

When players are hundreds of feet from your camera, existing light is your only option, of course. But other nighttime sports can be photographed from closer distances. I shoot a lot of high school football, where I am able to prowl the sidelines. I own a huge "potato masher" external flash that attaches to the side of the camera and provides prodigious amounts of light. If I am patient enough to wait for the action to run down the sidelines on my half of the field, the flash provides plenty of light. Moreover, I've used this flash with a camera that synchronizes at 1/500th second, too, so the ghost images described in Chapter 4 aren't much of a problem. Yet, I rarely use this flash at football games anymore, even though it served me well back in the film era.

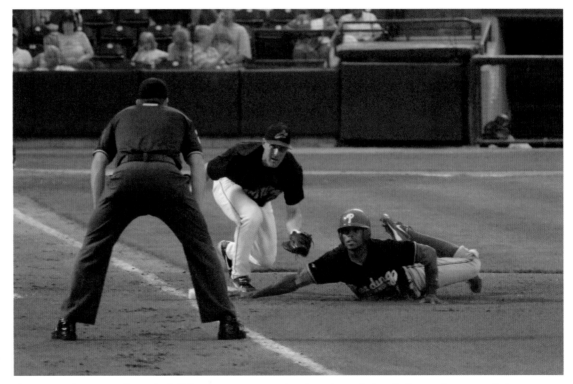

Figure 7.15 A grain-producing high ISO setting was required to shoot this night baseball game by existing light.

Why not? I find that the ability to shoot this sport under existing light gives me a lot more flexibility than I ever had with flash. The "inverse square" law mentioned earlier in this chapter comes into play again. The light fall-off as the distance of the players from the camera increases is too great. Typically, a runner doing an end sweep in my direction will pass within 10 yards or so of my camera. But other players will typically be located 20 yards away, and the light falls off by two stops or more at that distance. It's difficult to expose a group of players of any size with flash, as you can see in Figure 7.16. Indeed, the closest players are overexposed, while those in the distance are underexposed.

Of course, when I am using flash, I have to wait for the action to come within range, which is usually no closer than mid-field, and more frequently involves action at the nearest hash mark. So, instead of flash, I gain flexibility these days by almost always relying on existing light. As you can see in Figure 7.17, higher ISO settings (up to ISO 3200 with very little visual noise) allow capturing everyone on the field embraced by my aperture's depth-of-field, and even the opposite sideline is lit well enough to add some bench atmosphere to the photo. For outdoors action, flash isn't really useful anymore, except as fill-in daylight. Indoors is another matter, assuming you own some radio controlled strobes and a tall ladder.

Figure 7.16 Light fall-off limits the usefulness of electronic flash for actions.

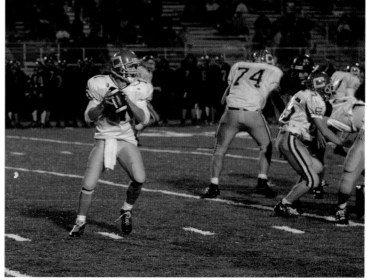

Figure 7.17 Available light is more flexible for outdoors action—assuming your camera performs well at sensitivity settings from ISO 1600-3200.

Close-up and Macro Lighting

Providing the proper lighting for macro photography is exacting work. But, fortunately, many kinds of close-up pictures involve inanimate objects that will remain patiently in front of your camera for hours while you arrange lighting and choose the perfect angle. This is one type of photography you can use to hone your lighting skills and gain experience in the finer points of illuminating subjects. You'll often have the time to do this, and the results will be worth it.

Of course, other macro photographs picture living creatures that can scarcely be coaxed to remain in the frame long enough for an exposure or two, presenting more of a challenge from the lighting standpoint. You may take close-up pictures indoors in a mini-studio of your devising, or take your work outdoors and suffer the vagaries of the environment. Given the right subject and right lighting, macro photographs can picture the familiar in new ways, or result in images that are abstract and thought provoking.

Above all, macro photography is convenient. You don't necessarily have to jump into your car or travel by plane to photograph something that's out of the ordinary. That weird crystal saltshaker you found at a garage sale might be a perfect subject when you zoom in close to capture its angles and texture. You can find many close-up subjects right in your own backyard. And if you do need to travel to take your macro shots, you don't need a ton of equipment. A camera, sturdy tripod, perhaps a macro lens or close-up attachment, some reflectors, and an off-camera flash are all you need.

In some ways, close-up lighting is a lot like lighting portraits, as discussed earlier in this book. So, I'm not going to repeat all the tips on using multiple lights, fill lights, and other typical people picture lighting effects here. Instead, I'll concentrate on the special requirements of lighting close-up subjects.

Lighting Challenges

Lighting macro and close-up subjects presents a whole new set of challenges, whether you're shooting under semi-controlled lighting conditions in a living room "studio" or outdoors in the wild. I'll address some of the best ways to deal with these challenges later in this chapter, but here's a summary of some of the factors you might be up against:

◆ **Bad lighting angle.** If you want to use your camera's built-in flash for close-up photography of objects that are very near the camera (and in most cases, you shouldn't, except for fill), the internal flash is so high, relative to the position of your subject, that it is probably aimed "over" it and either won't illuminate the subject at all or will only partially illuminate it.

◆ **Too much light.** Built-in flash may be too powerful for close-up photos, and you may be unable to reduce power enough to compensate for the close distance. Backing off your light source to reduce light levels changes the character of the light, turning a soft, diffuse source of illumination harder and more directional as the distance increases.

◆ **Lighting obstructions.** Your camera's lens or the lens hood itself may cast a shadow on the subject, either from your flash or from other illumination you use.

◆ **Bad lighting angles.** Because of the limited working space you may have, it's possible that your light source may be visible in the frame, or cause glare.

◆ **No room to maneuver.** The camera may be so close to the subject that there isn't room to light the front of the subject. Unless you're looking for a totally backlit effect, the results may not be pleasing. One solution may be to move the camera farther back and use a longer focal length lens to produce the same magnification, but that creates new problems, as I'll describe in the next section.

Figure 8.1 is a good example of the bad lighting angle syndrome. (The "needle" in the How It's Lit figure represents the position of the subject only; a "bird's eye" view would render it unrecognizable, of course.) I was trying for a backlit approach that would silhouette the needle while transilluminating the translucent thread. But with the light behind the subject and just slightly to the left, all I got was a photo with glare in it, which you can see at top. I switched to side lighting and produced a more dynamic and vivid effect, shown at bottom in the figure.

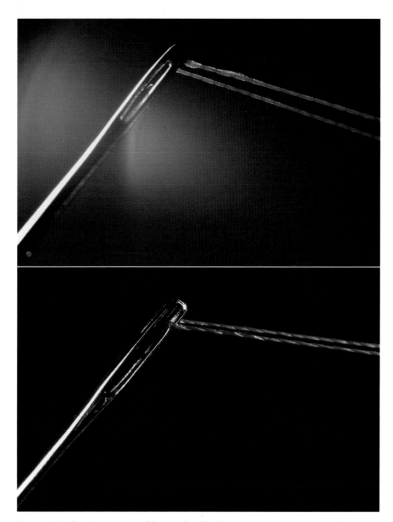

HOW IT'S LIT

At left, the light was positioned behind the needle, which caused glare. By moving the light to the right, a glare-free exposure was possible. The light is still dramatic, showing the texture of the needle and thread.

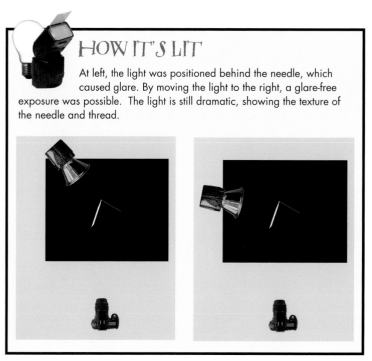

Figure 8.1 If you're not careful, your backlight source can intrude into the photo, or cause glare (top). Switch to side lighting for better illumination.

Magnification and Perspective

Get too close to your subject, and you may not have enough room to position your lights properly. In Figure 8.2, you'll see what happens when you don't have sufficient room to manipulate your lights. The dandelion is so close to the camera that there was no room to light up the front properly. Even with lights to the left and right of the camera, the lens itself cast a shadow. In this case, I liked the backlit effect. If not, I could have moved the camera back and used a longer focal length lens to produce the same magnification from a greater distance.

But, retaining the same magnification from a greater distance causes problems with perspective. In close-up photography, it's not how close you can get to your subject, but how large your

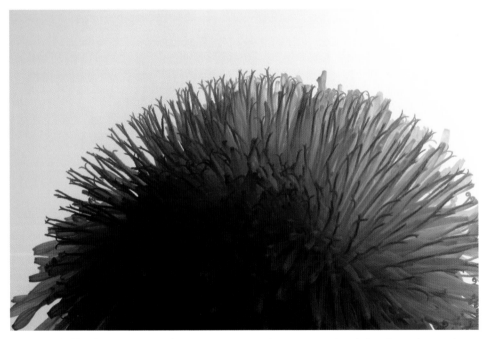

Figure 8.2 When shooting extreme close-ups, you may not have room to place light in front of your subject.

HOW IT'S LIT

The light was positioned behind the subject to produce a back-lit effect.

subject appears in the frame. Take a photograph of a coin eight inches away using a normal or wide-angle setting of 50mm (your camera's "crop factor" doesn't matter for this example). Now, move the camera back so it's 16 inches away from the coin, but change to a 100mm focal length. You can probably guess the result: The coin will be exactly the same size in both images. Indeed, with a flat subject like a coin, the focal length and distance don't make much difference, as long as you achieve the magnification you're looking for. In fact, the specifications of lenses intended specifically for close-up photography are described in terms of magnification: A lens with a 1:1 magnification ratio produces an image that is life size on the sensor; one that has a ratio of 1:2 creates a half life size image; a 2:1 ratio generates an image that is twice life size, and so on.

However, if you've shot portraits, in particular, you know that an image that is technically the same

size won't be the same from a perspective and, consequently, an aesthetic standpoint. A head-and-shoulders portrait taken from a foot away with a wide-angle lens will distort your subject: Ears will appear too small, noses, too large. A human face photographed with a short telephoto lens (50-85mm, accounting for "crop" factors) looks normal. A face cropped to the same size taken from a distance with a very long telephoto lens may appear to be too flat.

This distortion of perspective applies to close-up and macro subjects as well. The effects may be more subtle and harder to discern, because we aren't as sensitive to the proportions of the typical macro image as we are to pictures of people. The most important types of subjects affected by perspective concerns are tabletop setups such as architectural models and model railroad layouts. Use the right perspective, and your model may look like a full-scale subject. With the wrong perspective, the model looks exactly like what it is: a tiny mock-up.

Figure 8.3 (top) shows an aloe vera plant photographed from about two feet away using the equivalent of a 28mm wide-angle lens. For the bottom version, I

Figure 8.3 Although the size of the main subject is the same in both versions, the perspective of the wide-angle shot (top) is different from the one taken with a telephoto lens (bottom).

moved back to about 5.5 feet and shot at the 80mm zoom setting. Note that the magnification of each image is exactly the same (at least, in terms of the flowerpot), even though one photo was taken at a distance that's nearly three times as far. The difference in perspective can be seen by comparing the two versions. Check out the stool seat the plant is resting on. At top, the stool seat looks larger and "wider," whereas at bottom, the seat is more compressed (which is what telephoto lenses do). When changing focal lengths to give yourself more room to light your image, choose the focal length of your lens carefully to provide the kind of perspective that you're looking for.

Working with Existing Light

Lighting for close-ups can make the difference between a successful picture and a so-so effort. You can choose from the existing light (modified with reflectors if need be), electronic flash units (or incandescent illumination such as photoflood lights), high intensity lamps, or other auxiliary lighting. If you want to be pedantic, you can also shoot close-ups with light emitted by the subject itself, so if you have some lighted candles or lightning bugs to capture, knock yourself out.

The existing light that already illuminates your subject may be the most realistic and easy to use option for close-up photos, as long as you're prepared to manipulate the light a bit to achieve the best effect. That's particularly true when you're shooting on location or outdoors. Making the most of the existing light means not having to set up special light sources or possibly locating a source of electrical power (not always an option outdoors).

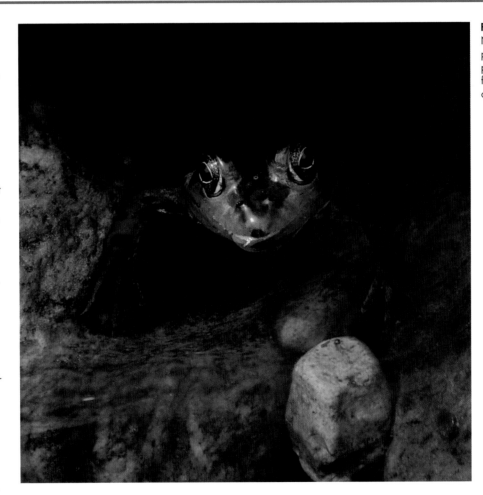

Figure 8.4
Natural daylight provided the perfect illumination for this close-up of a tiny frog.

Figure 8.4 shows an apparently unintimidated frog I cornered under an overhanging rock at the edge of a pond. The little fellow was less than an inch long, and I ended up taking his picture with a 200mm lens from a few feet away, which seemed to be fine with him. In this case, the skylight on an overcast day provided plenty of illumination with enough contrast, and the "fill" light came from the light-colored stones on the bottom of the pond. The natural lighting made a natural-looking picture.

Although Figure 8.5 almost looks as if it could be a studio shot, it, too, was taken outdoors on a bright, sunny day. It was just after noon, and the light was coming from directly overhead. I dropped down flat in my front yard and focused on this dandelion from only two inches away with a 55mm macro lens. The woods located behind the flower provided a suitable dark background for this extreme close-up. Naturally, the camera was locked down on a mini-tripod, which rose only four inches from the lawn.

While the camera was rock-steady, I had to contend with slight breezes that caused the blossom to, at best, quiver slightly, and, at worst, drift entirely out of the frame. You'll find that reflectors (discussed later in this chapter) can be your friend in more ways than one. Not only do they fill in the shadows, but they can provide a wind break to shield outdoor subjects.

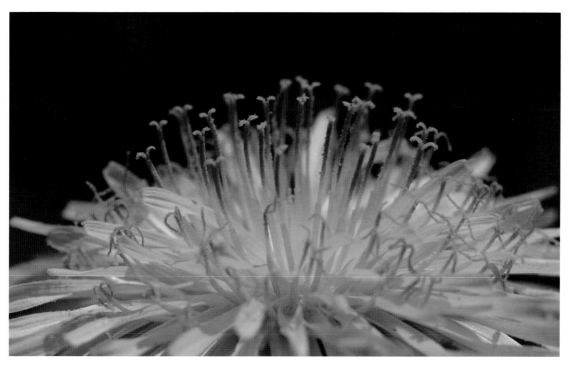

Figure 8.5 The sun overhead was bright enough to allow an f/22 aperture needed to increase depth-of-field for this shot.

Working with Electronic Flash

The electronic flash built into your digital camera may work fine for quick and dirty pictures, but usually it will provide illumination that is too bright, too harsh, and might not cover your subject completely. This is because built-in flash are typically "aimed" to light subjects that are at least a few feet away from the camera. It's more difficult to visualize how electronic flash illumination will look in the finished picture. While available light provides an automatic "preview," with electronic flash, what you get may be a total surprise. On the plus side, the short duration of electronic flash will freeze any moving subject this side of a hummingbird.

In many cases, electronic flash is most applicable to macro work indoors, especially if you plan to work with several lights and set them up on stands. Outdoors, you might be limited to one or two battery-operated flash units. But even a single flash can be useful. You can dial it down to provide fill-in flash. I like to use

flash when shooting living macro subjects to add a life-like "catch light" to the eyes, as you can see at bottom in Figure 8.6. The colorful parrot in question was eyeing me closely but was turned so that the side of his head was in deep shadow. I popped up my electronic flash, set it for 1/128th power, and snapped the bottom picture. You can compare the results with flash with the same parrot's eye photographed a few minutes earlier with no flash fill (top).

Here are some of your choices for electronic flash used for close-up photography:

◆ **Built-in flash.** This is the flash unit built into your digital camera. You'll find that in most extreme close-ups, the light it produces will look unnatural and may not illuminate your subject evenly. You probably can't aim the built-in flash in any meaningful way, and you may find that the lens casts a shadow on your close-up subject. Use it for fill, or to add a catch light, as I did for Figure 8.6.

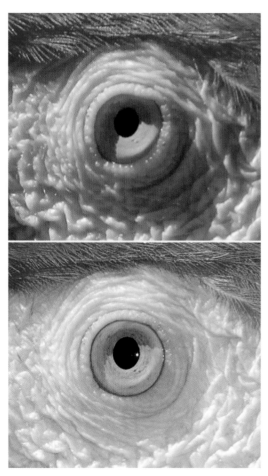

Figure 8.6 Outdoors, electronic flash filled in the shadows and added a catch light to the parrot's eye.

154

◆ **External flash units.** As I mentioned earlier in this book, many digital cameras have a connector for attaching an external flash unit. These can be inexpensive flash units, or more elaborate (and more costly) devices with modeling lights, which are extra incandescent lamps that mimic the light that will be emitted by the flash. Modeling lights are most useful indoors, or in dark locales where the ambient illumination won't disguise their effect.

◆ **Slave flash.** These are electronic flash units with light-detecting circuitry that automatically trigger them when another flash goes off. You can also purchase add-on slave detectors that set off any flash. Slaves are useful when you want to use two or more electronic flash units. Keep in mind that you may need to disable your main flash's preflash feature to avoid tripping the slave too early.

◆ **Ringlights.** These are specialized electronic flash units made especially for close-up photography. They have circular tubes that fit around the outside of a camera lens, providing very even lighting for close-ups. Ringlights are generally a professional tool used by those who take many close-ups, particularly with interchangeable lens cameras. If you can afford an SLR digital camera, and do enough close-up work to justify a ringlight,

they make a great accessory. Models like the terrific Alien Bees model (www.alienbees.com) shown in Figure 8.7 are even used for portraits!

When working with flash for close-up photography, lack of light will rarely be a problem. In fact, you may find yourself with too much light even at your lens's smallest f/stop, and end up with a washed-out picture. Here are several possible solutions:

◆ **Dial down ISO.** If your flash is too powerful, choose the lowest ISO setting your camera offers.

Figure 8.7 Ringlights provide soft, even lighting.

◆ **Add a neutral density filter.** A neutral density filter in one-, two-, or three-stop values can reduce the amount of light reaching the sensor and prevent overexposures.

◆ **Move back.** Step back a little and use a tighter zoom setting to produce the same size image, while keeping in mind the potential perspective problems I mentioned earlier in this chapter. As you move the flash farther from your subject, it will be less likely to wash out the picture. If you need yet another reminder, remember that electronic flash obeys the inverse-square law: A light source that is 12 inches away from your subject produces only one-quarter as much illumination as it does when it's six inches away.

◆ **Fool the meter.** If you're using a dedicated flash unit (either your camera's internal flash or a flash designed to work with the automatic exposure features of your camera), use your camera's exposure value (EV) control to deliberately "under" expose the picture, thus fooling the flash autoexposure mechanism.

◆ **Cover up.** Consider covering your flash with a layer or two of tissue paper or other neutral translucent covering. You'll cut down on the light, and soften it a bit at the same time.

Working with Continuous Lighting

Good old-fashioned incandescent or even fluorescent lights (both falling under the umbrella of "continuous lighting") are usually your best tool for lighting indoor close-ups of things that don't hop around or wiggle. While not as intense as electronic flash, that's not usually a problem with your camera locked down on a tripod and with longer exposures. Many of the close-up illustrations in this book were taken with continuous lighting. The main advantage is that you see exactly what your lighting effect will be (indeed, as I noted, studio flash units usually have an incandescent light, too, not for illumination but as a "modeling light").

Continuous lights are cheap, too, so you can use several to achieve the exact lighting effect you want. The most important thing to remember when using them is to set your white balance manually, or make sure your camera's automatic white balance control is turned on. These lights are much more reddish than daylight or electronic flash.

Any gooseneck high-intensity lamp or table lamp, like the one shown in Figure 8.8, that you can twist and turn to adjust its angle will work great as illumination for close-up pictures. Other types of lamps can also be used, but will be less flexible, so to speak, when it comes to positioning. High-intensity bulbs may

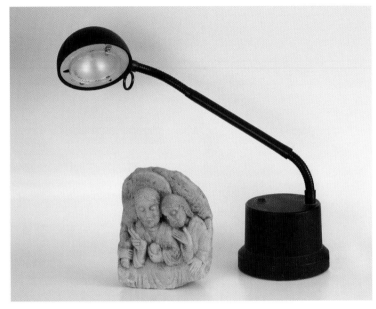

Figure 8.8 An ordinary desk lamp can be used for close-up photography.

have too much contrast, especially for shiny objects. You can use reflectors to soften their light, or investigate adjustable neck lamps that can use conventional "soft-white" light bulbs. Watch out for the heat generated by your incandescent lamps! They are a poor choice for photographing ice sculptures or chocolate candies, but a good choice for illuminating burgers and fries you want to be toasty warm after the shoot is over.

The flower shown in Figure 8.9 was photographed with that single high intensity lamp, placed off to the left and slightly behind the blossom to backlight it a little. You can see the lamp itself reflected in the shiny ceramic vase the flower was nestled in. I feathered the light a little—just using the lamp's "focused" beam to direct light on the flower itself, rather than on the vase, to provide a high-contrast look in which only the flower was brightly lit.

Figure 8.9 A single high-intensity lamp placed off to the left provided all the illumination needed for this shot.

Once you've got the single-light routine working, you'll want to add lights to give you some flexibility. If you're shooting in a mini-studio, you'll probably want to use at least two light sources to illuminate your subject from both sides. Shine the lights directly onto your subject, or bounce the light off a reflector like those described in Chapter 3. Just as with portrait lighting, you'll want to make sure there is some light on the background to separate your subject from its surroundings, unless you're going for a dramatic look, as in Figure 8.9.

As you light your scene, remember that depth-of-field is always limited when taking close-ups, so anything you can do to increase the amount of light available will make it possible to shoot at a smaller aperture, which in turn increases depth-of-field. Figure 8.10 shows a close-up of a dandelion taken with the lens wide open, while Figure 8.11 is the

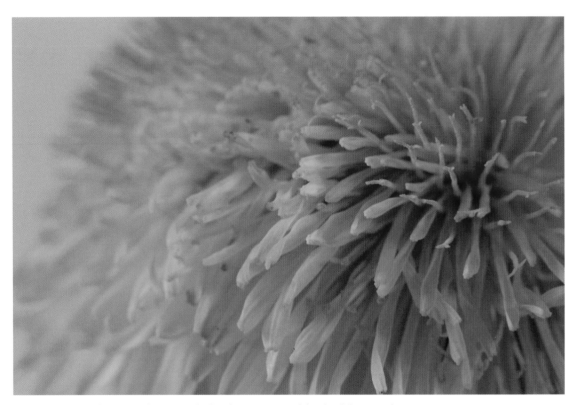

Figure 8.10 With the lens wide open, only the closest portion of the dandelion is in focus.

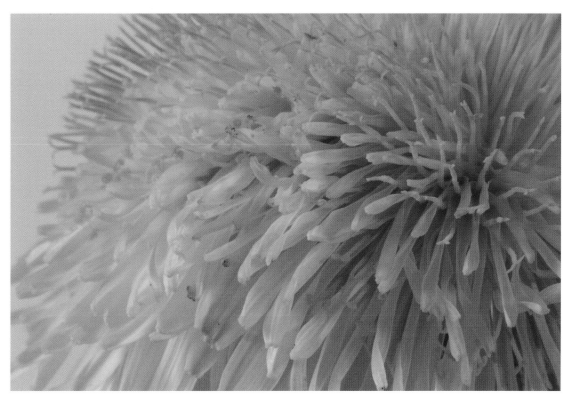

Figure 8.11 If you stop down the lens to a smaller aperture, the depth-of-field increases.

same shot with the aperture stopped down to increase depth-of-field. (These are the final dandelion photos of this chapter, I promise you; my backyard is a little sparse when it comes to more exotic blooms.) To get that smaller f/stop, you can increase the amount of light falling on the subject, use a slower shutter speed, add some light, or raise the ISO. Going the additional light route can be especially helpful if you're shooting without a tripod and can't really lengthen the shutter speed any more.

Watch for glare reflecting off shiny objects. If you're not using a tent (discussed at the end of this chapter), you may have to arrange your lights carefully to prevent reflections from ruining your shot.

High- and Low-Contrast Close-ups

Although high-contrast and low-contrast lighting has been covered multiple times in this book, it might be helpful to revisit the topic as it applies to close-up and macro photography. The qualities of soft and hard lighting mentioned earlier apply equally to this kind of picture taking, but some of them take on special importance. Here are some things to consider:

◆ **Disguise flaws.** Extreme close-ups can reveal tiny flaws that aren't apparent when examining an object from ordinary viewing distances. Soft lighting can help disguise those defects. The crayons pictured in Figure 8.12 were taken from a brand-new box purchased specifically for a photographic session. Yet, even these minty-fresh crayons had multiple chips and dings, and even some ugly dust spots that weren't readily apparent, but which showed up under high magnification. So, to hide the defects, and, as a creative option, I used low-contrast lighting and a wide aperture. The soft light and shallow depth-of-field emphasized the color of the crayons, rather than their blemishes.

Figure 8.12 This low-contrast image, combined with a wide aperture and shallow depth-of-field, reduces the garishness of the colors and de-emphasizes any chips and dings in the crayons.

◆ **Emphasize texture.** Later in the same shooting session, I decided I wanted to highlight the shiny texture of the crayons. So, I photographed them from above illuminated by harsh, direct lighting rather than the soft bounce lighting I'd used earlier, as you can see in Figure 8.13. This lighting gave the crayons an almost metallic look. I used a smaller aperture, too, to provide additional depth-of-field.

Of course, because the crayons were shot head on (so to speak) rather than at an angle, they were all more or less in the same plane of focus, anyway.

◆ **Desaturate or enrich colors.** The soft lighting in Figure 8.12 tones down the richness of the colors (which is, admittedly, not that easy to do with a box of such garish colors). This effect is why you might want to choose your camera's Vivid setting on an overcast day (and why film photographers favor Kodak Ektachrome or Fujifilm Velvia under such conditions). As you can see when you compare both of our crayon images, the direct light used in Figure 8.13 provides much richer colors—without touching the camera's saturation controls.

◆ **Create a high-key look with high contrast.** Emphasizing bright tones with few middle tones and almost no shadows creates a distinctive high-key look, as I first described in Chapter 1. High key can be especially effective when shooting close-up pictures, like the one in Figure 8.14. The high-contrast lighting offers two of the effects already mentioned in this list: It emphasizes the texture of the peppers and enriches the colors.

Figure 8.13 High-contrast lighting, on the other hand, enriches the colors and emphasizes the texture.

Figure 8.14 High-contrast lighting with few middle tones and no shadows produces a high-key look that works with some close-up subjects.

Tent Lighting

Lighting tents are closely related to those photographic soft boxes described earlier in this book. As you'll recall, a soft box is a large box-like affair holding a light source and having a large diffusing surface on the front to soften the light. They're widely used to provide flattering lighting for portraits and for product photography where glare might be a problem. A tent turns the soft box concept inside out: The translucent material wraps *around* the subject and diffuses the light penetrating its sides, producing a soft light that can be used to photograph the object inside the tent. I think a tent might be more useful for some kinds of close-ups, because it almost ensures a glare-free image with no reflections of the lights used to illuminate the image. When photographing with direct lights, umbrellas, or even soft boxes, reflections of the light source on the subject itself can be a problem.

For very small objects, you can make your own tent out of an ordinary one-gallon plastic milk container. You'll want the kind that is white and translucent. Clean the jug carefully and cut off the bottom so you can place it over your subject. Enlarge the opening in the top so your camera lens will fit through. You can light the jug from all sides to provide a soft, even lighting, while photographing the subject through the top.

More versatile commercial tents come in various sizes and can cost as little as $50. They fold

Figure 8.15 A tent provides soft, shadow free lighting.

down and set up easily and quickly. You can use the tent as is, or place your own background (seamless or otherwise) inside. A cubical tent like the one shown in Figure 8.15 offers all kinds of flexibility in terms of use and how you light it. For example, you can place stronger lights on one side and slightly weaker lights on the other to provide a soft modeling effect. Or hit all the sides with bright lights for flat, low-contrast illumination. Figure 8.16 shows a photograph of a figurine made inside a tent. There was enough directional quality to the light so that the raised features of the knight can still be seen easily. Yet, nearly all the glare that a direct light source would produce has been eliminated. You can see how the soft lighting has no glare to interfere with viewing the knight's features, but there is still enough contrast to see the texture of the figurine.

In the version at left, you can see the background of the tent. If you want a plain background, you can use a piece of poster board to provide a seamless surface. It's simple to drop out the back-

ground entirely in an image editor, producing the "catalog" shot shown at right.

Tents provide a slit in one side that you can shoot through, so

that only the lens of the camera can possibly reflect off a shiny surface. I like to set the tent apparatus on a tall barstool so I can get close from any angle and move around for the best

perspective. As you might guess, product photographers use tents extensively, but there are lots of applications for other kinds of close-up and macro photography.

Figure 8.16 Tent lighting can be directional, yet soft and without glare.

Travel and Architecture

There are two types of travel and architectural photography. One variety involves the slick, polished pictorial representation of scenes, native populations, and structures, with a great deal of control exercised over angles, lighting, and, even, content (for example, whether or not people appear in the photos). These kinds of travel and architectural photographs end up published in magazines, from *National Geographic* to *House Beautiful.* Most of us don't aspire to take such pictures and, in fact, probably feel that such photography doesn't reflect the reality of our own styles and experiences.

The second type of travel and architectural photography is more personal, and a bit looser. When you're on a trip to a part of the country you enjoy, or maybe visiting some foreign land, you want to savor the experience as well as capture it photographically. Photographing buildings and structures is a part of travel photography, but also can be enjoyed close to home for the pleasure to be found in architectural photography. Although I frequently travel solo specifically to shoot photos, I still enjoy soaking in the scenery, interacting with the people in the places I visit, and studying the interesting architecture.

As a result, like you, I don't worry about having absolute control over the lighting in any of these situations. That's often too much to hope for, in any case. So, this chapter will deal primarily with ways to optimize the lighting that is already present for your travel and architecture photos.

Choosing the Best Light and Best Angle

Every exterior scene has a "best" angle, the one that provides the optimum view. However, depending on the time of day, that angle might not put your subject in its best light—both figuratively and literally. If you can't choose your angle, then choose the time of day that provides the best lighting. And, if you can't choose

your lighting, your best bet is to choose a different angle, even if it's not the very best perspective. And, of course, even though this is a *lighting* book, I'd be remiss if I didn't mention that lens focal length or zoom setting also factors into the best use of light and angle.

Figures 9.1, 9.2, and 9.3 show the changes possible when switching angle *and* time of day. I arrived at this hilltop castle about an hour before sunset, with the sun low in the sky. The perspective that showed the castle's most attractive side, as well as the town below, happened to have the worst possible light, as

shown in Figure 9.1. The sun was behind the castle, and a little off to the right, providing backlighting that cast the side facing me in shadows that revealed almost nothing of the structure's interesting texture. Worse, when exposing to capture detail in the shadow, the sky was washed out. Although this view was probably

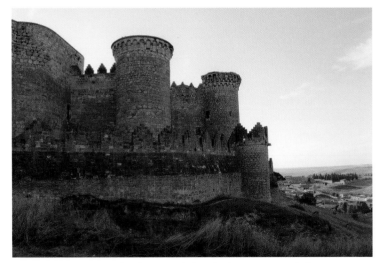

Figure 9.1 Sometimes, the "best" angle has the least attractive lighting.

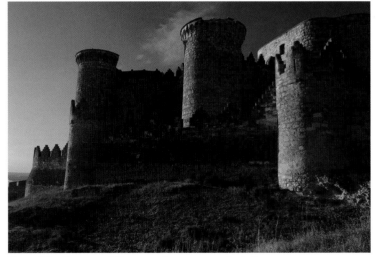

Figure 9.2 Choose a different angle to improve the lighting.

the best angle to shoot from pictorially, the light from this standpoint was atrocious.

So, I clambered around to a view on the other side, with the sun shining directly on the castle from the left, as shown in Figure 9.2. Instead of the picturesque town in the valley, this angle showed an agricultural field that was smoky from a burn-off, so I cropped it out. Although this wasn't the best possible view, the lighting was much better, and showed off the rough texture of the 15th Century structure.

I returned the next day to take another shot at photographing the castle from the "best" angle, producing the image shown in Figure 9.3. The mid-day sun was a bit harsh, but I was able to capture the most attractive all-around view. Sometimes changing angles *and* choosing a different time of day can be your best option.

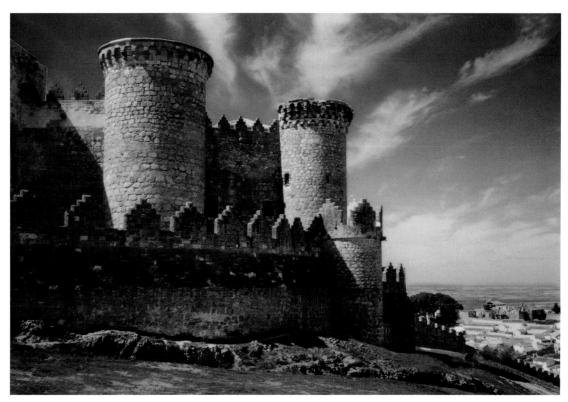

Figure 9.3 Or, come back at a different time when the lighting is better.

Monuments and Museums

During your travels, you'll discover that some of the most interesting architecture will be found in monuments and museums. In some locations, these will be major attractions in their own right, a destination where travelers marvel at the grandeur of the structure, or revel in the richness of the artwork and exhibits. But don't overlook the smaller museums and less important monuments, which have a charm of their own.

These subjects frequently offer lighting challenges that await your creative interpretation. Here are some techniques you can use:

◆ **Use lighting as a frame.** One interesting approach that I like is to use lighting to help frame a building in an interesting way. Figure 9.4 shows a cathedral basking in full mid-morning sunlight. It was located down the street from an archway that was only dimly illuminated. By composing the photo so the archway forms a frame, the shadowy area in the foreground provides a picturesque setting that establishes the medieval environment that surrounds the cathedral.

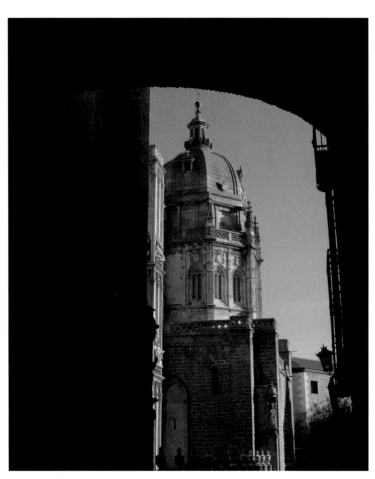

Figure 9.4 The darker area of the archway provides a frame for the sunlit cathedral.

◆ **Capture details.** If a structure is unevenly lit or poorly lit, you can still come away with an interesting photograph if you zero in on important details that tell a story of their own. Figure 9.5 shows a pair of lions that guard the aptly-named Puerta de los Leones outside the Toledo Cathedral in Spain. After capturing the shot that resulted in Figure 9.4, I continued to walk around the cathedral and found these stone creatures illuminated by the mid-morning sunshine. I zoomed in on one of them, and captured this detail. Later, on the shady (sombra) side of the cathedral, I found some carvings and a knocker on a centuries-old wooden door. The lighting was too flat to show the texture, so I used an off-camera flash to cast some shadows, as shown in Figure 9.6.

◆ **Exploit the available lighting.** Uneven lighting isn't always a problem. It actually adds a mood, and helps show how the scene actually looked in real life. Your goal shouldn't be for bland lighting that masks the character of the monument or building. Learn to use the light that is actually there.

◆ **Work with a monopod.** Inside a museum interior, you'll want to use a monopod to steady the camera so you can take longer exposures in the dim lighting without resorting to astronomically high (and visual noise-inducing) ISO sensitivity settings. Most museums and many religious structures (and, indeed, in Europe, especially, you'll find they are often one and the same) won't allow tripods. Many do permit monopods. You'll find more on shooting interiors in the next section.

Figure 9.5 A detail can sometimes be more interesting than the full structure.

Figure 9.6 The detail on this centuries-old door was revealed with the addition of some direct flash, placed off to one side.

Interiors

Shooting under indoor lighting is potentially one of the most challenging kinds of architectural photography. Unless the interior is huge, your widest wide-angle setting may not provide enough of a view, and there certainly is no way you can back off further (although I've sometimes resorted to stepping outside and shooting through an open window).

In addition, the lighting is likely to be problematic, presenting one or more of the following predicaments:

◆ **Insufficient light.** The illumination is so dim you're forced to make a long exposure with the camera mounted on a tripod.

◆ **Harsh illumination.** Glaring lighting can give an image excessive contrast.

◆ **Uneven illumination.** The light may be strong in one area of the interior and dim in another, making it difficult to evenly expose the entire image.

◆ **Mixed illumination.** You may have daylight streaming in the windows, mixing its blue light with the orangish incandescent illumination of the room. I'll address this type of situation in the section that follows this one, because mixed illumination can be present indoors or out.

◆ **Off-color illumination.** The light in the interior may be distributed evenly, diffuse and pleasant—and entirely the wrong color, thanks to fluorescent lighting or, worse, colored illumination. Your digital camera's white-balance controls might or might not be able to correct for this problem.

Insufficient illumination can sometimes be countered by using a tripod-mounted camera and a long exposure. If the light is evenly distributed and otherwise pleasing, a longer exposure may do the trick, as long as your camera isn't subject to excessive noise during long and time exposures (or, if it is, you can correct the noise in your camera or image editor). Sometimes using a lower ISO setting helps reduce noise, although at the cost of even longer exposures. Many public buildings don't allow tripods, but you might be able to get special permission to shoot at a certain time.

Harsh lighting adds contrast, and, indoors when shooting a large space, as shown in Figure 9.7, there is not a lot you can do about it. The vaulted corridor was relatively dimly-lit compared to the apse that adjoined it, but in this case, I wanted the ceiling to show up clearly, so I went ahead and overexposed. That caused some areas to be unacceptably bright. By cropping tightly at the right side of the photo, I was able to eliminate the most blatantly overexposed parts of the image. That's crucial, because the eye is inherently drawn to the brightest portion of an image, even if it's not the most important subject.

Uneven illumination can be your enemy or your friend. It can make a particular shot difficult to capture, or can add some extra drama to your image. Uneven (and harsh illumination) can be compensated for by additional lighting, softening existing light, or, perhaps by using reflectors to spread the illumination around. But if you don't have that option, as in Figure 9.8, you can make the best of the existing light to produce a dramatic effect. The version at left shows a statue illuminated by an overhead spotlight, with enough light bouncing around to partially fill in the shadows. At right, the exposure was reduced by a little more than one f/stop, and the contrast of the resulting underexposed image increased to create an image with more impact.

Off-color illumination and mixed lighting (discussed in the next section) can often be partially compensated for by setting the right color balance—but only if one light source predominates. Figure 9.9 shows the interior of a former mosque that was primarily lit by very warm incandescent illumination, with only a little daylight spilling in through small windows in the walls. By adjusting the white balance for the incandescent lights, a fairly natural color balance results.

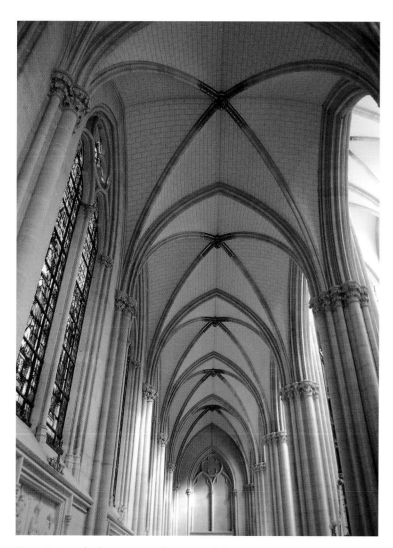

Figure 9.7 Fairly dim areas can be captured if you are able to provide enough exposure, even if that's at the expense of other portions of the image.

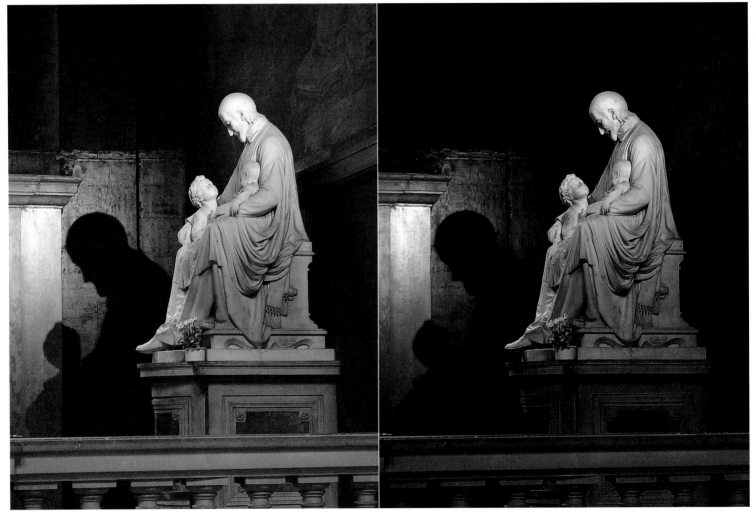

Figure 9.8 At left, a properly exposed image; at right, slight underexposure and a contrast boost in Photoshop produces a more dramatic version using the existing spotlighting.

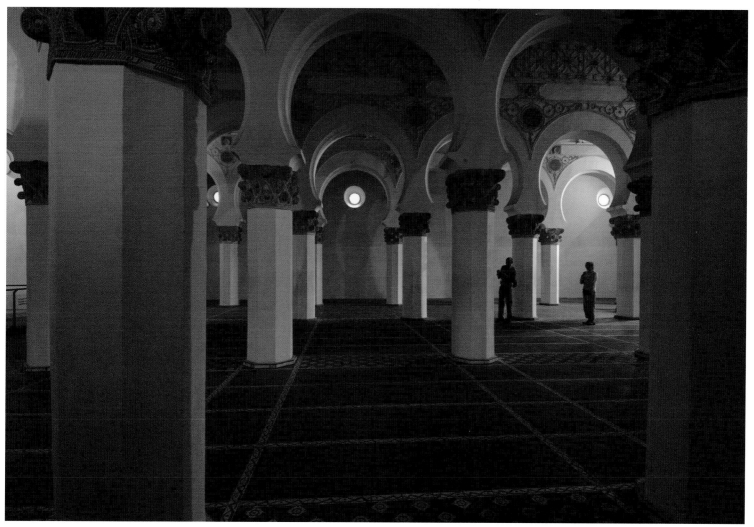

Figure 9.9 If off-color illumination is the predominant light source, you can often compensate for it using your camera's White Balance controls.

Mixed Illumination

Mixed illumination is created when more than one light source provides the lighting, and the different sources are mismatched. This can happen when an interior lit by incandescent or fluorescent lighting also has some window light bathing the scene. The "pro" solution is to use orange colored gels on the windows themselves, which converts the daylight to the equivalent of a tungsten white balance.

I sometimes use mixed illumination as a special effect. It can be carried to extremes by placing colored filters or gels over light sources to get, not only warm and cool lighting mixtures, but mixed red/green or other combinations. One of my favorite tricks is to set my camera up on a tripod at night, and take a long exposure with an electronic flash lighting up the foreground.

The background illuminated by tungsten light ends up with an orange tint that contrasts with the bluer illumination in the foreground.

You can see an example of this technique in Figure 9.10, a fish-eye shot that took advantage of the camera's built-in flash, which couldn't cover the fish-eye's view, and instead provided a bluish circle of illumination that added to the distorted effect.

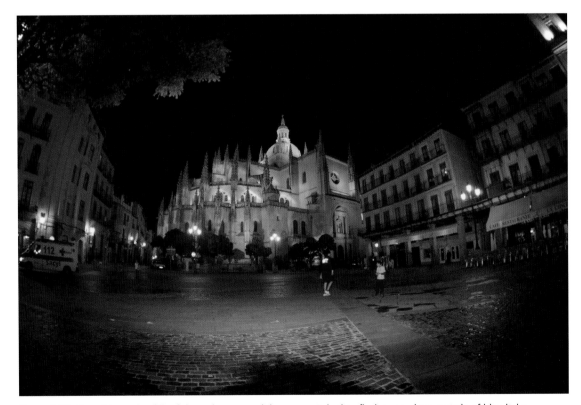

Figure 9.10 The wide angle of the fish-eye lens caused the camera's built-in flash to produce a circle of blue light.

If you encounter mixed illumination and don't want to use it as a special effect, your best bet is to settle on one source or another and stick with that. If you want to use the blue daylight coming through a window, you'll have to dim the room's incandescent illumination and, perhaps, substitute soft, diffuse electronic flash (say, bounced off a piece of white cardboard, such as the reverse side of a poster you bought in a tourist shop). Or, cut the room lights entirely and use reflectors, as was done for the photograph in Figure 9.11.

This room in a converted castle tower in Villaba, Spain, had walls that were five feet thick. The light streaming in from the open window was used to illuminate the whole room, with reflectors off to the left behind the camera. I let the furniture and other foreground details go dark in order to preserve the Medieval mood of this photograph.

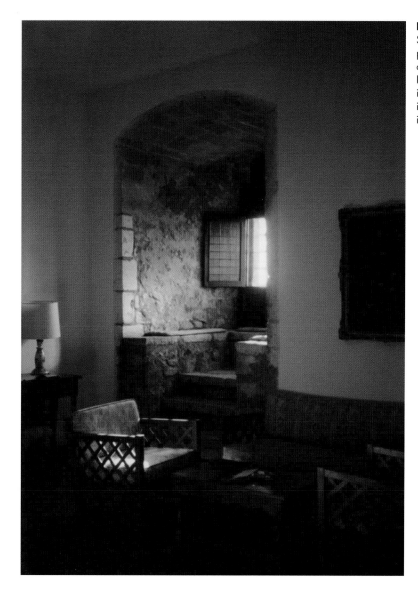

Figure 9.11
Solve mixed lighting problems by eliminating one of the light sources. In this case, window illumination was used instead of the room's incandescent lighting.

Sunsets and Sunrises

Sunsets and sunrises are popular subjects because they're beautiful, colorful, and their images often look as if a lot of thought went into them, even if you just point the camera and fire away. Some photographers specialize in them. Although photographically they are almost identical, sunsets seem to be photographed most often. Perhaps it's because most of us are awake for sunset, but fewer manage to make it out of bed in time to photograph a sunrise. Of course, for those who don't like cold weather, but who live in higher latitudes, for much of the year it's a lot warmer at sundown than at sunrise. Finally, to photograph a sunset, you can spend hours looking for just the right spot and use the waning daylight to decide exactly where to stand to capture the sunset as the sun dips below the horizon. Dawn, in sharp contrast, occurs after a really dark period (night), and you may have difficulty planning

your shot in the relatively short interval just before sunrise.

Sometimes, the look of the two events can be quite different. On one photo shoot, I arrived at a hilltop overlooking the Spanish plain about an hour before sunset, and took a series of photos, culminating with the one shown

at left in Figure 9.12. I returned the next morning to shoot the same windmill from the opposite side, an hour after sunrise, when the sun was still low on the horizon, and the fog and dew of the new day hadn't been burned off. Both pictures show the windmill illuminated from the rear, but the look is very different.

Here are some tips for taking advantage of the gorgeous lighting effects you find during sunsets (or sunrises):

◆ If your camera has an automatic white balance control that can be overridden, see if you have a Sunset/Sunrise white balance setting as well as a Sunset/Sunrise programmed exposure mode. The former will let you avoid having the desired warm tones of the sunset neutralized by the white balance control, and the latter can allow you to get a correct exposure despite the backlighting provided by the sun. With sunset photos, you generally *want* a dark, silhouette effect punctuated by the bright orb of the sun.

◆ Don't stare at the sun, even through the viewfinder. I usually compose my sunset photos with the sun slightly out of the frame, then recompose just before taking the photo.

Figure 9.12 Sunset (left) and sunrise (right) can have very different looks.

- Avoid splitting your photo in half with the horizon in the middle. Your picture will be more interesting if the horizon is about one-third up from the bottom (to emphasize the sky) or one-third down from the top (to emphasize the foreground). But don't shy away from breaking that rule if the image you want to capture dictates it, as I did for Figure 9.13.

- Sunsets don't have to be composed horizontally! Vertically oriented shots, like the one shown in Figure 9.14, can be interesting. In that photo, I broke several "rules" by using vertical orientation for a "landscape" photo, and didn't wait until the last moment to shoot. True sunset was actually about 30 minutes away when the picture was taken. I deliberately underexposed the photo to create a sunset image.

- Take advantage of the sun's backlighting to get some good silhouettes, whether the silhouette is a tree or a windmill (as in Figure 9.12), a church spire, or some other subject matter. Use your camera's exposure value (EV) compensation to reduce exposure by two stops.

- If you have a person or other object in the near foreground that you *don't* want in silhouette, try a few shots with your camera's flash turned on. The mixed lighting effect can be dramatic.

- Plan carefully and work fast. Once the sun starts to set, you might have only a few minutes to shoot your pictures, so be ready, have your camera settings locked in, and take many pictures. If some prove to be duds, you can always erase them.

- Make sure your lens is focused at infinity. Sunsets can fool the autofocus mechanisms of some cameras. Use manual focus if you must.

- Exposures can be longer than you might have expected when the sun dips behind the trees or below the horizon, so have a tripod handy.

Figure 9.13 Never let the horizon divide the frame in half—unless you want to. Rules are made to be broken.

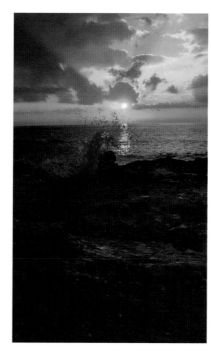

Figure 9.14 Here's another broken rule: shoot vertical sunset "landscape" shots and don't wait until the sun reaches the horizon.

Night Lighting

Once the sun has gone down, photography becomes more of a challenge, because there is much less light available to take the photo, and any supplementary light you add tends to make the image look less realistic. Auxiliary light sources, including electronic flash, can be used only as a last resort, because as soon as you add a light, the scene immediately loses its nighttime charm. Unless you're looking for the look of Speed Graphic-toting photojournalists of the 1950s, flash at night is an imperfect solution.

The goal of most night and evening photography is to reproduce a scene much as it appears to the unaided eye, or, alternatively, with blur, streaking lights, or other effects added that enhance the mood or create an effect. Because night photography is so challenging technically, you'll find it an excellent test of your skills, and an opportunity to create some interesting images.

Your first challenge will be to boost the amount of light that reaches your sensor. That can be accomplished using several different techniques, alone or in combinations. For example, you can use the largest f/stop available to you. A fast prime lens, with a maximum aperture of f/1.8 to f/1.4, may allow you to shoot some brightly lit night scenes handheld using reasonably short shutter speeds. Or, you can resort to the longest exposure time you can hand-hold. For most people, 1/30th second is about the longest exposure that can be used without a tripod with a wide-angle or normal lens focal length. Short telephoto focal lengths require 1/60th to 1/125th second, making them less suitable for night photography without a tripod. However, lenses with vibration reduction/image stabilization built in can often be handheld for exposures of 1/15th second or longer.

If light is exceptionally dim, use a tripod, monopod, or other handy support. Brace your camera or fix it tight and you can take shake-free photos of several seconds to 30 seconds or longer. Figure 9.15 shows a lakeside photo taken at 10 p.m., and illuminated solely by starlight, a glow at the horizon from a distant city, and (at right) from light spilling into the scene from an adjacent parking lot.

To reduce the length of exposures, increase the ISO sensitivity. When you boost the sensor's sensitivity, it magnifies the available light. Unfortunately, raising the ISO setting also magnifies the grainy visual effect known as *noise*. If you're not in a hurry, use your camera's noise-reduction options (there are two options: *long exposure noise reduction* and *high ISO noise reduction*).

The former tool takes a second, blank frame for the same interval as your original exposure, and then subtracts the noise found in this dark frame from the equivalent pixels in your original shot. This step effectively doubles the time needed to take a picture, meaning you'll have a 30-second wait following a 30-second exposure before you can take the next picture. High ISO noise reduction often involves algorithms that remove as much visual noise as possible. Both options tend to mask detail as they turn noise into mush, and should be used with caution.

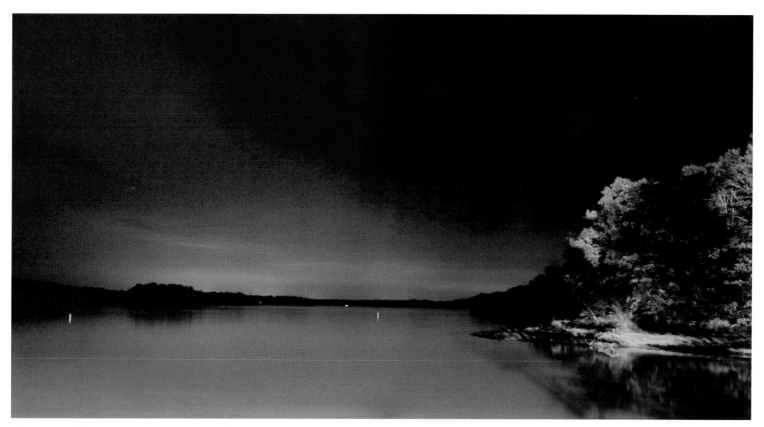

Figure 9.15 Although it was 10 p.m. on a moonless night, a 30 second exposure revealed this lake-side scene.

Here are some more suggestions:

◆ **Bracket exposures.** Precise exposure at night is tricky even under the best circumstances, so it's difficult to determine the "ideal" exposure. Instead of fretting over the perfect settings, try bracketing. A photo that's half a stop or more under- or overexposed can have a completely different look and can be of higher quality than if you produced the same result in an image editor. For the skyline scene shown in Figure 9.16, I set my camera up on a solid tripod and took a series of exposures at 8, 15, and 30 seconds. This eight-second photo was the best of the lot.

◆ **Shoot in twilight.** This allows you to get a nighttime look that takes advantage of the remaining illumination from the setting sun.

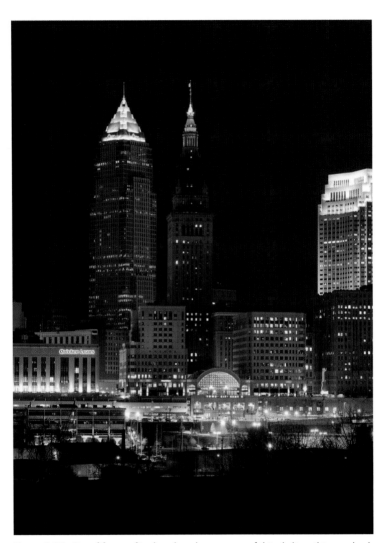

Figure 9.16 Out of four or five bracketed exposures of this skyline, this one had the most detail in the distant skyscrapers.

◆ **Add interest with filters.** An ordinary shot can be spiced up with filters, like the star filter used for Figure 9.17. If you don't own a star filter, and ordinary piece of window screen (or two) can add the same effect, turning all the bright point sources in your photos into multi-pointed stars.

◆ **If possible, choose a night with a full moon.** The extra light from the moon can provide more detail without spoiling the night-scene look of your photo.

◆ **If you absolutely *must* use flash, use Slow-Sync mode.** This allows use of longer shutter speeds with your flash. Then, the existing light in a scene can supplement the flash illumination. With any luck, you'll get a good balance and reduce the direct flash look in your final image.

◆ **When blur is unavoidable due to long exposure times, use it as a picture element.** Streaking light trails can enhance an otherwise ordinary night-scene photo. You can find out more about a particular kind of light trail in the next section, which deals with fireworks.

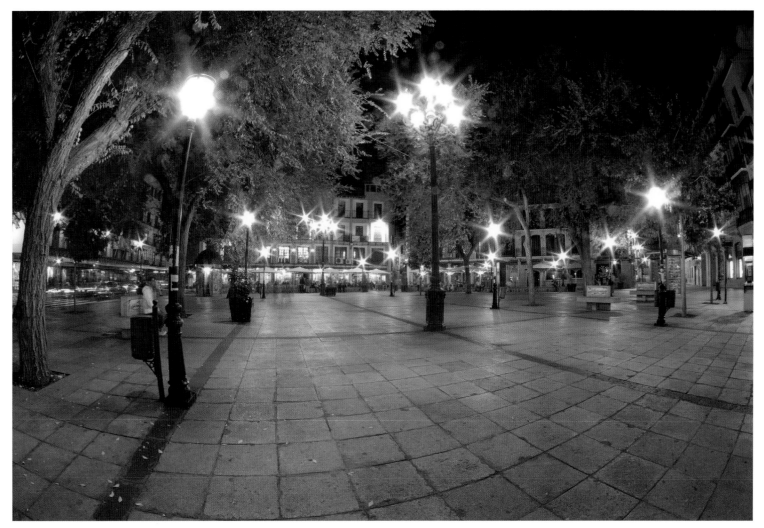

Figure 9.17 A cross-screen filter turned all the point light sources into multi-pointed stars for this night shot.

Fireworks

Fireworks are fun to shoot, and it's easy to get spectacular results. I got some great fireworks shots during the last Fourth of July celebration. My big complaint is that I didn't get to see the fireworks! I was so busy fiddling with my digital camera and the tripod and trying to push the shutter release at exactly the right time that I really saw only glimpses of the show, and only then through the viewfinder of my camera. You can do better if you follow these tips:

◆ **Use a tripod.** Fireworks exposures usually require a second or two to make, and nobody can handhold a camera for that long. Set up the tripod and point the camera at the part of the sky where you expect the fireworks to unfold, and be ready to trip the shutter. Use a remote release so you don't have to touch the camera, and possibly introduce some vibration.

◆ **Capture multiple bursts.** Try leaving your shutter open for several sets of displays. Cover the lens with your hand between displays to capture several in one exposure, as shown in Figure 9.18.

◆ **Incorporate your surroundings.** Some of the best fireworks photos show bursts of light against a city skyline or other backdrop. If you live in the boonies, like me, it's worth making a trip to the big city to get a shot like the one shown in Figure 9.19, taken after a Cleveland Indians victory at Progressive Field.

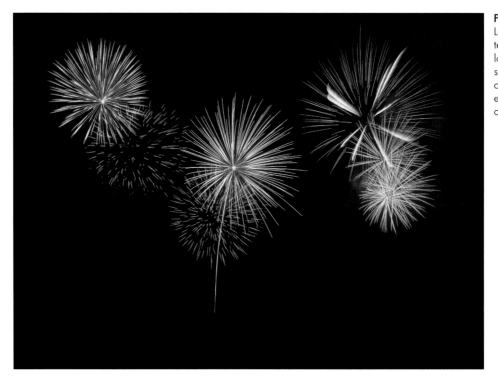

Figure 9.18 Leave the shutter open for as long as four seconds to combine several bursts into one shot.

- **Take the photo before the burst appears.** Watch as the skyrockets shoot up in the sky; you can usually time the start of the exposure for the moment just before they reach the top of their arc. With the camera set on time exposure, trip the shutter using a remote release (or a steady finger) and let the shutter remain open for all or part of the burst. Usually an exposure of 1 to 4 seconds works.

- **Adjust your exposure.** Review your shots and adjust your f/stop so you won't overexpose the image. Washed-out fireworks are the pits. At ISO 100, you'll be working with an f/stop of about f/5.6 to f/11.

- **Tolerate noise.** Expect some noise in your photos. Most digital cameras produce noise during long exposures, especially if you boost the ISO rating to 200 or 400.

- **Let there be light.** Take along a penlight so you can check your camera settings and make manual adjustments. It's going to be dark, and your camera's LCD illuminator only shows you the settings—not where particular knobs and buttons might be located!

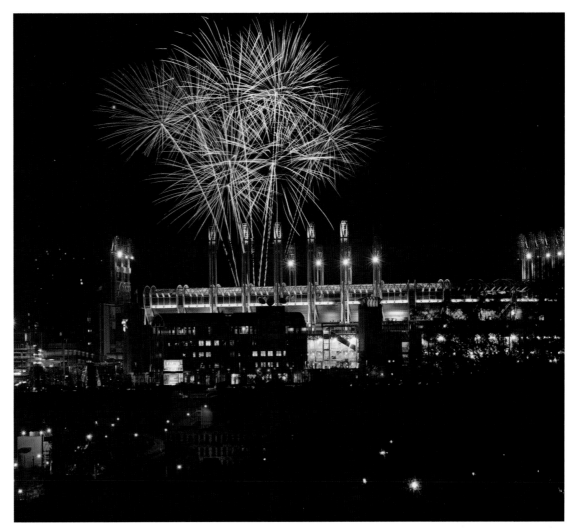

Figure 9.19 Try to include some of the surroundings to add interest to your fireworks photos.

Water, Beaches, and Snow

Whether you're at the ocean, by a lake, alongside a river, beneath a waterfall, or following the towpath of a canal, beaches, water, and snow make for some great scenic photography, not only for the beauty of the scene itself, but for the reflections and the excitement when the water is moving. Your images might take a languid approach, or mix in a bit of kinetic energy from the ocean or a roiling stream or river, like that pictured in Figure 9.20. Here are some tips for water and beach photos:

◆ **Watch your exposures at the ocean.** The bright sand can fool the exposure meter of your camera, giving you underexposed pictures. Review your first few shots on the LCD and dial in some EV corrections if necessary. But don't overexpose, unless you want a very high key look as shown in Figure 9.21.

Figure 9.20 Although some water scenes can be calm and cool, movement and vivid lighting make for a more exciting photo.

Figure 9.21
Bright light at the beach will often produce a high-key look.

◆ **Incorporate the reflections in the water into your photographs.** Many good scenic photos use water and reflections to good effect. Light bouncing off the surface of the water has a special look and you'll find the reflections add interest to your image.

◆ **Use a tripod and long exposures to capture waterfalls and streams.** Mount your camera on a tripod, add at least an 8X neutral density filter to your lens, and try a long exposure that lets the water merge into a foamy blur. At ISO 200 with an ND filter, you should be able to shoot at 1/15th second at f/32, or 1/8th second at f/32 on an overcast day. The water will appear silky smooth, giving you the next best thing to laminar flow in a photograph. The tripod keeps the rest of the image rock solid and sharp. If you don't have a neutral density filter to achieve a long enough exposure in daylight, try streams and waterfalls in open shade or later in the day, rather than shooting those in full sunlight.

◆ **Vary your angles.** Instead of standing at one end of a beach and pointing your camera up or down the shore, find a way to position yourself offshore, and shoot the beach from the perspective of a breaker. A fishing pier that extends out from the shore is a good place to start. You can also shoot from this vantage point onboard a boat that's brought to a halt a safe distance from shore. Or, shoot down

on the shore from a nearby cliff, a lighthouse that's open to the public, or, if you're adventurous, a hang-glider. Try a low angle. Get down so your camera is almost resting on the sand (but keep the sand out of your camera!) and try some seascapes that are heavy on foreground emphasis and quite unlike anything you've seen before.

◆ **Remember the tides.** High tide will provide a clean beach, but low tide leaves behind a treasury of shells, seaweed, and other objects (including old shoes and tires) that can enhance or detract from your photos. Learn which time of day a particular seashore is most photogenic before setting out on your seascape trek.

Photographing in snow is a lot like photographing at the beach: You have to watch out for glare and overexposures. You'll often end up with high key photos, like the one shown in Figure 9.22.

Batteries of all types put out less juice in cold temperatures, and those in your digital camera are no exception. Keep your camera warm if you want it to perform as you expect.

Also, watch out for condensation on the camera, particularly on the lens, which can occur when you bring your cold camera into a warmer, humid environment, like your automobile, even if only for a few moments. (Perhaps you're ducking in and out of the shelter of a car between shots, as I often do in colder climes.) Then, when you go back out in the cold, you've got a moist camera in your hands. If your camera uses an optical viewfinder instead of an electronic viewfinder or SLR system, you may not notice water drops on your lens until it's too late.

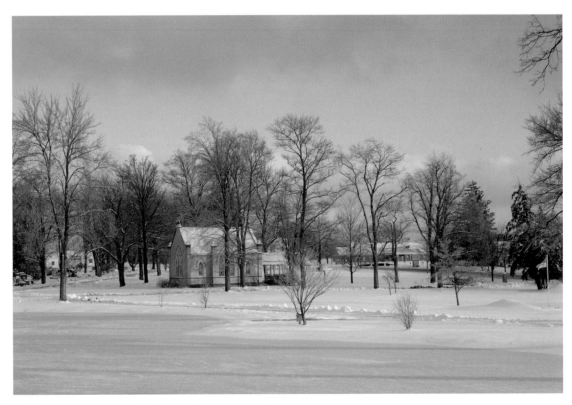

Figure 9.22 High key lighting shows up in snow scenes, too.

Consider using a skylight filter that you can clean off with a soft cloth as necessary. These filters are tougher than the glass of your lens and cheaper to replace if they get scratched.

In terms of lighting, snow and beach photography share a great deal with other kinds of outdoors pictures: the best illumination is often found at the beginning or end of the day, three to four hours before sunset, or after sunrise. Figure 9.23 was taken late in the afternoon, with the sun low enough in the sky to backlight the ice that clung to the trees. Remember that in regions far enough north to have snow, the sun is lower in the sky for most of the day than it is for the entire rest of the year.

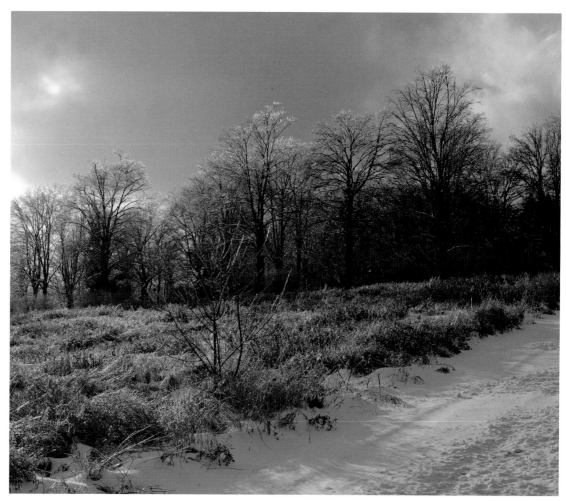

Figure 9.23 Snow scenes are often best captured early or late in the day, when the sun is low.

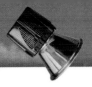

Glossary

ambient lighting Diffuse nondirectional lighting that doesn't appear to come from a specific source but, rather, bounces off walls, ceilings, and other objects in the scene when a picture is taken.

angle of view The area of a scene that a lens can capture, determined by the focal length of the lens. Lenses with a shorter focal length have a wider angle of view than lenses with a longer focal length.

Aperture-Priority A camera setting that allows you to specify the lens opening or f/stop that you want to use, with the camera selecting the required shutter speed automatically based on its light-meter reading.

Autofocus A camera setting that allows the camera to choose the correct focus distance for you, usually based on the contrast of an image (the image will be at maximum contrast when in sharp focus) or a mechanism such as an infrared sensor that measures the actual distance to the subject. Cameras can be set for *Single Autofocus* (the lens is not focused until the shutter release is partially depressed) or *Continuous Autofocus* (the lens refocuses constantly as you frame and reframe the image).

averaging meter A light-measuring device that calculates exposure based on the overall brightness of the entire image area. Averaging tends to produce the best exposure when a scene is evenly lit or contains equal amounts of bright and dark areas that contain detail. Most digital cameras use much more sophisticated exposure measuring systems based in center-weighting, spot-reading, or calculating exposure from a matrix of many different picture areas. See also *spot meter*.

B (bulb) A camera setting for making long exposures. Press down the shutter button and the shutter remains open until the shutter button is released. Bulb exposures can also be made using a camera's electronic remote control, or a cable release cord that fits to the camera.

backlighting A lighting effect produced when the main light source is located behind the subject. Backlighting can be used to create a silhouette effect, or to illuminate translucent objects. See also *front lighting, fill lighting,* and *ambient lighting.* Backlighting is also a technology for illuminating an LCD display from the rear, making it easier to view under high ambient lighting conditions.

barrel distortion A defect found in some wide-angle prime and zoom lenses that causes straight lines at the top or side edges of an image to bow outward into a barrel shape.

blooming An image distortion caused when a photosite in an image sensor has absorbed all the photons it can handle, so that additional photons reaching that pixel overflow to affect surrounding pixels producing unwanted brightness and overexposure around the edges of objects. Also known as "blown highlights."

blur In photography, to soften an image or part of an image by throwing it out of focus, or by allowing it to become soft due to subject or camera motion (intentionally or accidentally). In image editing, blurring is the softening of an area by reducing the contrast between pixels that form the edges.

bokeh A buzzword used to describe the aesthetic qualities of the out-of-focus parts of an image, with some lenses producing "good" bokeh and others offering "bad" bokeh. *Boke* is a Japanese word for "blur," and the h was added to keep English

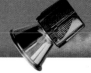

speakers from rhyming it with *broke*.

Out-of-focus points of light become discs, called the *circle of confusion*. Some lenses produce a uniformly illuminated disc. Others, most notably *mirror* or *catadioptic* lenses, produce a disc that has a bright edge and a dark center, producing a "dough-nut" effect, which is the worst from a bokeh standpoint. Lenses that generate a bright center that fades to a darker edge are favored, because their bokeh allows the circle of confusion to blend more smoothly with the sur-roundings. The bokeh characteris-tics of a lens are most important when you are using selective focus (say, when shooting a por-trait) to deemphasize the back-ground, or when shallow depth-of-field is a given because you're working with a macro lens, long telephoto, or with a wide-open aperture. See also *circle of confusion*.

bounce lighting Light bounced off a reflector, including ceiling and walls, to provide a soft, natural-looking light.

bracketing Taking a series of photographs of the same subject at different settings to help ensure that one setting will be the correct one. Many digital cameras will automatically snap off a series of bracketed exposures for you. Other settings, such as color and white balance, can also be "bracketed" with some models. Digital SLRs may even allow you to choose the order in which bracketed settings are applied.

brightness The amount of light and dark shades in an image, usually represented as a percent-age from 0 percent (black) to 100 percent (white).

burn A darkroom technique, mimicked in image editing, which involves exposing part of a print for a longer period, making it darker than it would be with a straight exposure.

burst mode The digital cam-era's equivalent of the film cam-era's "motor drive," used to take multiple shots within a short period of time.

calibration A process used to correct for the differences in the output of a printer or monitor

when compared to the original image. Once you've calibrated your scanner, monitor, and/or your image editor, the images you see on the screen more closely represent what you'll get from your printer, even though calibration is never perfect.

camera shake Movement of the camera, aggravated by slower shutter speeds, which pro-duces a blurred image. Some of the latest digital cameras have *image stabilization* features that correct for camera shake, while a few high-end interchangeable lenses have a similar vibration correction or reduction feature. See also *image stabilization*.

cast An undesirable tinge of color in an image.

center-weighted meter A light-measuring device that emphasizes the area in the mid-dle of the frame when calculating the correct exposure for an image. See also *averaging meter* and *spot meter*.

chroma Color or hue.

circle of confusion A term applied to the fuzzy discs

produced when a point of light is out of focus. The circle of confu-sion is not a fixed size. The view-ing distance and amount of enlargement of the image deter-mine whether we see a particular spot on the image as a point or as a disc.

color correction Changing the relative amounts of color in an image to produce a desired effect, typically a more accurate representation of those colors. Color correction can fix faulty color balance in the original image, or compensate for the deficiencies of the inks used to reproduce the image.

contrast The range between the lightest and darkest tones in an image. A high-contrast image is one in which the shades fall at the extremes of the range between white and black. In a low-contrast image, the tones are closer together.

crop To trim an image or page by adjusting its boundaries.

dedicated flash An electronic flash unit designed to work with the automatic exposure features of a specific camera.

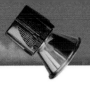

density The ability of an object to stop or absorb light. The less light reflected or transmitted by an object, the higher its density.

depth-of-field A distance range in a photograph in which all included portions of an image are at least acceptably sharp. With many dSLRs, you can see the available depth-of-field at the taking aperture by pressing the depth-of-field preview button, or estimate the range by viewing the depth-of-field scale found on many lenses.

desaturate To reduce the purity or vividness of a color, making a color appear to be washed out or diluted.

diaphragm An adjustable component, similar to the iris in the human eye, which can open and close to provide specific sized lens openings, or f/stops. See also *f/stop* and *iris*.

diffraction The loss of sharpness due to light scattering as an image passes through smaller and smaller f/stop openings. Diffraction is dependent only on the actual f/stop used, and the wavelength of the light.

diffuse lighting Soft, low-contrast lighting.

diffusion Softening of detail in an image by randomly distributing gray tones in an area of an image to produce a fuzzy effect. Diffusion can be added when the picture is taken, often through the use of diffusion filters, or in post-processing with an image editor. Diffusion can be beneficial to disguise defects in an image and is particularly useful for portraits of women.

dodging A darkroom term for blocking part of an image as it is exposed, lightening its tones. Image editors can mimic this effect by lightening portions of an image using a brush-like tool. See also *burn*.

Exif Exchangeable Image File Format. Developed to standardize the exchange of image data between hardware devices and software. A variation on JPEG, Exif is used by most digital cameras, and includes information such as the date and time a photo was taken, the camera settings, resolution, amount of compression, and other data.

existing light In photography, the illumination that is already present in a scene. Existing light can include daylight or the artificial lighting currently being used, but is not considered to be electronic flash or additional lamps set up by the photographer.

exposure The amount of light allowed to reach the film or sensor, determined by the intensity of the light, the amount admitted by the iris of the lens, and the length of time determined by the shutter speed.

exposure program An automatic setting in a digital camera that provides the optimum combination of shutter speed and f/stop at a given level of illumination. For example a "sports" exposure program would use a faster, action-stopping shutter speed and larger lens opening instead of the smaller, depth-of-field-enhancing lens opening and slower shutter speed that might be favored by a "close-up" program at exactly the same light level.

exposure values (EV) EV settings are a way of adding or decreasing exposure without the need to reference f/stops or

shutter speeds. For example, if you tell your camera to add +1EV, it will provide twice as much exposure, either by using a larger f/stop, slower shutter speed, or both.

fill lighting In photography, lighting used to illuminate shadows. Reflectors or additional incandescent lighting or electronic flash can be used to brighten shadows. One common technique outdoors is to use the camera's flash as a fill.

filter In photography, a device that fits over the lens, changing the light in some way. In image editing, a feature that changes the pixels in an image to produce blurring, sharpening, and other special effects. Photoshop CS includes several new filter effects, including Lens Blur and Photo Filters.

flash sync The timing mechanism that ensures that an internal or external electronic flash fires at the correct time during the exposure cycle. A dSLR's flash sync speed is the highest shutter speed that can be used with flash. See also *front-curtain sync* and *rear-curtain sync*.

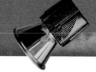

flat An image with low contrast.

focal length The distance between the film and the optical center of the lens when the lens is focused on infinity, usually measured in millimeters.

framing In photography, composing your image in the viewfinder. In composition, using elements of an image to form a sort of picture frame around an important subject.

fringing A chromatic aberration that produces fringes of color around the edges of subjects, caused by a lens' inability to focus the various wavelengths of light onto the same spot. *Purple fringing* is especially troublesome with backlit images, but can sometimes be fixed with some image editors.

front-curtain sync The default kind of electronic flash synchronization technique, originally associated with focal plane shutters, which consist of a traveling set of curtains, including a front curtain (which opens to reveal the film or sensor) and a rear curtain (which follows at a distance determined by shutter speed to conceal the film or sensor at the conclusion of the exposure).

For a flash picture to be taken, the entire sensor must be exposed at one time to the brief flash exposure, so the image is exposed after the front curtain has reached the other side of the focal plane, but before the rear curtain begins to move.

Front-curtain sync causes the flash to fire at the *beginning* of this period when the shutter is completely open, in the instant that the first curtain of the focal plane shutter finishes its movement across the film or sensor plane. With slow shutter speeds, this feature can create a blur effect from the ambient light, showing as patterns that follow a moving subject with subject shown sharply frozen at the beginning of the blur trail (think of an image of The Flash running backwards). See also *rear-curtain sync*.

front lighting Illumination that comes from the direction of the camera. See also *backlighting* and *sidelighting*.

f/stop The relative size of the lens aperture, which helps determine both exposure and depth-of-field. The larger the f/stop number, the smaller the f/stop itself. It helps to think of f/stops as denominators of fractions, so that f/2 is larger than f/4, which is larger than f/8, just as 1/2, 1/4, and 1/8 represent ever-smaller fractions. In photography, a given f/stop number is multiplied by 1.4 to arrive at the next number that admits exactly half as much light. So, f/1.4 is twice as large as f/2.0 (1.4 × 1.4), which is twice as large as f/2.8 (2 × 1.4), which is twice as large as f/4 (2.8 × 1.4). The f/stops that follow are f/5.6, f/8, f/11, f/16, f/22, f/32, and so on. See also *diaphragm*.

gamut The range of viewable and printable colors for a particular color model, such as RGB (used for monitors) or CMYK (used for printing).

Gaussian blur A method of diffusing an image using a bell-shaped curve to calculate the pixels that will be blurred, rather than blurring all pixels, producing a more random, less "processed" look.

graduated filter A lens attachment with variable density or color from one edge to another. A graduated neutral density filter, for example, can be oriented so the neutral density portion is concentrated at the top of the lens' view with the less dense or clear portion at the bottom, thus reducing the amount of light from a very bright sky while not interfering with the exposure of the landscape in the foreground. Graduated filters can also be split into several color sections to provide a color gradient between portions of the image.

gray card A piece of cardboard or other material with a standardized 18-percent reflectance. Gray cards can be used as a reference for determining correct exposure.

highlights The brightest parts of an image containing detail.

histogram A kind of chart showing the relationship of tones in an image using a series of 256 vertical "bars," one for each brightness level. A histogram chart typically looks like a curve

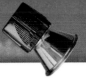
with one or more slopes and peaks, depending on how many highlight, midtone, and shadow tones are present in the image.

hyperfocal distance A point of focus where everything from half that distance to infinity appears to be acceptably sharp. For example, if your lens has a hyperfocal distance of four feet, everything from two feet to infinity would be sharp. The hyperfocal distance varies by the lens and the aperture in use. If you know you'll be making a "grab" shot without warning, sometimes it is useful to turn off your camera's automatic focus and set the lens to infinity, or, better yet, the hyperfocal distance. Then, you can snap off a quick picture without having to wait for the lag that occurs with most digital cameras as their autofocus locks in.

image stabilization A technology, also called vibration reduction and anti-shake, that compensates for camera shake, usually by adjusting the position of the camera sensor or lens elements in response to movements of the camera.

incident light Light falling on a surface.

infinity A distance so great that any object at that distance will be reproduced sharply if the lens is focused at the infinity position.

interchangeable lens Lens designed to be readily attached to and detached from a camera; a feature found in more sophisticated digital cameras.

International Organization for Standardization (ISO) A governing body that provides standards such as those used to represent film speed, or the equivalent sensitivity of a digital camera's sensor. Digital camera sensitivity is expressed in ISO settings.

interpolation A technique digital cameras, scanners, and image editors use to create new pixels required whenever you resize or change the resolution of an image based on the values of surrounding pixels. Devices such as scanners and digital cameras as well as image editors can also use interpolation to create pixels in addition to those actually captured, thereby increasing the

apparent resolution or color information in an image.

invert In image editing, to change an image into its negative; black becomes white, white becomes black, dark gray becomes light gray, and so forth. Colors are also changed to the complementary color; green becomes magenta, blue turns to yellow, and red is changed to cyan.

iris A set of thin overlapping metal leaves in a camera lens, also called a diaphragm, that pivot outwards to form a circular opening of variable size to control the amount of light that can pass through a lens.

Kelvin (K) A unit of measurement based on the absolute temperature scale in which absolute zero is zero; used to describe the color of continuous spectrum light sources, such as tungsten illumination (3200 to 3400K) and daylight (5500 to 6000K).

latitude The range of camera exposures that produces acceptable images with a particular digital sensor or film.

lens One or more elements of optical glass or similar material designed to collect and focus rays of light to form a sharp image on the film, paper, sensor, or a screen.

lens aperture The lens opening, or iris, that admits light to the film or sensor. The size of the lens aperture is usually measured in f/stops. See also *f/stop* and *iris*.

lens flare A feature of conventional photography that is both a bane and creative outlet. It is an effect produced by the reflection of light internally among elements of an optical lens. Bright light sources within or just outside the field of view cause lens flare. Flare can be reduced by the use of coatings on the lens elements or with the use of lens hoods. Photographers sometimes use the effect as a creative technique, and Photoshop includes a filter that lets you add lens flare at your whim.

lens hood A device that shades the lens, protecting it from extraneous light outside the actual picture area, which can reduce the contrast of the image, or allow lens flare.

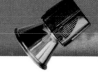

lighting ratio The proportional relationship between the amount of light falling on the subject from the main light and other lights, expressed in a ratio, such as 3:1.

luminance The brightness or intensity of an image, determined by the amount of gray in a hue.

macro lens A lens that provides continuous focusing from infinity to extreme close-ups, often to a reproduction ratio of 1:2 (half life-size) or 1:1 (life-size).

magnification ratio A relationship that represents the amount of enlargement provided by the macro setting of the zoom lens, macro lens, or with other close-up devices.

Matrix metering A system of exposure calculation that looks at many different segments of an image to determine the brightest and darkest portions, often comparing your image with stored image examples.

maximum aperture The largest lens opening or f/stop available with a particular lens, or with a zoom lens at a particular magnification.

midtones Parts of an image with tones of an intermediate value, usually in the 25 to 75 percent range. Many image-editing features allow you to manipulate midtones independently from the highlights and shadows.

monochrome Having a single color, plus white. Grayscale images are monochrome (shades of gray and white only).

neutral density filter A gray camera filter reduces the amount of light entering the camera without affecting the colors.

noise In an image, pixels with randomly distributed color values. Noise in digital photographs tends to be the product of low-light conditions and long exposures, particularly when you have set your camera to a higher ISO rating than normal.

noise reduction A technology used to cut down on the amount of random information in a digital picture, usually caused by long exposures at increased sensitivity ratings. Noise reduction involves the camera automatically taking a second blank/dark exposure at the same settings that contain only noise, and then using the blank photo's information to cancel out the noise in the original picture. With most cameras, the process is very quick, but does double the amount of time required to take the photo. Noise reduction can also be performed within image editors and stand-alone noise reduction applications.

overexposure A condition in which too much light reaches the film or sensor, producing a dense negative or a very bright/light print, slide, or digital image.

panning Moving the camera so that the image of a moving object remains in the same relative position in the viewfinder as you take a picture. The eventual effect creates a strong sense of movement.

panorama A broad view, usually scenic. Photoshop's new Photomerge feature helps you create panoramas from several photos. Many digital cameras have a panorama assist mode that makes it easier to shoot several photos that can be stitched together later.

perspective The rendition of apparent space in a photograph, such as how far the foreground and background appear to be separated from each other. Perspective is determined by the distance of the camera to the subject. Objects that are close appear large, while distant objects appear to be far away.

pixel The smallest element of a screen display that can be assigned a color. The term is a contraction of "picture element."

polarizing filter A filter that forces light, which normally vibrates in all directions, to vibrate only in a single plane, reducing or removing the specular reflections from the surface of objects and emphasizing the blue of skies in color images.

prime A camera lens with a single fixed focal length, as opposed to a zoom lens.

RAW An image file format offered by many digital cameras that includes all the unprocessed information captured by the camera. RAW files are very large, and must be processed by a

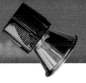

special program supplied by camera makers, image editors, or third parties, after being downloaded from the camera.

rear-curtain sync An optional kind of electronic flash synchronization technique, originally associated with focal plane shutters, which consist of a traveling set of curtains, including a front curtain (which opens to reveal the film or sensor) and a rear curtain (which follows at a distance determined by shutter speed to conceal the film or sensor at the conclusion of the exposure).

For a flash picture to be taken, the entire sensor must be exposed at one time to the brief flash exposure, so the image is exposed after the front curtain has reached the other side of the focal plane, but before the rear curtain begins to move.

Rear-curtain sync causes the flash to fire at the *end* of the exposure, an instant before the second or rear curtain of the focal plane shutter begins to move. With slow shutter speeds, this feature can create a blur effect from the ambient light, showing as patterns that follow a moving subject with subject shown sharply frozen at the end of the blur trail. If you were shooting a photo of The Flash, the superhero would appear sharp, with a ghostly trail behind him.

red eye An effect from flash photography that appears to make a person's eyes glow red, or an animal's yellow or green. It's caused by light bouncing from the retina of the eye, and is most pronounced in dim illumination (when the irises are wide open) and when the electronic flash is close to the lens and therefore prone to reflect directly back. Image editors can fix red eye through cloning other pixels over the offending red or orange ones.

red-eye reduction A way of reducing or eliminating the red-eye phenomenon. Some cameras offer a red-eye reduction mode that uses a preflash that causes the irises of the subjects' eyes to close down just prior to a second, stronger flash used to take the picture.

reflector Any device used to reflect light onto a subject to improve balance of exposure (contrast). Another way is to use fill-in flash.

reproduction ratio Used in macrophotography to indicate the magnification of a subject.

resample To change the size or resolution of an image. Resampling down discards pixel information in an image; resampling up adds pixel information through interpolation.

resolution In image editing, the number of pixels per inch used to determine the size of the image when printed. That is, an 8 × 10-inch image that is saved with 300 pixels per inch resolution will print in an 8 × 10-inch size on a 300 dpi printer, or 4 × 5-inches on a 600 dpi printer. In digital photography, resolution is the number of pixels a camera or scanner can capture.

saturation The purity of color; the amount by which a pure color is diluted with white or gray.

selective focus Choosing a lens opening that produces a shallow depth-of-field. Usually this is used to isolate a subject by causing most other elements in the scene to be blurred.

sensitivity A measure of the degree of response of a film or sensor to light.

shadow The darkest part of an image with detail, represented on a digital image by pixels with low numeric values or on a halftone by the smallest or absence of dots.

sharpening Increasing the apparent sharpness of an image by boosting the contrast between adjacent pixels that form an edge.

shutter In a conventional film camera, the shutter is a mechanism consisting of blades, a curtain, plate, or some other movable cover that controls the time during which light reaches the film. Digital cameras can use actual shutters, or simulate the action of a shutter electronically. Quite a few use a combination, employing a mechanical shutter for slow speeds and an electronic version for higher speeds.

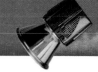

shutter-preferred An exposure mode in which you set the shutter speed and the camera determines the appropriate f/stop.

sidelighting Light striking the subject from the side relative to the position of the camera; produces shadows and highlights to create modeling on the subject.

single lens reflex (SLR) camera A type of camera that allows you to see through the camera's lens as you look in the camera's viewfinder. Other camera functions, such as light metering and flash control, also operate through the camera's lens.

slave unit An accessory flash unit that supplements the main flash, usually triggered electronically when the slave senses the light output by the main unit, or through radio waves.

slow sync An electronic flash synchronizing method that uses a slow shutter speed so that ambient light is recorded by the camera in addition to the electronic flash illumination, so that the background receives more exposure for a more realistic effect.

soft focus An effect produced by use of a special lens or filter that creates soft outlines.

soft lighting Lighting that is low or moderate in contrast, such as on an overcast day.

specular highlight Bright spots in an image caused by reflection of light sources.

spot meter An exposure system that concentrates on a small area in the image. See also *averaging meter*.

telephoto A lens or lens setting that magnifies an image.

time exposure A picture taken by leaving the shutter open for a long period, usually more than one second. The camera is generally locked down with a tripod to prevent blur during the long exposure.

tint A color with white added to it. In graphic arts, often refers to the percentage of one color added to another.

tolerance The range of color or tonal values that will be selected with a tool like the Photoshop's Magic Wand, or filled with paint when using a tool like the Paint Bucket.

transparency A positive photographic image on film, viewed or projected by light shining through film.

tripod A three-legged supporting stand used to hold the camera steady. Especially useful when using slow shutter speeds and/or telephoto lenses.

TTL Through-the-lens. A system of providing viewing through the actual lens taking the picture (as with a camera with an electronic viewfinder, LCD display, or single lens reflex viewing), or calculation of exposure, flash exposure, or focus based on the view through the lens.

tungsten light Usually warm light from ordinary room lamps and ceiling fixtures, as opposed to fluorescent illumination, which in many cases is deficient in red light.

underexposure A condition in which too little light reaches the film or sensor, producing a thin negative, dark slide, muddy-looking print, or dark digital image.

unsharp masking The process for increasing the contrast between adjacent pixels in an image, increasing sharpness, especially around edges.

vignetting Darkening of corners in an image, often produced by using a lens hood that is too small for the field of view, or generated artificially using image-editing techniques.

white balance The adjustment of a digital camera to the color temperature of the light source. Interior illumination is relatively red; outdoors light is relatively blue. Digital cameras often set correct white balance automatically, or let you do it through menus. Image editors can often do some color correction of images that were exposed using the wrong white-balance setting.

wide-angle lens A lens that has a shorter focal length and a wider field of view than a normal lens for a particular film or digital image format.

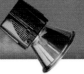

Index

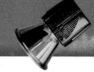